JAPANESE AMERICAN RESETTLEMENT
THROUGH THE LENS

UNIVERSITY PRESS OF COLORADO

Lane Ryo Hirabayashi

WITH KENICHIRO SHIMADA

PHOTOGRAPHS BY HIKARU CARL IWASAKI

FOREWORD BY THE HONORABLE NORMAN Y. MINETA

JAPANESE AMERICAN RESETTLEMENT
THROUGH THE LENS

HIKARU CARL IWASAKI AND THE

WRA'S PHOTOGRAPHIC SECTION, 1943–1945

© 2009 by the University Press of Colorado

Published by the University Press of Colorado
5589 Arapahoe Avenue, Suite 206C
Boulder, Colorado 80303

 The University Press of Colorado is a proud member of
the Association of American University Presses.

The University Press of Colorado is a cooperative publishing enterprise supported, in part, by Adams State College, Colorado State University, Fort Lewis College, Mesa State College, Metropolitan State College of Denver, University of Colorado, University of Northern Colorado, and Western State College of Colorado.

∞ The paper used in this publication meets the minimum requirements of the American National Standard for Information Sciences—Permanence of Paper for Printed Library Materials. ANSI Z39.48-1992

Library of Congress Cataloging-in-Publication Data

Hirabayashi, Lane Ryo.
 Japanese American resettlement through the lens : Hikaru Iwasaki and the WRA's Photographic Section, 1943–1945 / Lane Ryo Hirabayashi ; with Kenichiro Shimada ; photographs by Hikaru Carl Iwasaki.
 p. cm.
 Includes bibliographical references and index.
 ISBN 978-0-87081-928-5 (hardcover : alk. paper) 1. Japanese Americans—Evacuation and relocation, 1942–1945. 2. United States. War Relocation Authority. Photography Section. 3. Iwasaki, Hikaru, 1923– 4. World War, 1939–1945—Photography. I. Shimada, Kenichiro. II. Iwasaki, Hikaru, 1923– III. Title.

 D769.8.A6H578 2009
 940.53'1773—dc22

 2008054090

Design by Daniel Pratt

18 17 16 15 14 13 12 11 10 09 10 9 8 7 6 5 4 3 2 1

To
George & Sakaye Aratani
and
Don Nakanishi

Contents

Figures

Japanese American Resettlement: A Personal Story

THE HONORABLE NORMAN Y. MINETA

The publication of this book is a milestone, if only because the history of Japanese American "resettlement" is relatively unknown. Through its text and fascinating photos, *Japanese American Resettlement through the Lens* sheds a great deal of light on what this process was all about, from the point of view of both the Japanese Americans who experienced it firsthand and the federal bureaucrats who carried it out. For many Japanese Americans who were incarcerated, including my own family, resettlement began as women, men, and families left camp during and after World War II.

As one of five children in a large, comfortably situated family, I had a wonderful childhood. My father, Kunisaku Mineta, an energetic young man, arrived from Japan in 1902 at the age of fourteen. Like many Issei immigrants, he started off his new life in America in agriculture. Even though he was ineligible to become a U.S. citizen because of his ancestry, my father eventually made a nice living selling insurance in San Jose. By the 1920s he established his own business, the Mineta Insurance Agency, and prospered. I have joyous memories of family vacations that we took to Crater Lake, Lake Tahoe, the Grand Canyon, and other national parks. Although the Depression years that followed were difficult, my father was able to provide a loving and stable home for us.

Our American dream came crashing down in 1942, when I was only ten years old. Shortly after Pearl Harbor, FBI agents came into the community and began arresting men who were on

their shortlist of "suspect enemy aliens." I will never forget how a next-door neighbor's daughter, around my age, ran to our house screaming that her father was being taken away by the police. Similar things occurred throughout the community. The fear and uncertainty were palpable even to young children like myself.

My father was forced to close his business, as all Issei bank accounts were frozen after Pearl Harbor. My father's savings were confiscated and, to this day, have never been acknowledged or returned. A few months after the first arrests, Franklin Roosevelt signed Executive Order 9066, which led to the immediate removal of more than 110,000 persons of Japanese ancestry from the West Coast. We had to relinquish our cherished possessions, even the family dog, as the government ordered us to prepare for removal and to pack only what we could carry. Our only piece of good fortune was that we were able to lease our house to a professor at San Jose State University. The professor watched over our place during the war and then handed it back to us in good shape when we returned to California. Many others were not so lucky.

In May 1942 we were ordered to report to authorities, and then we were taken by train under military guard from San Jose to the WCCA camp at the Santa Anita Race Track just east of Los Angeles proper. I went in my Cub Scout uniform, but if anyone noticed the irony of that, no one said anything about it. To a ten-year-old, our barrack at the track contrasted greatly with our former home in San Jose. We endured the crowded and sometimes unsanitary conditions at Santa Anita for months. Then, in October 1942, we were moved again: this time to the more permanent WRA camp known as Heart Mountain, located between the towns of Cody and Powell, in northwestern Wyoming.

In nature, Heart Mountain is a ruggedly beautiful site. For us it was isolated and harsh: blazing hot in the summer and bitingly cold in the winter. When we got off the train we were welcomed by a blinding sandstorm. Our life in camp became an endless ordeal. Our new "residence" had been hastily constructed; there were many gaps in the floors and knotholes in the second-rate lumber used to construct the barracks. Sweeping up the dust became a daily part of the family routine. There were lines for everything, very limited supplies, and no privacy. The six of us lived in an eighteen by twenty-five foot space that initially had no walls or separate rooms. We had only a potbellied stove for heat and had to eat at the communal mess hall on our block. Although any semblance of family conviviality at the dining table was limited, to say the least, we somehow managed to make the best of things. Still, our focus was on getting out of Heart Mountain as soon as we possibly could.

Like many other Japanese Americans in the WRA camps, our family left Heart Mountain in phases. One of my sisters landed a job in Chicago and left. My father was also able to secure a leave, even though he was an Issei. Because he was willing and able to teach Japanese, the War Relocation Authority released him to work at a special U.S. Army language school that had been set up at the University of Chicago. My mother and I followed. After getting clearance, we simply left camp and caught the bus from Highway 20 in front of Heart Mountain to Greybull, Wyoming. We then caught the train and made it to Billings, Montana. We had dinner at a local restaurant there, and when we were done, I started to stack up our dishes just as I had been doing in camp. My mother watched this and said, softly, "Norman, you don't have to do that anymore." All of a sudden, it hit me: We were free again. The ordeal of camp life was finally over.

The Mineta family stayed in Chicago for about four years. During the last two years of the war, the Windy City became one of the primary destinations for Japanese American resettlers starting new lives. Even though there were many Issei and Nisei there, we did not spend a lot of time socializing. My father and mother struggled to make ends meet, and I, of course, was busy returning to my normal school activities in Evanston, Illinois, where we settled for the duration.

In November 1945, after the war was over, we pulled up stakes and headed back to San Jose to rebuild our lives. I enrolled as a ninth grader at Peter Burnett Junior High School. Interestingly enough, just like Hikaru, I became fascinated with photography.[1] And, like Hikaru, I became good enough with a camera to be one of the photographers for the San Jose High School newspaper as well as for the yearbook.

When I graduated in 1949, I decided to go to the University of California at Berkeley. By 1953, with my bachelor's degree in business in hand, I had an ROTC commission in the U.S. Army, went straight on active duty, and eventually served in Korea and Japan. At the same time, my father worked hard to reestablish himself. After I was discharged in 1956, I decided to help him out at the Mineta Insurance Agency. Looking back, my siblings and I had our challenges, but perhaps because we were young we were able to get back on track relatively quickly. However, it took my father the better part of a decade to build things back to what they had been before the war. In sum, my family and I lived the history recounted in *Japanese American Resettlement through the Lens*. Now, on the sixty-sixth anniversary of Roosevelt's signing of Executive Order 9066, I have more cause than ever to make sure that the events that 9066 precipitated are not forgotten by future generations.

In the 1980s, as a congressman, I spent countless hours over a number of years to craft and coordinate the passage of what became the Civil Liberties Act of 1988. Since that landmark legislation, I have had a special concern tied to the preservation of the Heart Mountain, Wyoming, campsite, where my family and I were incarcerated in 1942. Working closely with a group of concerned citizens from Powell and beyond, the Heart Mountain Wyoming Foundation has labored to preserve the grounds of the camp and build a site where visitors could contemplate the story of the more than 10,000 Japanese Americans who were confined there during the war.[2] Thankfully, the foundation's efforts have been supported by legislation that promises to ensure that these campsites are not obliterated.[3]

Japanese American Resettlement through the Lens fully complements the Heart Mountain Wyoming Foundation's educational objectives. Readers will see many photos of Japanese American individuals and families who, like my own, were confined in WRA camps solely because of their ancestry. Upon release, they were left largely to their own devices in their struggles to fit back into society and rebuild their lives as best they could. Some, many perhaps, never fully recovered materially, let alone psychologically.

It was in this historical context, a time when many Americans distrusted anyone of Japanese ancestry, that Hikaru Carl Iwasaki and his colleagues in the WRA's Photography Section took thousands of photographs to convince the public otherwise. Through their skillful portraits, they strove to tell a different story: the story of a population that was unjustly deprived of liberty but, despite all it had suffered, was willing to take the risk and reenter society before the war was even over.

Although the Minetas regained freedom relatively quickly, I, along with my father and mother and siblings, found out that recovery was not an easy process. *Japanese American Resettlement through the Lens* takes us back to these trying and uncertain times when there was much debate inside of the Japanese American community. Did we, in fact, have a future in America? And after all that had happened to us, to society, to the world, could we return to the places we considered home?

Like many Japanese Americans, the Minetas decided in good faith to give resettlement a try. I am profoundly grateful that, despite all that they suffered, my parents lived long enough to see just how well everything would work out for the family, especially for their children. After all, it was in no small part because of the indomitable spirit of the Issei that we were able to answer, "Yes." "Yes, we do." "Yes, we can."

NOTES

1. As a kid, I always knew him as Hikaru, and then later as Carl, which is an Americanization of his Japanese name. *Hikaru* means "light" in Japanese, which I always thought was neat.

2. The official Web site of the Heart Mountain Wyoming Foundation is http://www.heartmountain.us. Interested readers will find a letter there that Senator Alan Simpson and I coauthored, endorsing the foundation and describing its efforts to establish a state-of-the-art interpretive learning center at the site of the camp.

3. The bill I am referring to here was signed by President Bush in 2006 and authorized up to $38 million for the preservation of the ten War Relocation Authority camps. Justin Ewers, "Preserving the Japanese-American Internment Camps," *U.S. News and World Report*, February 25, 2008, http://www.usnews.com/articles/news/national/2008/02/25. Congress, however, has yet to appropriate the funding to support these preservation activities.

Preface

THE ELECTRONIC CIRCULATION OF WRA PHOTOS

At the end of the twentieth century, a quiet revolution began in terms of the public availability of photographs of the Japanese American experience during World War II.[1] The War Relocation Authority (WRA) alone generated some 17,000 photos of Japanese Americans who were subject to confinement from 1942 to 1945.

Because of advances in electronic scanning and information services, three major archives began to put many of these photographs online. These Web sites were part of somewhat overlapping but equally ambitious digitization projects. One is JARDA, or the Japanese American Relocation Digital Archive, run by a University of California consortium known as Calisphere. A second is the National Archives and Records Administration's Archival Research Catalog (ARC) Gallery on Japanese American internment. A third project is the Library of Congress's online compilation of Farm Security Agency / Office of War Administration black-and-white negatives.[2]

I say "revolution" because, although they have long been available, copies of the WRA photographs were buried in somewhat obscure collections that were difficult, time-consuming, and often expensive to retrieve. This was the case even though these photos are in the public domain and hence free to reproduce and even publish with the proper acknowledgments, but without other typical constraints.[3]

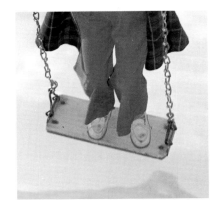

I celebrate the wider availability of these WRA photographs because despite their inherent limitations, they offer a rich resource for understanding the travails that Japanese Americans endured during the 1940s. On the other hand, thousands of WRA images are now online with little in the way of historical context to explain how, by whom, and exactly why these photos were generated. Such a context is critical to understand and appreciate these pictures for what they are, and also for what they are not.

Japanese American Resettlement through the Lens was written as a first step toward providing this context. It is only a first step because to keep this book a manageable size, I focused on the photographs of only one official WRA photographer, Hikaru Iwasaki. Moreover, I limited the scope of this book to a specific phase of the WRA's operation (1943–1945) and the basic theme of Japanese American resettlement.

Japanese American resettlement refers to the overall process from 1942 to 1946 in which Japanese Americans removed from their homes during the war and incarcerated in American-style concentration camps were released and reentered the larger society. But a lesser-known part of this process was the War Relocation Authority's mission in 1943 to pressure "loyal" Japanese Americans in its camps to leave confinement before the war was over and to disperse and assimilate as they reentered the larger society.[4] It is important to emphasize that the latter group was a select sample of the camps' populations. Japanese Americans who were released from the WRA camps between 1943 and the war's end in 1945 were those who were most open, psychologically and emotionally, to reducing—if not cutting—their ties to the ethnic community.

Additional research is needed to fashion a complete account of the WRA's photographic corpus. Nonetheless, I am satisfied that this book makes a unique contribution to this effort, presenting more information about the institutional matrix of WRA photographs and the WRA's official photographers in the WRA's Photographic Section (WRAPS) than previously available.

Although there are three names on the title page, I should explain why this preface is written in the first person. I bear the responsibility for writing this particular account, and so this book bears the overall imprint of my vision and expression. The foundations of this study, however, would never have been possible without the archival research and keen insights of my collaborator in this project, Kenichiro Shimada. Nor would this book have been possible without the photos, detailed accounts, and encouragement of Hikaru Carl Iwasaki.

Many people have aided us over the course of this project. Colleagues have been generous with their time and advice, including Cal Aoyama, Ed Guerrero, Stacey Hirose, Karen Ishizuka,

Akemi Kikumura-Yano, Ben Kobashigawa, Reynaldo Macías, Valerie Matsumoto, Alfredo Mirandé, Takeya Mizuno, Eric Muller, Robert Nakamura, Phil Tajitsu Nash, Alison Shaw, Jeffery A. Smith, Gene and Bob Stewart, Mike Sweeny, Tritia Toyota, Gretchen Van Tassel, and Jun Xing. Art Hansen, Brian Niiya, and Malcolm Collier read complete iterations of the manuscript along the way. None of the above, however, are responsible for errors that may remain.

Archivists at NARA I and II have also offered their specialized expertise, especially Aloha South, Nathaniel Natanson, and Roseanne Mesinger. Joe McCary at Photo Response did an outstanding job of scanning original WRAPS negatives in a quick and efficient fashion.

I am grateful for two key opportunities to talk about this project while it was still in progress. One was at the Center for Pacific and American Studies at the University of Tokyo (Todai), where Professor Masako Notoji hosted my presentation. The second was for the Migration Studies Group at UCLA, organized by Professors Roger Waldinger, Min Zhou, and their colleagues.

I am especially grateful to George and Sakaye Aratani, who have done so much on behalf of the Japanese American community. Among many other projects, their generosity created the endowed chair at UCLA that I presently hold. Don Nakanishi, director of the Asian American Studies Center, and Cindy Fan, former chair of the Asian American Studies Department, welcomed me to UCLA. They and our colleagues and staff in Asian American Studies provided a scholarly environment where I was able to write this book.

Darrin Pratt, director of the University Press of Colorado, encouraged me to pursue the story of the WRA photographs, and Laura Furney and Dan Pratt have worked with us every step along the way.

Finally, each of us acknowledges the much-appreciated support of our immediate and extended families.

Lane thanks Marilyn, along with the Hirabayashi, Kitchell, Alquizola, Torres, and Baltazar families.

Kenichiro thanks his family, and Papa Andoh.

Carl thanks his family, especially his children, Janice Kishiyama, Dean Iwasaki, and Dr. John Iwasaki.

LANE RYO HIRABAYASHI

George and Sakaye Aratani Professor of the
Japanese American Internment, Redress, and Community
Asian American Studies Department, UCLA

JAPANESE AMERICAN RESETTLEMENT
THROUGH THE LENS

Introduction

PHOTOGRAPHING JAPANESE AMERICAN RESETTLEMENT

This book has two primary aims. The first is to describe the War Relocation Authority's use of photography as part and parcel of its primary bureaucratic mission to pressure "loyal" Japanese Americans in its camps to return to the larger society as quickly as possible.[1] The second aim is to assess the WRA Photographic Section's output.

Our analytic approach to WRAPS photo work has two related dimensions. One is to evaluate critically the overall contribution of the WRA's Photographic Section to the resettlement process from 1943 to 1945, the key years in which the WRAPS was in operation. This is a descriptive task, but one that also involves gauging the efficacy of a federal agency's use of photography in a public relations campaign geared to promote its policies.

A second dimension is theoretical and has to do with explicating the communicative power of the WRA's photographs. Examination of the official resettlement photographs in terms of the WRA's policies reveals a great deal about their construction, in regard to both their visual and their textual aspects. I contend that the combination of image and text produced a type of testimonial that was anything but neutral.

At the same time, the meaning of the official photographs is not inherent or fixed. This claim might seem surprising. The WRAPS approach to its overall mission was photojournalistic,

and so WRAPS photographers often attempted to capture a whole resettlement story in a single image.[2] But WRAPS output was photojournalism of a very special kind. The historical context of WRAPS work reveals the matrix of institutional power that enveloped it and helps us to see that these photographs were shaped by the Authority from the beginning; that is, the purpose of these photos was to be made into photo-narrative public relations packages.

Indeed, the WRA's hope was that these images, accompanied by official Authority-approved narratives, would interpolate the viewer as an active subject willing to support loyal but hard-pressed Japanese Americans. Concomitantly, sympathetic viewers would be favorably inclined toward government agencies like the WRA working on their behalf. WRAPS photos were realist but also functional in the sense that they were explicitly created to be used with text in order to garner understanding of and support for the Authority's resettlement policies.

When set within this larger context, the history and products of the WRA's Photographic Section from 1943 to 1945 offer many relevant insights into the exact nature of the WRA's resettlement mission. A close examination of the Authority's presentation and use of WRAPS photographs, in turn, reveals how images and text were deployed in order to promote resettlement, to influence society's views and actions vis-à-vis this impounded population under federal control, and to implicitly promote proper comportment in terms of the Japanese Americans who were released from camp.

THE WRA'S APPROACH TO JAPANESE AMERICAN RESETTLEMENT, 1943–1945

With the issuing of Executive Order 9102 (on March 18, 1942), the War Relocation Authority, a civilian agency originally part of the Office of Emergency Management, was established. This new agency essentially continued the process begun by Executive Order 9066, dated February 19, 1942, which allowed the mass confinement of Japanese Americans. After a branch of the U.S. Army's Western Defense Command, the Wartime Civil Control Administration, supervised the initial incarceration of more than 110,000 West Coast residents of Japanese ancestry in temporary holding facilities euphemistically called "assembly centers," the WRA took control of the operation.[3]

Within a year's time, the Authority supervised the transfer of detainees to ten more permanent WRA camps. Thus, during 1942 the WRA's mission revolved primarily around the setup, consolidation, and administration of these ten camps.[4]

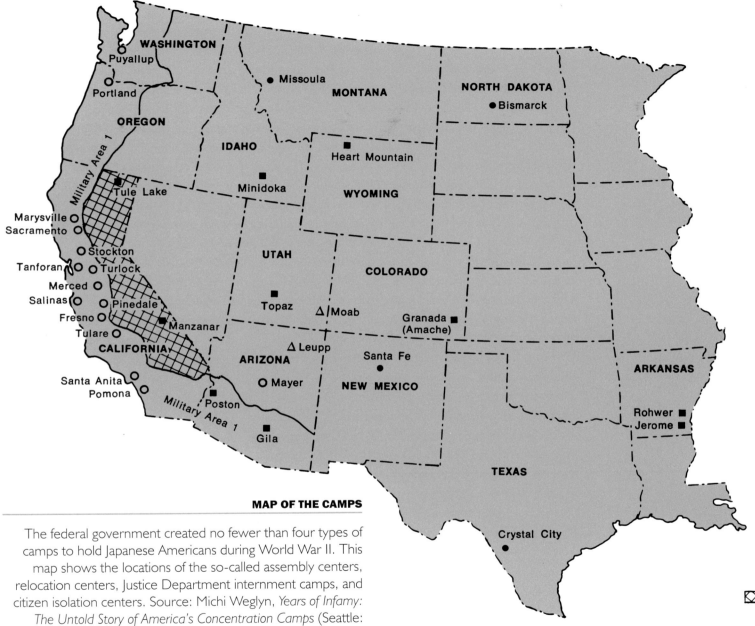

KEY

○ ASSEMBLY CENTERS

Puyallup, Wash.
Portland, Ore.
Marysville, Calif.
Sacramento, Calif.
Tanforan, Calif.
Stockton, Calif.
Turlock, Calif.
Merced, Calif.
Pinedale, Calif.
Salinas, Calif.
Fresno, Calif.
Tulare, Calif.
Santa Anita, Calif.
Pomona, Calif.
Mayer, Ariz.

■ RELOCATION CENTERS

Manzanar, Calif.
Tule Lake, Calif.
Poston, Ariz.
Gila, Ariz.
Minidoka, Idaho
Heart Mountain, Wyo.
Granada, Colo.
Topaz, Utah
Rohwer, Ark.
Jerome, Ark.

● JUSTICE DEPARTMENT INTERNMENT CAMPS

Santa Fe, N.Mex.
Bismarck, N.Dak.
Crystal City, Tex.
Missoula, Mont.

△ CITIZEN ISOLATION CAMPS

Moab, Utah
Leupp, Ariz.

▨ Military Area 2 or "Free Zone" until March 29, 1942

MAP OF THE CAMPS

The federal government created no fewer than four types of camps to hold Japanese Americans during World War II. This map shows the locations of the so-called assembly centers, relocation centers, Justice Department internment camps, and citizen isolation centers. Source: Michi Weglyn, *Years of Infamy: The Untold Story of America's Concentration Camps* (Seattle: University of Washington Press, 1996); used with permission.

As early as 1943, however, negative public opinion as well as pressure from Congress forced a major shift in WRA policy. The WRA's activities during that year included the administration of a so-called loyalty questionnaire. Both the Authority and the U.S. Army believed that the questionnaire would allow the government to identify "loyal" Japanese Americans.[5] If those who proved to be "loyal" could not be drafted by the army, the WRA was determined to pressure such persons and families to leave the camps and resettle into society.

Why was this of concern to the Authority? First, WRA director Dillon S. Myer thought that the camps were a pernicious environment. In particular, Myer worried about the impact of camp life on the democratic sensibilities of Japanese American prisoners. Second, the camps were expensive and controversial in wartime America. Myer's response to these two issues was to propose as early as 1943 that all efforts be made to close the camps as soon as possible and that the War Relocation Authority be shut down by the end of World War II.[6]

Before actually implementing the new policy of resettling the "loyals," Myer had to overcome two immediate barriers. One had to do with the larger American public, which had long harbored suspicions of Asian immigrants and who now felt justified in suspecting their fellow citizens because the government had deemed them dangerous enough to put into camps. The second had to do with the Japanese Americans, who understandably had doubts about being forced back into a society that had so easily supported the gross violation of their constitutional and human rights. To combat these obstacles, in 1943 the WRA decided to utilize every means within its power to influence the perceptions of these two constituencies—the American public and the Japanese Americans who remained in confinement—and win their support.

As has often been noted, the WRA's resettlement policy entailed more than simply getting people to leave. Top officials, including Franklin Roosevelt and WRA director Dillon S. Myer, are on the record as saying that it was in everyone's best interests for Japanese American resettlers to disperse themselves around the country and blend into the mainstream. Myer believed that if resettlers eschewed living in "Little Tokyos," they could assimilate into mainstream society more fully and be more accepted in and by members of the larger society.[7]

The WRA was committed to the resettlement process, in terms of both encouraging Japanese Americans to assimilate as they reentered society, and identifying ostensibly loyal Japanese Americans in confinement and pressuring those persons to leave. A good example of the Authority's orientation in terms of the latter is found in the images from a photographic essay taken in 1944. This photo essay was clearly designed to show confined Japanese Americans

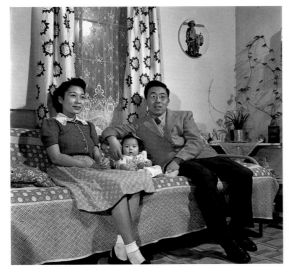 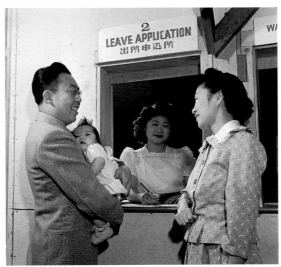 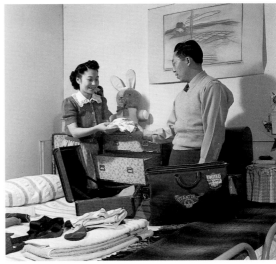

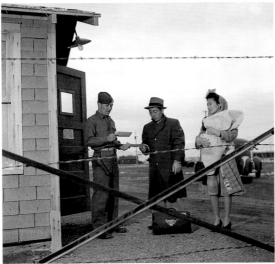 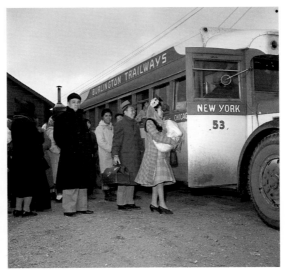 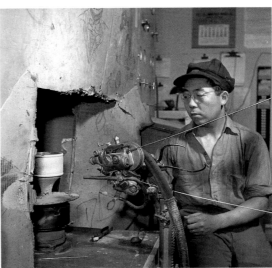

A photographic essay showing the steps taken by Mr. and Mrs. Thomas Oki as they apply and prepare for their release from the WRA camp at Heart Mountain, Wyoming. In the last photo, Mr. Oki, who had a Stanford degree in bacteriology, is shown working at the Neo Mold Company factory in Cleveland, Ohio. Photographer: Hikaru Iwasaki, March–September 1944.

National Archives photos no. 210-G-I-130, 210-G-I-126, 210-G-I-128, 210-G-I-115, 210-G-I-116, 210-G-I-593

the steps that potential resettlers needed to take in order to pursue their release from WRA camps.

Yet, release from camp did not mean total freedom for Japanese Americans.[8] The WRA required that potential resettlers had to pass security reviews. A black mark on one's record, or any sign of suspicion, meant that a candidate's aspirations for release could be officially stymied.[9] Furthermore, few resettlers were allowed to return to the West Coast before 1945, even if they had owned businesses or property there before the war. Indeed, prior to August 1945 most resettlers were obliged to go to areas that had not been designated as "off-limits" by the U.S. military, namely the Rockies, Midwest, South, and eastern seaboard. Even in those areas that were open to resettlers, the WRA encouraged Japanese Americans to disperse. The Authority hoped that dispersal, along with Japanese Americans' active efforts to "Americanize" themselves, would ultimately ameliorate many of the anti-Japanese sentiments and actions that had marred their experiences on the West Coast of the United States before and during the war.[10] If they were deemed loyal Americans and agreed not to return to the West Coast, candidates still had to have proof of the promise of gainful employment once they were released. In this fashion the WRA hoped to avoid concerns that the Japanese Americans they let out of camp were destined to wind up on the dole. Finally, those Japanese Americans who were released from camp had to sign an oath promising to avoid congregating with other Japanese Americans and to conduct themselves as law-abiding members of the larger society.[11] By demanding all this, the WRA hoped that the release of Japanese Americans would win the approval of at least the reasonable members of society.

The WRA's policy of Japanese American resettlement was a liberal policy in terms of the race relations of the day. Today some Japanese Americans and others condemn the WRA's dispersal policy as a paternalistic and assimilationist approach to race relations. Indeed, viewed from today's perspective, WRA resettlement policy can be seen as a pernicious form of forced Americanization that was inherently inimical to any positive dimensions of Japanese American identity, culture, and community.[12]

Policy and Production of WRAPS Photographs

PHASE ONE: THE WRA'S PHOTOGRAPHIC SECTION, 1942

From the beginning of the WRA's program, plans were in place to photograph the mass removal, initial concentration, longer-term incarceration, and release of Japanese Americans. As early as 1942, the stated purpose of this record was to document every step of the process. Authorities in charge of the incarceration also realized early on that pictures were needed for public relations purposes.[1]

Our analysis of the archival records, along with the secondary literature, indicates that the photographic mission changed over time. It is thus convenient to divide WRA photo operations into two phases. What I am calling Phase One started in March 1942 and lasted through the end of that year. Phase Two was in place by 1943 and lasted until the WRA's Photographic Section was closed in January 1946.

The available records indicate that photographers were on the payroll even as the WRA came into existence. As far as we have been able to determine, early WRA photographic work was done via short-term assignments given to select professional photographers, such as Clement Albers, Dorothea Lange, Russell Lee, and Francis L. Stewart.[2] These photographers were assigned (Lee) or hired (Albers, Lange, and Stewart) by federal agencies, including the Office of War Information and the War Relocation Authority. Although some of the four's

WRA pictures had to do with removal, most of their photographs detailed selected, typically noncontroversial aspects of Japanese Americans' daily life in Wartime Civil Control Administration (WCCA) assembly centers as well as scenes from the first months in the ten more permanent WRA camps.[3]

Relatively little is known about Clem Albers and Francis Stewart, but both men worked for San Francisco newspapers. The WRA hired Albers from the *San Francisco Chronicle*, and Stewart from the *San Francisco Call Bulletin*. Both men were given only short-term contracts.

Two of the best known Phase One photographers are Dorothea Lange and Russell Lee, both former photographers for the Farm Security Agency (FSA). Scholars have researched Lange's and Lee's stories in some depth, and although both worked for the WRA in Phase One, their experiences indicate that no one employee's experiences were typical.

Lange was hired because she was both in California and available after completing her job for the FSA. Influential people in government circles knew of her reputation as a documentary photographer. Lange's selection certainly was related to the bureaucracy that by 1942 linked the FSA, the WCCA, the Office of War Information, and the WRA together. Before the war, for example, FSA photographers were often assigned to take pictures for other government agencies, such as the Office of Emergency Management, for which they were asked to document "a particular phase of the war-preparation effort."[4]

After the United States entered the war, Roy E. Stryker, Lange and Lee's boss at the FSA, became the head of one of two photographic divisions that were run out of the Office of War Information. The OWI was the official bureaucracy within the larger Office of Emergency Management that was in charge of news, press releases, and public relations domestically as well as internationally. This was the reason that the OWI became a clearance point in terms of WRA publicity once the WCCA relinquished its direct administrative control over the camps.[5]

Because they were experienced, established, and already in residence on the West Coast, Lange and Lee were among the first of the professional photographers on the job. According to Lee's biographer Jack Hurley, Roy Stryker obtained permission from Washington and assigned Lee, who by that time was already on the Office of War Information staff, to photograph the incarceration. Lange was already shooting by March 1942, before she was officially on the WRA's payroll, taking photos of Japanese Americans closing up their homes, farms, and businesses immediately prior to the roundup.[6]

As WRA photographers, Lee and particularly Lange were subject to a great deal of scrutiny and censorship.[7] Partially, this was the result of the military's control of all aspects of the Japanese Americans' roundup and removal in 1942 during Phase One. Specifically, the WCCA was responsible for all preparations leading up to exclusion and incarceration of all persons of Japanese ancestry on the West Coast. Similarly, the WCCA was in charge of the early stages of the temporary camps that served as points of initial assembly. Because the WCCA was essentially part of the U.S. Army, the initial photographic work was subject to military oversight. Official correspondence indicates that, as was common during the day, Lange did not keep the negatives of her government photos. One memo clearly indicates that Lange had to request permission in order to get access to, and official clearance for, prints of her own photographs.[8] Lange was the subject of even more scrutiny and harassment because military authorities were apparently suspicious of her, and her husband Paul Taylor's, political agenda. Censors eventually determined that some of Lange's pictures were too raw for public consumption, and impounded, but did not destroy, a number of negatives.[9]

Furthermore, the actual period that Lee and Lange spent photographing Japanese Americans during Phase One operations was brief. Lange began shooting in March 1942 and finished the job four months later. What is more, Lange made only three short visits to Manzanar in late June and early July. By 1943, Lange was working for the Office of War Information, where she recorded domestic war efforts in places like the shipyards of Richmond, California.[10]

Restrictions on photographers began to soften in late 1942 as the WCCA relinquished its jurisdiction over Japanese American subjects and the War Relocation Authority took over. The remaining portion of Phase One photographic work was carried out under the auspices of the War Relocation Authority from 1942 to early 1943 and handled by the Visual Information Section, which was a part of the WRA's Office of Information.

Based in Washington, D.C., and with a staff of only eight persons initially, the WRA's Office of Information's general purpose was to issue reports and publications, to handle press releases and radio announcements and programs, and to produce photographs of Japanese Americans in the WRA camps.[11] Thus, as the short-term contracts of Stewart, Albers, Lee, and Lange ran out, more of the overall responsibility for WRA publicity and public relations fell on the Office of Information. Concomitantly, as the responsibilities and pressures placed on the office grew, its mission evolved and its staff expanded.

It is worth mentioning that beyond the small group of photographers that the WRA hired in 1942, a number of the Authority's photographers were camp APs (appointed personnel), at least some of whom also had backgrounds in photojournalism and/or were WRA reports officers. ROs (Reports Officers) were in charge of records at the WRA camps.

One such WRA photographer was Joe McClelland, who was both an AP and an RO.[12] Also known as Cactus Joe, McClelland was a native Coloradan. He was born in 1909 and raised on a farm near Fort Collins, approximately sixty miles north of Denver. McClelland was interested in journalism even as a student at Fort Collins High School. By 1932 he had graduated from the University of Missouri with a B.A. in journalism. When the war broke out, McClelland found employment as the RO for Camp Amache at Granada, in southeastern Colorado. In that capacity, he took many photographs of the WRA camp, some of which are preserved in the National Archives collection.[13]

Perhaps because Lange's photos had been subject to censorship, by the end of Phase One the WRA bureaucracy began to formulate how military orders impacted the Authority's photographic production across the board. This issue was addressed, for example, on October 10, 1942, in a memo from the WRA's Solicitor's Office by Philip Glick to WRA director Dillon Myer, clarifying army regulations.[14] Military criteria took pride of place in the overall tone of Phase One photographic operations.

By the end of 1942, the Authority set up its own formal photography section staffed by more-or-less permanent professional photographers. Although bureaucrats agreed that the WRA's Photographic Section was ultimately accountable to the WRA's central office in Washington, D.C., the site chosen for the Photographic Section's operations was the WRA's regional office in Denver, Colorado. Presumably, Denver's central location would allow its photographers to easily travel throughout the lower forty-eight.

Thus, by 1943 the initial cadre of professional photographers had given way to a combination of reports officers from the ten permanent WRA camps and a small team of photographers in the WRA's Photographic Section, located in downtown Denver, Colorado.

PHASE TWO: THE WRA'S PHOTOGRAPHIC SECTION, 1943–1945

THE REORGANIZATION OF THE WRA'S PHOTOGRAPHIC OPERATIONS

The physical office in the Midland Savings Building in downtown Denver, Colorado, and the longer-term elements of the WRA's photo operations were established in 1942 as the Phase

One photographers finished their short-term assignments. The new head of the WRA's photo office, Thomas (Tom) Wesley Parker, was transferred from the Denver office of the Federal Work Agency. His account of his goals and accomplishments, which he wrote for a postwar job application, provides a summary of the WRAPS mission under Parker's direction.

> Established and directed a photographic section to provide still and motion pictures for historic documentation and public information. The section included photographers traveling throughout the U.S., a production and publications liaison unit in Denver, and an editorial office in Washington, D.C. I interpreted policy, planned coverage, assigned personnel, maintained quality standards which assured acceptance by national magazines of high professional standards. I did much of the picture taking.[15]

Tom Parker was quickly joined by another full-time photographer, Francis L. Stewart. By December 1942, Stewart was transferred from the WRA's San Francisco regional office and to his new assignment as the second official photographer in the new WRAPS office in Denver, Colorado. At that time, positions for a darkroom specialist and a full-time clerk/secretary were still open.

Even as the new WRAPS office was being staffed, the WRA's legal team strove to clarify and expand the rules and regulations governing WRA photography and photographers, building on their initial formulations from fall 1942. The most prominent example is Administrative Instruction No. 74, generated out of Myer's office and dated January 2, 1943.[16] Section VI, "Procedures in Providing Photographic Prints," is especially significant. The WRA bureaucrats wrote:

> Films of all official photographs shall be sent, undeveloped, to the Photographic Section's laboratory (in the Midlands Savings Bank Building, Denver, Colorado). One file print of each exposure (usually 4 × 5 inches in size) shall be made and sent promptly to the Chief of the Division in Washington for clearance. After inspection of file prints the Washington office will notify the photographic section of approval or disapproval of the respective pictures for use in any form.
>
> Photographs not suitable for publication, because of subject matter, will be designated for impounding, and negatives of such photographs shall be forwarded promptly to Washington. All existing prints of such photographs will be destroyed.[17]

John C. Baker, head of the Office of Information in 1943, had the prerogative to censor the photos. In practice, overt censorship of the Photographic Section's work diminished as the

John C. Baker, chief of the WRA's Office of Reports. Photographer: Gretchen Van Tassel, March 1944.

National Archives photo no. 210-G-G-432

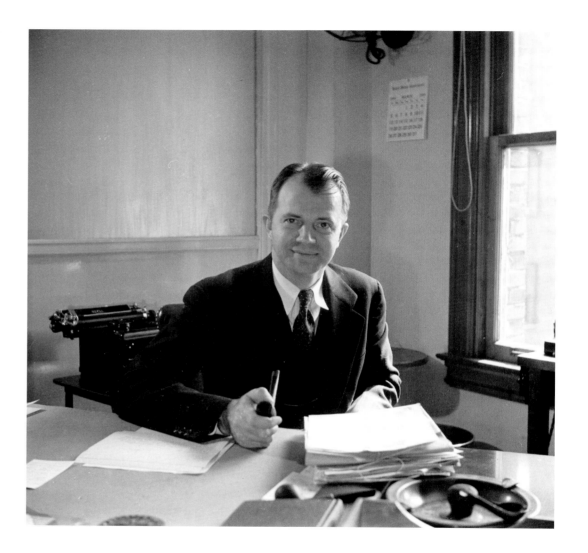

war went on, probably because the WRA's priorities changed as Japan began its slow slide into defeat, thereby lessening the need for security as well as tight control over the kinds of photos WRAPS generated.

As the Phase Two photographic mission unfolded in 1943, the WRA modified and expanded the old Office of Information to create the new WRA Reports Division.[18] Still based

primarily in Washington D.C., the Reports Division staff grew from eight in 1942 to twenty-eight by the end of 1943. The old Visual Information Section was reorganized but remained based in Denver and was renamed the WRA's Photographic Section (WRAPS). This consolidation thus coincided closely with a shift in policy toward prioritizing the resettlement of those who had been deemed "loyal" by military and government agents.

The documentary record concerning the setup and initial operations of Denver's WRAPS is fragmentary at best. We found no formal directives issued by the WRA in regard to the photographic approach to resettlement as the primary subject of WRAPS photos as of 1943. It is not difficult, however, to conjecture the overall orientation of the WRAPS resettlement photo work. Photojournalism was the basic orientation of the WRAPS staff, and so its photographers sought that one perfect shot that told a story.

As early as the 1930s, professional photographers were utilized to document a wide range of federal and state government projects. The basic epistemological framework for this kind of work is realism.[19] Following Charles Peirce's theories, a photograph's indexical qualities are key—in this case, the photograph's status as a document.[20] The professional manifestation of this approach is most readily identifiable as government or institutional photography. The standards of the day meant that this entailed the use of photographs to demonstrate the existence and nature of a place, an object, a person, an event, an impact, or some combination of the above. The intended effect is to elicit the response, from the viewer, that what is visually presented actually exists, really happened, or is/was true. The same features allow government photography to be utilized for public relations, if not overtly political, purposes.

THE MODIFIED MISSION

In Phase Two the focus shifted from removal and concentration to resettlement. By 1943, this new mission of the WRAPS was clearly delineated in office correspondence between Denver and Washington, D.C. The chief of the Reports Division expressed it in terms of "an acute need" for visual evidence of the "successful return" of Japanese Americans who had been released from WRA camps.[21] This mission was rearticulated in various ways from 1943 to 1945 in the intra-agency exchanges between Washington, D.C., and Denver that have been preserved. WRA bureaucrats in the Reports Division gave the staff photographers in the Denver office the explicit charge of photographing all aspects of resettlement, which would include shots focusing on Japanese American students, workers, and soldiers. Some Japanese Americans today regard

the WRAPS work as inherently (and perhaps even hopelessly) biased because of its overly positive depiction of the resettlers; however, Parker and his colleagues actually photographed a fairly representative sample of Japanese American resettlers from 1943 to 1945.

Parker and other key WRAPS photographers deliberately took copious shots of resettled Japanese Americans to show the public exactly what was happening now across the United States and, furthermore, to instruct them that what was happening was good and should be supported. The photos depict their Japanese American subjects as law-abiding, loyal, productive, and assimilated. But perhaps most important was the message—to both Japanese Americans and the general public—that the WRA's resettlement policy during World War II had been, practically and ideologically, right.[22]

This characterization allows a clear differentiation between WRAPS and FSA photographic work. The latter was much more sweeping in scope, since Stryker's staff often stayed in a locale and attempted to produce documentary records of people and places. Under Stryker's mentorship, the FSA photographers had ethnographic and aesthetic ambitions that were never an inherent part of the WRAPS orientation or mission.

We will return to this discussion of the WRAPS resettlement corpus, as the epistemology behind WRAPS photographic work is closely tied to select characteristics of the images that Parker and his colleagues composed and shot and that were eventually printed and circulated.

THE WRAPS FIELD OFFICE

WRAPS was located in Denver's WRA Field Office, which was on a floor of the old Midland Savings Building at Seventeenth and Welton on the eastern side of downtown Denver. All of the field office departments, including the WRAPS, were on one floor. The WRAPS office was one large room with an attached darkroom.

WRAPS was initially made up of a darkroom specialist and two key staff photographers, including the head of the office, Tom Parker. Born in Leadville, Colorado, in 1907, Parker attended Northwestern for two years, where he took classes in journalism, advertising, and marketing, among other subjects. Parker returned to Denver during the Great Depression as head of the Works Progress Administration's photographic section in Colorado, where he worked from 1935 to 1938. Subsequently, he served as state information officer (for Colorado) for the Federal Works Agency (FWA), a position he held from 1938 to 1942. Parker then was transferred to the WRA in 1942 as the head of the WRAPS operation. Parker's official title was visual

Thomas (Tom) W. Parker, head of the WRAPS office, in a United States Information Agency official relations photograph from 1951.

United States Information Agency photo no. 306-PSB-PERS

information specialist for the WRA.[23] Well suited for the WRA's modified mission, Parker had a background in advertising and sales. By 1942, he was also quite familiar with the use of photography to both document and educate the public about various government policies and programs. Because of the kind of photo work he had done in and for the WPA and the FWA, Parker extended the basic tradition of institutional photography in his assignment with the WRA.

The second staff photographer was Francis Leroy Stewart. According to his job application forms, which I found in his WRA personnel records, Stewart was born in Arizona in 1909. He studied at Compton Junior College and at various art schools before receiving his degree in commercial art from Frank Wiggens Art School in Los Angeles in 1929. He worked in a variety of businesses as an artist before he joined the staff of the *San Francisco Call Bulletin* in 1935, where he served as head photographer. Stewart also managed the photo and art departments at that newspaper.

Stewart was hired by the WRA in May 1942, and he worked out of the WRA's San Francisco office. His official title was associate information specialist, and his primary responsibility was to "take and handle WRA photos." Six months later Stewart was tapped as the second main photographer in the new Denver-based WRAPS office.[24]

The third main WRAPS staff member was darkroom specialist Charles Eric Mace. Mace was born in 1889 in North Hampton, England. His parents, William and Mina, decided to come to America shortly after Charles was born, and so he grew up in Colorado. After high school, Mace cut his professional teeth as a staff photographer for the Associated Press as well as working for various local newspapers, including the *Rocky Mountain News* and the *Denver Post*. During World War I, Mace joined the army, serving as a signal corps photographer in the European theater. On assignment, Mace took more than 1,500 photos of the Meuse-Argonne Offensive as well as other battles in France.[25]

During the 1920s and 1930s, Mace ran a mountain inn that he started with his brother, Gordon, who was also a photographer. During this period, Mace continued to sharpen his craft. He exhibited his nature photos domestically and internationally and sold commercial-quality photographs for advertisements to Eastman Kodak, Colgate, and other well-known companies. When the Denver WRAPS office was set up, Parker hired Mace because of his skills in the darkroom and as a photographer.

When Francis Stewart resigned from WRAPS at the end of May 1943, citing "personal reasons," Mace replaced Stewart as the second key staff photographer after Tom Parker.

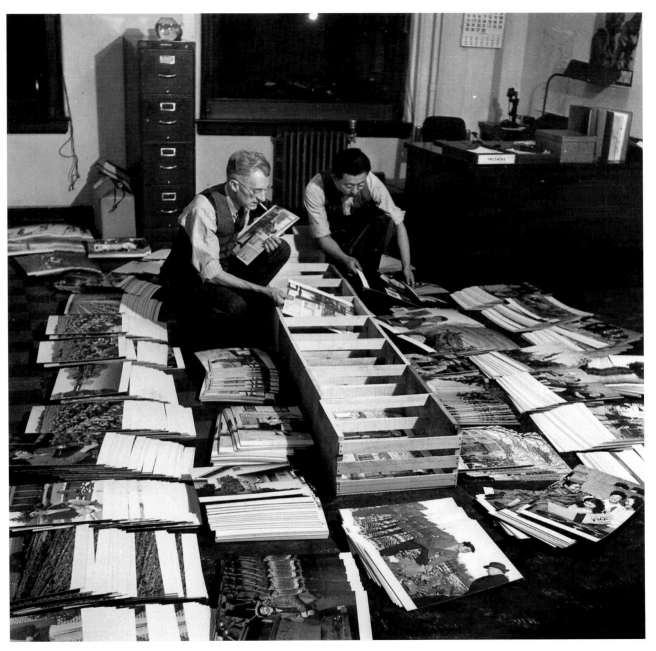

Charles E. Mace and Hikaru Iwasaki, in the WRAPS office, prepare more than 1,000 mounted enlargements to be distributed in order to promote resettlement.

National Archives photo no. 210-E-G-811

As demands for WRAPS work grew, the staff grew. In 1943, Hikaru Carl Iwasaki, a second-generation Nisei who had been incarcerated at the WRA camp at Heart Mountain, was hired as a darkroom technician.

Beyond the retention of these three key staff members, for unknown reasons the Authority's records concerning the setup and operation of WRAPS are incomplete and fragmented. Piecing together different items from the three years the section was in operation, however, provides information about other employees, salaries paid, and the amount spent for operational expenses.

In an undated report (but circa December 3, 1943) Parker outlined the projected budget for the following year and also the rank and salaries of the WRAPS staff.[26] The WRAPS was made up of five staff persons: two photographers, a darkroom technician, a full-time secretary, and a number of part-time assistants.

According to official correspondence, WRAPS salaries ranged from $3,800 for Parker, who had a job classification of CAF-11, to $2,000 for secretary Edna M. George, who had a CAF-5 rank. In addition to the photographers' salaries, $5,000 was set aside in 1944 for their travel and related expenses on the shoots. George became the WRAPS chief secretary and supervised the typists who typed the official captions that were printed on the back of the photos. These positions had the lowest pay and had a high turnover rate.[27]

In April 1944, Takashi "Bud" Aoyama joined the team. Aoyama, a second-generation Japanese American, was born in 1913 in Pacific Grove, California.[28] His Issei parents hailed from Hiroshima prefecture. Not much is known about Aoyama's background. There are no published accounts or biographies of Aoyama, perhaps because he passed away only six years after the end of the war. His only surviving sibling was younger and cannot say whether Aoyama studied photography before the war.

Although he considered San Francisco his home, after Executive Order 9066 was issued, Aoyama appears to have joined family members in Los Angeles, because he was removed from there to the WCCA camp at Santa Anita, California. From there the family was moved again to the WRA camp at Heart Mountain.

Carl Iwasaki met Bud Aoyama when both were working at the Heart Mountain camp hospital. Subsequently, when Parker and Mace asked Iwasaki to become the third WRAPS staff photographer, Iwasaki recommended that his friend Bud take over the section's darkroom operations. Aoyama's main job was thus to process and print photos, but he eventually

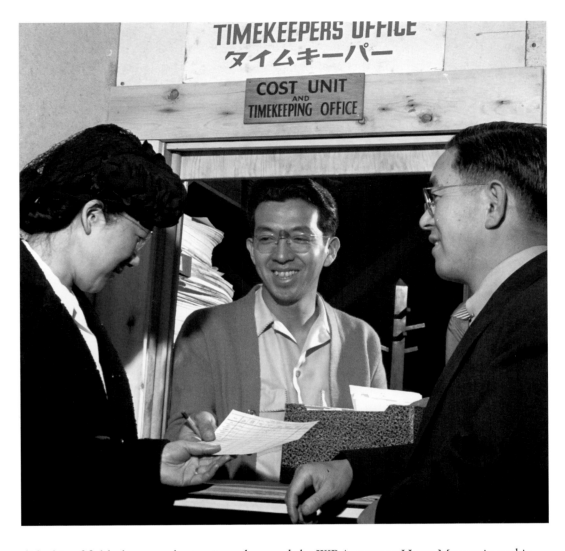

Takashi "Bud" Aoyama (at center), shown at the Timekeeper's Office at Heart Mountain.

National Archives photo no. 210-G-I-109

did a bit of field photography too in and around the WRA camp at Heart Mountain and in Denver.[29]

No other photographers were ever associated with the Denver WRAPS office during Phase Two, either as participants or as long-term independently contracted photographers. Other photographers, however, did submit photos. Most were connected with the Reports

Division (e.g., Gretchen Van Tassel, in the Washington, D.C., office) or the reports offices in specific WRA camps (e.g., Pauline Bates, an RO from Poston). In 1943 the WRAPS also occasionally received rolls of film from photographers who were attached to the Office of War Information or the Army Signal Corps. The WRAPS staff developed and printed these shots, and they appear to have been subject to the same process of review and selection as the other WRA photographs. Beyond this, there is almost no information in the archival records about the technical setup and day-to-day operations of the Denver WRAPS office. Fortunately, I was able to locate and speak with former WRAPS photographer Hikaru Carl Iwasaki.[30]

Now retired after a long and successful career as a photographer for national magazines like *Life*, *Time*, *Sports Illustrated*, and *People*, Iwasaki is the only one of the key WRA photographers from either Phase One or Phase Two who is still alive as of 2008. And his reflections on his work and the WRAPS office are an invaluable resource because the archival record has many gaps. I have drawn extensively from his recollections as the basis for many of the points presented below.

WRAPS SUPPLIES AND EQUIPMENT

During the war, any kind of photography equipment and supplies generally was difficult to obtain. Because of its ties to the federal government, however, WRAPS had basic access to what it needed. Iwasaki said that, for example, the section had "just about any amount" of film and photo paper for printing that it asked for and had access to Speed Graphic cameras, which were state-of-the-art at that time. But because these cameras were too heavy to be carried around easily, the staff generally used Rolleiflex cameras when they went into the field.[31] According to Iwasaki, WRAPS photographers generally used an Eastman Kodak film, Plus X, which he characterized as being a "slow speed" film. Plus X was viable for WRAPS work, but Iwasaki noted that today's films are available at much faster speeds, they have a higher grain, and their overall quality is vastly superior to what was used during World War II.

Iwasaki emphasized that he often had to use flashbulbs when he took pictures indoors and sometimes even outdoors if there was not sufficient light. Although the effect is muted in most standard prints, Iwasaki's copious use of flashbulb lighting is obvious when viewing high-resolution digital scans made from the original WRAPS negatives. When I asked him about his technique, he said that his youthful experience working in a San Jose portrait studio gave him insights about lighting that turned out to be quite useful for his WRAPS shots.

Iwasaki seldom mounted a flash device on his camera; rather, he always brought a number of folding stands and reflectors. Depending on the shot, he set up one to as many as three or four stands. Lighting was always indirect. He placed the stand or stands behind (but not directly behind) the camera, to the side or sides of the subject, or both. Iwasaki emphasized that it took a combination of skill, art, and luck to make a given shot come out right because everything—the lighting, the shutter speed, the lens aperture—had to be set by hand. Furthermore, earlier in the war, camera flashbulbs were quite large (about the size of a 60-watt lightbulb), which meant it was a hassle to travel with all the requisite equipment. With the bulbs, stands, reflectors, and electrical wiring, Iwasaki noted that the lighting components he utilized were bulky and difficult to lug around.

Describing equipment and techniques unfamiliar to most readers today is important for understanding the WRAPS photos. The mechanics of the lighting, for example, meant that shots had to be composed, even staged. These details help explain why Iwasaki's WRAPS portraits have their own look, which is partly a matter of composition and partly a matter of lighting.

For processing film, WRAPS had access to professional-quality, top-of-the-line materials, including the necessary chemicals. They used Kodak D76 solution for developing the film. A related product, Kodak D72 solution, was used to develop prints. The prints themselves were made on Kodak paper, and the preferred stock was double weight. Single-weight paper was too thin and easily wrinkled.

For darkroom equipment, Iwasaki remembered that WRAPS had an enlarger, printer, and drier in the room they used as a darkroom. The drier was a machine where the darkroom technician put wet prints, right out of the bath, on a conveyor belt. The belt took the prints into a heated environment, and when they emerged, they were already dry and ready for mounting. This system greatly sped up the production of prints.

Iwasaki noted that professional photographers can do a great deal of artistic work in the darkroom. Various lenses and techniques can be employed to manipulate the print: contrasts can be heightened, or the photographer may decide to under- or overdevelop various parts of the picture to make portions of it stand out or recede. (According to Iwasaki, Ansel Adams was a master of such techniques. Adams's final prints were often the product of many tests and many hours spent in the darkroom, trying to achieve the best effect.) Because they were under time constraints and had to produce multiple copies of their pictures, WRAPS photographers did most of their darkroom work straight with little or no manipulation of the prints.

ASSIGNMENTS

The central office in command of the WRAPS, the WRA's Reports Division, was based in Washington, D.C. The Reports Division generally issued the photography assignments. These were either teletyped to Denver or called in. The core group of photographers—Parker, Mace, and Iwasaki—went out into the field on assignment on a regular basis. Iwasaki's routine gives us an idea of the way the assignments worked in general.

Iwasaki sometimes drove, sometimes flew, but most often journeyed by train to get to his assignments. Because of the war, transportation was sometimes difficult. When Iwasaki arrived at a given locale, someone always met him from the local WRA Resettlement Office. That person oriented him and took him throughout the area, showing him the different sites where the relocated Japanese Americans were working or residing. Then it was up to Iwasaki to photograph what he felt was important.

It was typical to return to Denver between assignments. This was largely so that the film could be processed right away, particularly when the assignment was the result of a request for photographs to illustrate a specific story or to show Japanese American resettlers in specific regions of the country.

Correspondence indicates that the Office of Reports was interested in WRAPS covering a broad geographical area.[32] On February 17, 1944, a letter came from the Office of Reports, indicating that Iwasaki should spend ten days in Kansas on assignment. Midyear, the bureaucrats in the Reports Division wanted Iwasaki to shoot in the Northeast, including Connecticut, Delaware, Maryland, Massachusetts, and Washington, D.C. Around mid-June of that year, Iwasaki was also instructed to shoot photographs of a special camp that the government set up for European refugees in Oswego, New York.[33] Then, in early August, the WRA bureaucrats asked him to cover additional locales on the East Coast. On September 27, 1944, Iwasaki was assigned to do a shoot at Seabrook Farms, New Jersey. Subsequently, correspondence indicates that he was supposed to do a shoot at Heston Farms, Pennsylvania, on October 9, 1944, and then go out to Philadelphia and Delaware on October 25, 1944. On November 6, 1944, Iwasaki was sent to the South to shoot Japanese Americans there. Then, on December 13, 1944, this itinerary was expanded to include Texas.

On occasion, Iwasaki would string together destinations, doing a series of shoots in different locales. An example Iwasaki gave was when he took photos in Boston and then drove to Storrs, Connecticut, for another assignment. He related that at the University of Connecticut,

Storrs, there were a dozen Nisei, including a young man about his own age that Iwasaki had known in the WRA camp at Heart Mountain, Wyoming. On another trip, he photographed Japanese American resettlers in New Hampshire and neighboring Vermont. For his WRAPS assignments Iwasaki generally traveled by himself.

Sometimes Iwasaki was asked to photograph specific individuals whose virtues the Authority wanted to extol. As a result, a number of important artists and intellectuals were highlighted in the WRAPS resettlement photos, such as Mrs. Fred Mittwer (Mary Oyama), a well-known Nisei writer; Chiura Obata, a famous Issei painter; and George Nakashima, a Nisei woodworking artist resettled and living in the aptly named New Hope, Pennsylvania.

Other specific requests appear in office correspondence. The individuals and families cited in these requests were not necessarily famous; rather, they were usually selected because they embodied characteristics the Authority wanted to highlight and extol. On March 3, 1944, for example, the Washington office suggested a series of shots focusing on resettlers who exemplified a strong Japanese American family formation. WRA records indicate that Iwasaki carried out this assignment, and these shots were taken, developed, and then shown back in the WRA camps.[34] The Washington office also wanted photos of wounded Japanese American veterans recuperating in army hospitals, such as the Fitzsimons Hospital in Denver.[35] This subject shows up over and over again in the WRA photographs, especially after 1943. The Reports Division bureaucrats also wrote to Parker about specific regions they wanted WRAPS to shoot. Not only were they interested in representing diverse regions, but they also wanted to get Japanese Americans to consider resettling in places that might not have ordinarily come to mind.

As early as June 1944 the Reports Division made sure that the WRAPS staff took photos of camp closures. Iwasaki and Mace were assigned to photograph the scene when the WRA closed its camp at Jerome, Arkansas—the first of the ten permanent camps to be shut down. Because this assignment was so important, Iwasaki and Mace drove out to Jerome together and worked as a team.

As other camps closed, such as Amache in Colorado, their final days were photographed, too. WRAPS staff also documented resettlers who were returning by train to their homes in California. Correspondence from the Reports Division's chief clearly shows that the explicit purpose of these shots was "to show that people are really moving out" of the WRA camps once and for all.[36] Thus, in the Washingotn, D.C., bureaucrats' minds, anyway, additional support for resettlement could be stimulated by using photographs to document the fact that, one

Iwasaki and colleague on a bridge constructed by Japanese Americans in the Jerome WRA camp in Denson, Arkansas. Photographer: Charles E. Mace, June 22, 1944

National Archives photo no. 210 G-H-491

by one, even before the end of the war, the WRA camps were closing down their operations and everyone was leaving.

The Reports Division also wanted to document the violence aimed at Japanese American resettlers, especially those who returned to the West Coast after the exclusion orders were rescinded. The Masada photograph (p. 143) is an excellent example of this kind of shot. Despite suffering an apparent hate crime, Mr. Masada appears confident, and this is reinforced by the text. This, by the way, was a typical textual maneuver found throughout the WRA resettlement photographic corpus, so one imagines that the narrative was a basic template generated out of the Reports Office in Washington, D.C.

In a related assignment, on March 3, 1944, Iwasaki was sent to shoot "damage photos," that is, photos depicting vandalized Japanese American property. Iwasaki reported that on another occasion he went to Stockton, California, to do the same. He also remembered spend-

ing a fair amount of time in Kent, Washington, which was then a farming community south of Seattle, shooting damaged property and vandalism.[37] On yet another occasion, a request for "damaged property" photographs came from the WRA's Evacuee Property Office.[38]

PHOTOGRAPHIC METHODOLOGY

Iwasaki's comments about the basic shooting methodology was "we didn't shoot a lot" and "we tried to keep it down." Iwasaki explained that when he and the others went into the field, they tried to limit each assignment to two or three dozen pictures. Iwasaki said that he thought of his WRAPS work largely in terms of a single shot that could tell the whole story. He acknowledged, however, that both he and Parker on occasion had shot sequences of photographs appropriate for composing visual stories, such as Iwasaki's assignment photographing a group of Colorado Japanese Americans who made a point of donating blood at the Denver Red Cross to demonstrate their support of U.S. war efforts (see photo of Dr. Howard Suenaga, p. 49). The reason for this restraint was primarily that the staff was aware that processing a large number of photos would be a problem for the lab to print. In contrast, when Iwasaki did a photo shoot for magazines like *Life* or *Time*, he might shoot sixty or seventy frames, "or even more," "because it was no problem processing all the shots in the Life or Time lab."

Iwasaki recalled that WRAPS did not ask Japanese American resettlers for permission to take photographs of them at work or staged outdoors. However, this was typical in photojournalism during that period. If a photo shoot involved going into a home or apartment, Iwasaki remembered asking for permission first. Consent forms were not utilized by any of the WRAPS photographers, although explanations about the work were offered if a potential subject inquired. Iwasaki recalled that he never had a potential subject refuse to be photographed during the entire time he worked for the WRAPS.

CENSORSHIP

A letter from the Reports Division, dated October 25, 1943, indicates that the WRAPS photos were supposed to be seen, evaluated, and cleared by the War Department before they were sent back to Denver for printing and release.[39] It is evident from correspondence that censorship did take place. As late as September 17, 1945, the official correspondence discusses WRAPS negatives that had been impounded and inquires about the status of the confiscated

shots.[40] Iwasaki, however, insisted that he was not personally subject to any instructions about what to shoot or not to shoot. Nor did he remember that any of his photographs were ever subject to censorship after they were developed.[41]

Unfortunately, no documentation is available in WRA records to verify or explain why Phase One photographers, like Dorothea Lange, were harassed and Carl Iwasaki was not. Here we conjecture that censorship was less important during Phase Two because Iwasaki and his WRAPS colleagues were photographing loyal Japanese Americans who had been cleared of all suspicions, had identified solid employment possibilities, and had been duly released from confinement. Furthermore, although the war was still raging in 1943 and 1944, the defeat of the Japanese Navy at the Battle of Midway in 1942 ended any possibility of a land invasion of the lower forty-eight. Finally, as we will explain below, the philosophical orientation of Iwasaki and the WRAPS photographers was in alignment with the WRA. These factors may explain why by 1943, censorship did not appear to present a problem to Iwasaki or any of the other WRAPS photographers.

PROCESSING SCHEDULE

According to Iwasaki, the photographers—initially Parker and Mace—went out during the day to shoot the photos. Then they brought the film back to the WRAPS office to be processed right away by the darkroom attendant. Iwasaki said that the processing work was sometimes done at night because the photographers wanted to be able to see their work immediately to make sure it was satisfactory.

SELECTION

When the photos were developed, all viable shots were printed on contact sheets for further examination. The team looked through the shots and then sorted the photographs into the discards and the keepers. Outtakes were simply discarded, along with the negatives of these discarded shots.

The WRAPS team then evaluated the photos to eliminate any sensitive shots as far as the U.S. military and the WRA were concerned. Any photos that were questionable could be sent to John C. Baker, the head of the WRA Reports Division, for review. Otherwise, one print of every photograph was kept on file in the Denver office, and another print was sent to Washington,

D.C. The Denver Photographic Section kept all of the original negatives, which were cut into individual shots, put into small folders, and filed.[42]

The prints were typically small (5" × 7") but suitable for publication purposes. On occasion, larger (11" × 14") prints were required and these were mounted on construction board for exhibits or display.

WRA PHOTO CAPTIONS

The Photographic Section's Phase Two photos in the National Archives, Branch II, are typically accompanied by extensive notes. WRAPS generated multiple copies of each picture (some for the camps, some for the Reports Division in Washington, as well as one to be held with the original negative in the WRAPS office in Denver). On the prints made for distribution, the caption was usually put directly on the back of each photo that was made.

The annotations on the Phase Two photos are incredibly detailed, including the subjects' full names, prewar residences, WRA camp(s), thoughts and feelings about resettlement, and present situation. In addition, most of the annotations include the specifications of the shot itself, such as the date, location, and photographer.

Iwasaki told me that there was always someone with him on his photo shoots. That person, typically the local WRA field officer, was the one who knew or collected the information that appeared in the annotations. Yet no accounts, explanations, or credits are offered for the captions—which are reproduced in the photo section as they were originally written, except for minor changes to correct obvious errors—and none are presently available in any of the extant literature online or in print. Iwasaki's comments, however, underscore the importance of the WRA resettlement field officer or staff in guiding the WRAPS photographers to the individuals and families who best matched the WRA's post-1943 resettlement mission. In any case, the steno pool at Denver's WRAPS office typed the final captions, put them on the back of the prints, and then sent them to the Reports Division in Washington, D.C., for filing and possible distribution.

DISTRIBUTION

Part of the mission of WRAPS was to generate photos that could be used to convince loyal Japanese Americans that it was safe to leave the camps. These photos were also supposed

C. Kimi, a resident in the WRA camp at Poston, Arizona, looks over WRAPS resettlement photographs. Photographer: Hikaru Iwasaki, September 1945.

National Archives photo no. 210-G-K-356

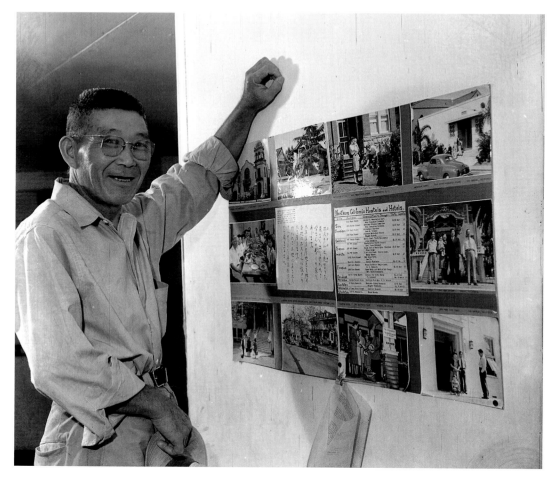

to be used to convince members of the larger public that they would be safe if loyal Japanese Americans who had been imprisoned were released. Thus, the WRA had to convince two different audiences that resettlement was an appropriate policy for the WRA to promote two years before the war was even over.

To reach these audiences, hundreds, if not thousands, of photographs were sent to the print media, largely by request, to illustrate newspaper and magazine articles as well as pamphlets, reports, and books. Exhibition prints were sent to camps, where they were displayed. The purpose of these photos was to encourage the incarcerated Japanese Americans to leave camps

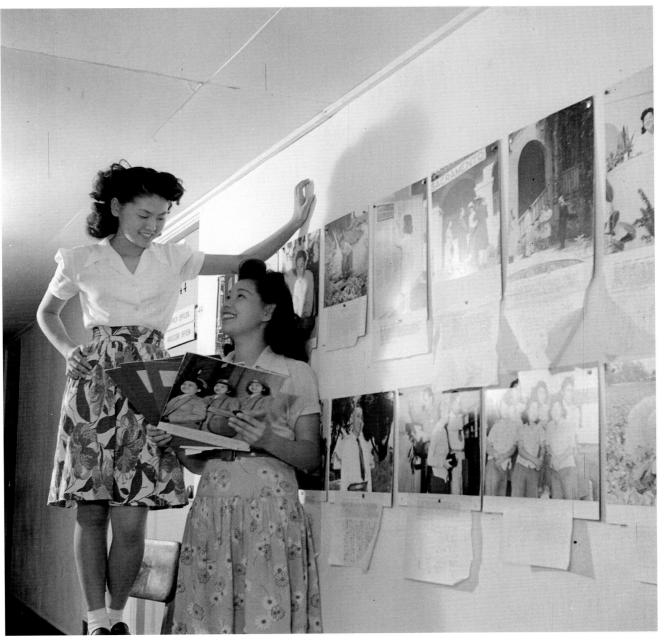

Poston residents Rose Yamada and Mitsuye Ohye look at WRAPS photographs of resettlers. Photographer: Hikaru Iwasaki, September 1945.

National Archives photo no. 210-G-K-357

Yuki Masutani (left) of Poston, Arizona, discusses resettlement plans with adviser Edith Mitrocsak. WRAPS photographs can be seen in background. Photographer: Hikaru Iwasaki, September 1945.

National Archives photo no. 210-G-K-358

Facing page: Heart Mountain selectee Albert Sumio Tanouye (right) reporting to Heart Mountain Selective Service clerk Helen Morioka, with WRAPS photographs in background. Photographer: Hikaru Iwasaki, March 3, 1944.

National Archives photo no. 210-G-I-46

SELECTIVE SERVICE DESK

STATEMENT OF UNITED STATES CITIZEN OF JAPANESE ANCESTRY

From left to right, Sylvia Leventhal, Mary Kitano, Col. H. A. Finch, Eva Lee, and Mary Suzuki at at the Pan-Pacific Industrial Exposition, Los Angeles, California. This booth was sponsored by Friends of the American Way, Council for Civic Unity, Fair Play Committee, WRA, and other organizations interested in returnees and in combating racism. Photographer: Hikaru Iwasaki, September 6, 1945.

National Archives photo no. 210-G-K-275

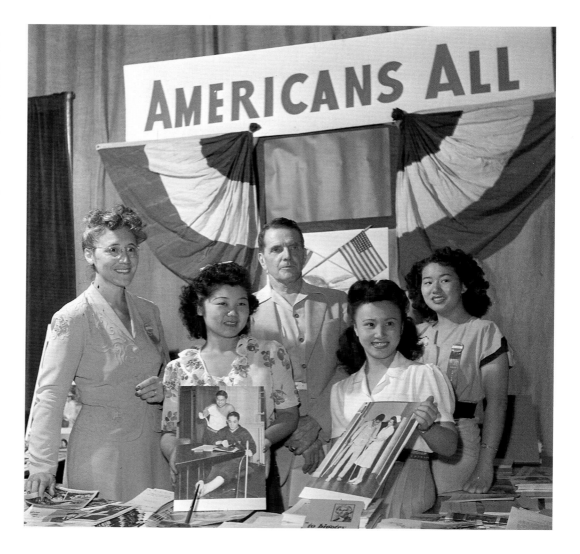

by showing them job, military service, educational, and living opportunities, and also that folks in the larger society were receptive to well-behaved resettlers.[43] Similarly, exhibit prints were sent by request to different WRA resettlement offices for display. Exhibit-size prints were also sent to organizations, such as the American Friends Service Committee (Quakers), to help educate the public about Japanese Americans in camp and the resettlers.

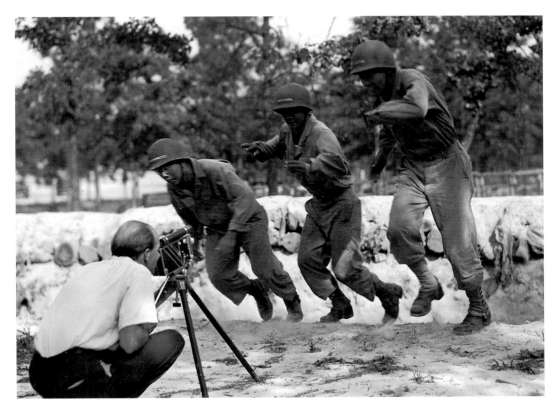

Tom Parker, WRA photographer, makes a close-up movie of Japanese American soldiers at Camp Shelby running the obstacle course. The 442nd Combat Team at Camp Shelby was composed entirely of Japanese Americans who volunteered for services in the armed forces. Photographer: Charles E. Mace, July 1943.

National Archives photo no. 210-G-H-108

What is notable is that WRAPS photographers were quite conscious of the different applied uses of their work. This is apparent in the numerous shots taken of Japanese Americans studying or displaying WRAPS photos. The photos deftly illustrate Japanese Americans in camp studying images of successful resettlers on the outside. Other photos show Japanese American resettlers using WRAPS images to let other Americans know about the release and reintegration of loyal Japanese Americans, even while the war was still in progress.

FILMS

Although we will not examine the WRA's "moving images" here, the National Archives holds at least three completed films that were developed to complement the WRAPS mission.[44]

According to Iwasaki, the films were the sole project of Tom Parker, although he drew from many still shots that WRAPS photographers had generated.

As far as the production process, Iwasaki believes that the footage was shot and then sent out to be processed, perhaps by the Eastman Kodak Company. Once the film was processed, it was shipped back to the Denver office and then Parker looked at the footage and edited it into the final product.

BROAD PHILOSOPHICAL ORIENTATION

Since the very origins of photography, it has always had an institutional utility to lawyers, law enforcement, and the state.[45] By the 1900s the traditional approach revolved around the government's use of pictures to illustrate printed text. An alternative approach in vogue by the late 1930s, however, involved the presentation of the photograph as a datum in its own right, capable of communicating an immediate, firsthand message through an image that was powerful in its capacity to both inform and touch its viewer. This new kind of institutional photography was useful for the government's purposes because a picture's tangible objective qualities offered an immediate epistemological veracity, as in the old adage that "seeing is believing."[46] It thus seems natural that the WRA sought out photographers and photography as a public relations tool.

The WRA has been characterized as an organization that was knowledgeable about the value of public relations. Michael Wallinger, in his dissertation, argues that the WRA was quite sophisticated in terms of knowing its audience and in terms of preparing messages aimed to influence specific audiences toward a favorable view of the WRA as well as toward its specific policies and actions.[47]

In this light, the WRA enlisted the tradition of government/institutional photography and harnessed it to a public relations campaign in favor of the Authority's resettlement policies, the assumption being that documentary photography entails a truthful and accurate representation of reality. From this standpoint, the WRAPS also extended the tradition of institutional photography pioneered by New Deal agencies, like the FSA and the WPA.

In sum, it is worthwhile to try to understand where the WRAPS photographers were coming from in the light of New Deal–related optimism. According to Iwasaki, based on his position in the Denver Field Office, the goal of the WRAPS staff was to take still photographs and show them "so that people would be more receptive to relocation" from all sides. Iwasaki said that his colleagues, Tom Parker and Charles Mace, were equally supportive of the WRA

resettlement program.[48] There is little textual evidence in the archives to support this interpretation of WRAPS staff, but a comment by Parker on a subsequent federal job application indicates how he characterized his own efforts on behalf of the Authority (as well as on behalf of Japanese Americans and in terms of race relations). Parker noted that as a secondary project, he "wrote and produced sound motion pictures which were widely credited as a major contribution to an improved national understanding of this minority group during a critical period."[49]

Thus, the WRAPS photographers appear to have believed in the indexical assumptions behind their work. They went into the field, met individuals and families who were reentering the mainstream, and took photographs of them as they lived their lives. In short, although they were steered toward particular individuals and families who the WRA felt exemplified successful resettlement stories, there was nothing fictional about the photos themselves. The photographers did not do anything that could be construed as falsifying their shots. Furthermore, as Iwasaki mentioned, he received no explicit instructions at any time about what specific images to take, or not to take, at any given assignment while he was employed at WRAPS.

Indeed, at the time, and according to Iwasaki, none of the WRAPS photographers believed that their work was a matter of propaganda. Nor did Iwasaki remember having any discussions among the WRAPS staff that reflected any doubts or insecurities about their work or how it was being used by the Authority.

OVERALL CLIMATE OF PRODUCTION IN WRAPS

It is worth noting that a tremendous sense of urgency permeates the official correspondence between the Washington-based Reports Division and the WRAPS in Denver. There were ongoing demands for shoots in many different locations and with many different kinds of Japanese American resettlers. Back in the Denver office, there were constant demands for prints and posters, usually on an ASAP basis. Speed, precision, and efficiency were all key words in WRAPS production and distribution. The style employed by WRAPS is best characterized as photojournalism. Pictures were taken for a client (the WRA) in a selective and focused fashion. The aim was to take photos that told a story in a single frame, always keeping in mind the public relations dimension of each picture.

Hikaru Iwasaki's Resettlement Photos, 1943–1945

HIKARU CARL IWASAKI

By the time he retired in the 1990s, Carl Iwasaki had reached the peak of the photojournalism profession. When I first visited his home, he showed me some of his featured photographs in magazines like *Life*, *People*, *Sports Illustrated*, and *Time*.[1] A number of his shots are iconic and include pieces like the 1961 photograph showing a shadow of two teenagers enjoying a kiss.

Now in his eighties, Iwasaki can look back on a lifetime of creative work. As a staff photographer who also worked on assignment, he traveled all over the world and covered all kinds of stories. He has witnessed humanity's highs and lows, having covered stories from the infamous Starkweather case; to Jackie Kennedy skiing with her kids in Aspen; to an iconic photo of Linda Brown (of *Brown vs. Board of Education*); to the football season when he followed Joe Namath around, on and off the field, for *Sports Illustrated*.[2]

Before presenting a number of Iwasaki's resettlement photographs, it is fitting to say something about his background as well as the criteria that governed the selection of his WRAPS photographs herein.[3]

Born in 1923, Hikaru Carl Iwasaki and his younger sister lived across the street from the Buddhist Church, located in the heart of San Jose's small but vibrant Japanese American community. His father was originally from the Yokohama area in Japan, and his mother was from

the Tokyo area. Unfortunately, his father passed away when Carl was in his mid-teens. Perhaps because of this, Iwasaki knew only a little about his parents' lives in Japan.

His father had been a tailor and had been fairly successful. The politician Norman Mineta's father was among his father's customers. Iwasaki remembers going to his father's shop after school and working there from six in the afternoon until ten. His father never taught him to sew, but Iwasaki thinks that he picked up his father's sense of craft and precision by watching him work. Iwasaki said that his father "was very detail-oriented." Carl remembered watching his father sew suits. He would measure the cloth, cut it, and carefully assemble the pieces. "He was meticulous," Carl told me. Other than that, Carl does not think that his parents had any particular orientation toward aesthetics or art that might have influenced him.

Iwasaki describes himself as generally a self-taught photographer. He was first exposed to photography while he attended Peter Burnette Junior High School in San Jose. Every Friday there was a photography class offered as a hobby course. He learned to shoot, develop, and print there. A good friend, Warren Okagaki, also showed him a great deal because Okagaki already knew all the basic steps to the craft, including how to process and develop film and then print the photographs. Iwasaki's first camera cost thirty-seven cents.

Once Iwasaki discovered that he liked photography, it became his great passion and everything else was of secondary importance in his life. He soon set up a small darkroom at home. He said that his mother did not know much about photography but she saw it as a good hobby for her son so "she was okay with it."

After his father passed away, Iwasaki's mother worked in a vegetable plant, washing and preparing the produce after it was delivered to the factory. Carl got a job in the Leiter Photo Studio in San Jose, one of the best local portrait studios, where he worked developing film. He did not have a car and so he rode his bike to school and then over to the studio.

When Iwasaki enrolled in San Jose High School, he immediately joined the staff of the school newspaper, *The San Jose High School Herald*, as well as the yearbook staff, as staff photographer. He noted that although he and his family were removed from San Jose, per Executive Order 9066, his classmates were kind enough to send him a copy of *The Bell*, the SJHS yearbook for 1942. That yearbook has a full-page picture of Carl posing with his camera and flash. By the time that he received it, Carl was residing in the WRA camp at Heart Mountain, Wyoming.

His forced removal to camp was a difficult experience for Iwasaki. He was pulled out of school and separated from his classmates and friends, which was painful. He liked many of his

In 1942, Executive Order 9066 forced the Iwasaki family into the "assembly center" at Santa Anita Race Track before the school year was over. Carl had been the yearbook's photographer but, to his dismay, he was forced to abandon this assignment as well as his studies. Classmates sent a copy of the yearbook to camp when it was published, and it featured this full-page portrait of Carl.

fellow students and missed their camaraderie. Iwasaki related that a girl from San Jose High drove all the way down to Santa Anita Assembly Center, east of Los Angeles, to visit him. Also, no cameras and no photography were allowed in the center, depriving him of his passion: "I really missed that." He also remembers seeing people being forced to live in horse stalls at the race track: "Seeing that was kind of tough on me," he remembered.

Iwasaki's first job at Santa Anita was working in the center's Camouflage Net project.[4] He worked loading and unloading the raw materials and the finished nets onto trucks. It was hot, dusty work and the pay was minimal. He was just eighteen years old at the time.

On another occasion a couple of his good friends from high school visited him in Santa Anita. They drove all the way from San Jose to see him. When they met, they were forced to speak to each other through the barbed wire fence. Iwasaki remembered the experience as "heartbreaking."[5]

From Santa Anita, the family was sent on to a more permanent WRA camp. Iwasaki recalls that the trip was by train with the shades pulled down. "We didn't know where we were headed." Their destination was the WRA camp known as Heart Mountain Relocation Center, outside of Powell, Wyoming. Iwasaki remembers that the family arrived from California in the winter and it was freezing. That was the first time he had ever seen snow. "It was so cold that sometimes if you touched the barrack doorknob your fingers stuck." Japanese Americans were only issued standard military peacoats. Anything else, such as good shoes or warm clothes, had to be purchased from Sears or Wards via catalog.

Once Iwasaki was in Heart Mountain, a job opened up for an orderly at the camp hospital. After a month or so, a better job, as a technician, opened up. Iwasaki did not know anything about X rays but he applied and got the position. He said that an X-ray man from a Denver-area hospital came to Heart Mountain and "gave me a rundown." At least the new job was somewhat related to photography. In the winter, the pond by the hospital froze over and Iwasaki learned how to ice-skate. Skating in the winter months at Heart Mountain offered both a momentary respite from the work routine and a way to get warm despite the freezing temperatures.[6]

Within a year, Iwasaki heard about a possible job opening in Denver. The position was for a darkroom technician, who would process film and make prints. Acquaintances of his, including Vaughn Machau and Bill Hosokawa, who worked at the *Heart Mountain Sentinel*, brought the position to his attention. Because of his great interest in photography, Iwasaki immediately applied for the job. He does not really remember, but he thought that it was Tom Parker who

came to the camp to take photos and interview applicants. Apparently, a good many people applied, but Iwasaki was the one who was selected. "I didn't know why [they picked me]," he said.

Iwasaki does not remember anything about the kind of leave clearance he received or any of the technical details of his release from Heart Mountain. His impression was that whatever arrangements were made, "the WRA took care of things." Apparently, once Parker expressed an interest in hiring Iwasaki, there were no barriers to his leaving camp.

When Iwasaki initially arrived in Denver he lived about five miles from the WRA office, which was located downtown. The WRA found a Japanese American family who was willing to take in Iwasaki—then a young, single Nisei man—as a boarder.

When Iwasaki was hired in 1943, he was nineteen years old. Once in Denver he was assigned to the darkroom where he did the developing and printing for Parker and Mace. After only a matter of months, however, Iwasaki began to take photos on his own, focusing largely on the Japanese American resettlers in Denver. Parker and Mace liked his work, and so Iwasaki began to go out on assignment.

When Iwasaki began taking photographs for the WRA, he was quite young, in terms of both his age and his experience as a photographer. His last "assignments" before joining WRAPS were taking photos for his high school newspaper and yearbook. As such, he was an amateur who had never worked in a professional context. By contrast, Russell Lee and Dorothea Lange were trained by Roy Stryker in the FSA tradition, Tom Parker had worked for the WPA and the Federal Works Agency (FWA) before the war, and Charles Mace had been a war, artistic, commercial, and newspaper photographer before 1942. These veterans were also much older than Iwasaki. Yet, despite his youth and inexperience, he remarkably was able to keep pace with these seasoned professionals.

Perhaps because of his youth and his personality, his WRAPS photos reveal a fundamental sense of optimism. This optimism emerges when talking to Carl about how he felt about WRA use of his photographs. Although he acknowledges the racism and hatred that faced people of Japanese ancestry during the 1940s, he told me that there was not much point in waiting out the war in confinement, especially since camps were often a negative influence on families and children. As his own experience of traveling around the country photographing resettlers proves, Carl said that bona fide opportunities existed for Japanese Americans during the war if they were willing to be open-minded and give their best efforts. He deliberately and self-consciously tried to imbue his photographs with this optimism.

Today the outstanding features of Iwasaki's demeanor are his civility, decency, and humanitarianism. Although critics might fault him for not assertively seeking out cases that might damage WRA claims of resettlement success, two points should be kept in mind. One is that those who defied the Authority in camp were not eligible for, nor did they usually secure, release. Two, those who were released before the end of the war—and thus, by definition, the subject of WRAPS focus—were likely the people most ready and most able (in terms of material and nonmaterial resources) to leave and succeed. They were a self-selected sample, and as such, resettlement from 1942 to 1945 needs to be distinguished from Japanese American resettlement as a whole between 1941 and 1946. These are not the same populations, and so to judge Iwasaki's work in terms of the latter is neither reasonable nor appropriate.

SELECTION

The Japanese American Relocation Digital Archive (JARDA) has more than 1,300 photos by Iwasaki alone. This number, of course, is not the complete collection of the shots that Iwasaki took for the WRA from 1943 to 1945. Yet, even this partial sample of his total output makes Iwasaki the most prolific photographer of Japanese American resettlement out of all WRA photographers, including Phase One and Phase Two.

The photos I selected for this book are presented here in chronological order (although they are not organized in this manner in the JARDA, ARC, or LOC online photographic collections). This organization clearly shows how quickly Iwasaki worked and also how much ground he covered in his assignments, which spanned the lower forty-eight states. This speed and broad scope were valued by the WRA. Interoffice memos about Iwasaki's and his colleagues' assignments clearly state that the WRA wanted pictures that showed Japanese Americans dispersed throughout the country and "doing well" in every location. And the WRA wanted these photos done quickly and effectively so that these images could be widely distributed for public consumption as soon as possible. To accurately reflect WRA priorities, I have selected photographs that depict Japanese Americans from across the country.

I also chose pictures that were accompanied by specific, detailed narratives. As already mentioned, none of these narratives were written by Iwasaki; he was responsible only for the photography. The detailed narratives were written by local WRA relocation officers, who often pointed out subjects they deemed to represent the best or most inspiring examples of successful

resettlement from the WRA's perspective. Naturally, the local relocation officers did not take WRAPS photographers to document the stories of Japanese Americans in difficult or impoverished conditions, which is precisely why almost no photographs along these lines appear in the official collection of WRAPS images preserved in the National Archives.

Knowing the background of the 1943 WRAPS photographs explains the themes that repeatedly appear in the images taken by Iwasaki, as well as by Tom Parker and Charles E. Mace, such as reestablishing families and homes, going back to school, working productively, enjoying leisure and the small pleasures of freedom, rubbing shoulders with Euro-Americans, and serving national interests, including military service. Many of the pictures depict obvious gender-based roles. Women are often shown in domestic settings, carrying out tasks like child care or homemaking. Men are shown at work or enjoying leisure as the paterfamilias.[7]

Sometimes noted in the extant literature on these images is the "overly posed," sometimes "stiff" quality of the WRAPS resettlement photographs. Others have noted that in the majority of portraits, subjects were apparently asked to smile for the camera right before the shot was taken.[8] As previously mentioned, technical issues related to lighting forced the photographers to carefully set up the WRAPS photographs. On the other hand, the portraits may seem posed precisely because the shots were made, explicitly and intentionally, to promote the key aims of the WRA. Consequently, in photo after photo from this period, Japanese Americans are depicted as smiling, happy, free, confident about their safety (despite occasional attacks by vigilantes), and eager to contribute to the war effort as they reestablished normal lives for themselves in the larger society. At least to some extent, these sentiments were shared by the WRAPS staff and their subjects alike.

WRA Photographs

ANTI-DISCRIMINATION POSTER

Government's latest anti-discrimination poster. [Photographer not identified.] Denver, Colorado. 7/19/43

National Archives photo no. 210 G-B-986

"No loyal citizen of the United States should be denied the democratic right to exercise the responsibilities of his citizenship, regardless of his ancestry.

"The principle on which this country was founded and by which it has always been governed is that Americanism is a matter of the mind and heart.

"Americanism is not, and never was, a matter of race or ancestry.

"Every loyal American citizen should be given the opportunity to serve this country wherever his skills will make the greatest contribution—whether it be in the ranks of our armed forces, war production, agriculture, government service, or other work essential to the war effort."

THE PRESIDENT OF THE UNITED STATES, FEBRUARY 3, 1943

OWI Poster No. 75. Additional copies may be obtained upon request from the Division of Public Inquiries, Office of War Information, Washington, D. C. U. S. GOVERNMENT PRINTING OFFICE : 1943—O-526093

DR. HOWARD SUENAGA AND RED CROSS NURSE

Dr. Howard Suenaga, physician and surgeon formerly of Guadalupe, California, leader of thirty-five Japanese Americans who volunteered to give their blood to the American Red Cross blood donor section in Denver as a protest against outrage perpetries [*sic*] by Japanese troops on American prisoners of war in the Philippines. Shown with Dr. Suenaga, a Sansei, or third-generation Japanese American, is Mrs. Margaret Plotkin, a Red Cross staff assistant, as she registers Dr. Suenaga preliminary to the blood donation. Dr. Suenaga relocated in Denver from the Gila River, Arizona, Relocation Center.—Photographer: Iwasaki, Hikaru—Denver, Colorado. 1/28/44

National Archives photo no. 210-G-G-344

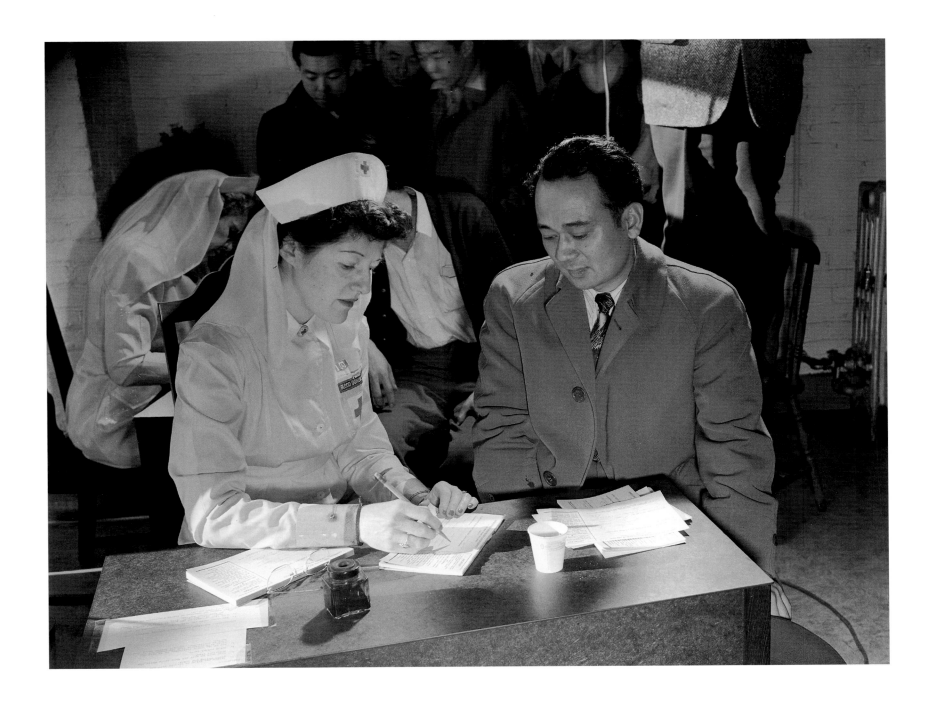

HEART MOUNTAIN SELECTEES

Heart Mountain selectees contingent in front of the Powell Draft Board Office waiting for bus to take them to Fort Warren, Wyoming, for pre-induction physicals. Front row (left to right), John Kitasako, Tom Higashi, James Nakashima, Sam Okada, and Masao Higashiuchi. Second row (left to right), Mason Funabiki, Albert Tanouye, Noboru Kikigawa, and John Miyamoto. Third row (left to right), Frank Shiraki, Sanji Murase, Edward Higashi, Harry Noda, Sadaji Ikuta, Motomu Nakasako, and John Okamura.—Photographer: Iwasaki, Hikaru—Powell, Wyoming. 3/3/44

National Archives photo no. 210-G-I-044

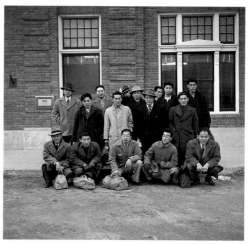

Photo 210-G-I-044, uncropped

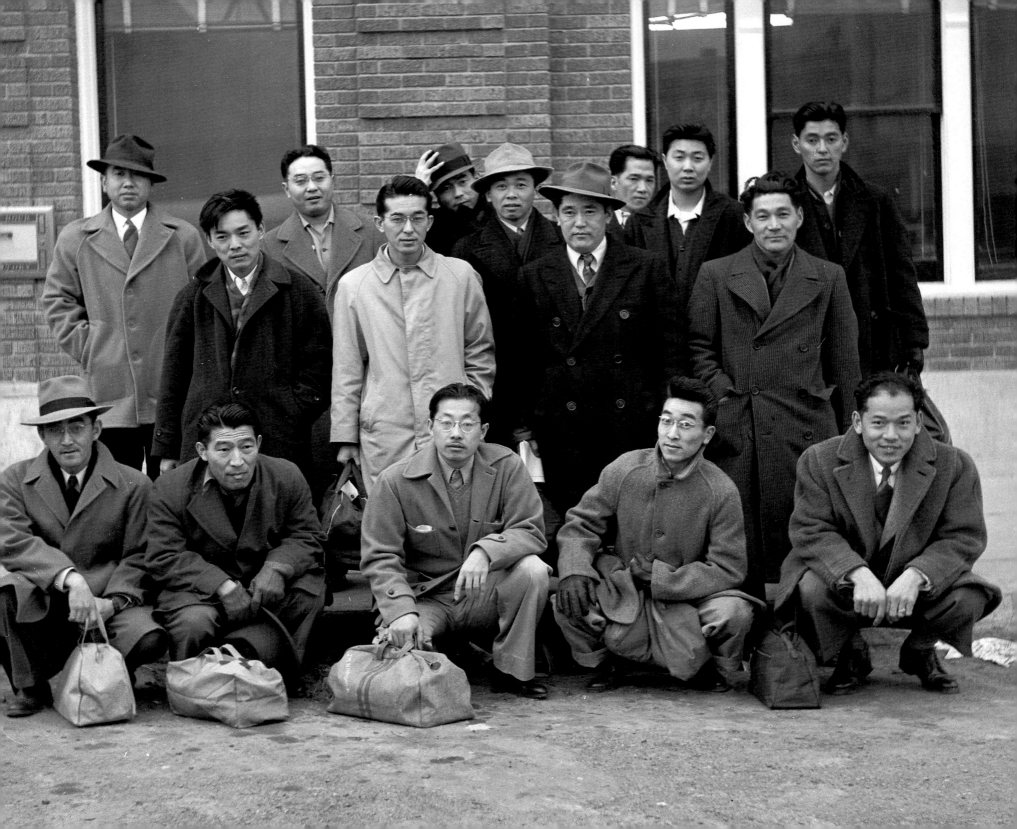

NISEI STUDENTS AT U CONN, STORRS

University of Connecticut, Storrs, Connecticut group (evacuees only). Left to right, Jim Nakano (Topaz, Redwood City, California); Tokuji Furuta (Poston, San Diego, California); Kei Hori (Heart Mountain, San Francisco, California); Edna Sakamoto (Tule and Denson); Yoneo Ono (Poston, Bakersfield, California); Ken Nakuoka (Denson, Torrance, California).— Photographer: Iwasaki, Hikaru—Storrs, Connecticut. 8/?/44

National Archives photo no. 210-G-I-292

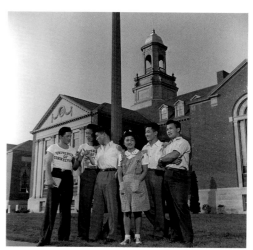

Photo 210-G-I-292, uncropped

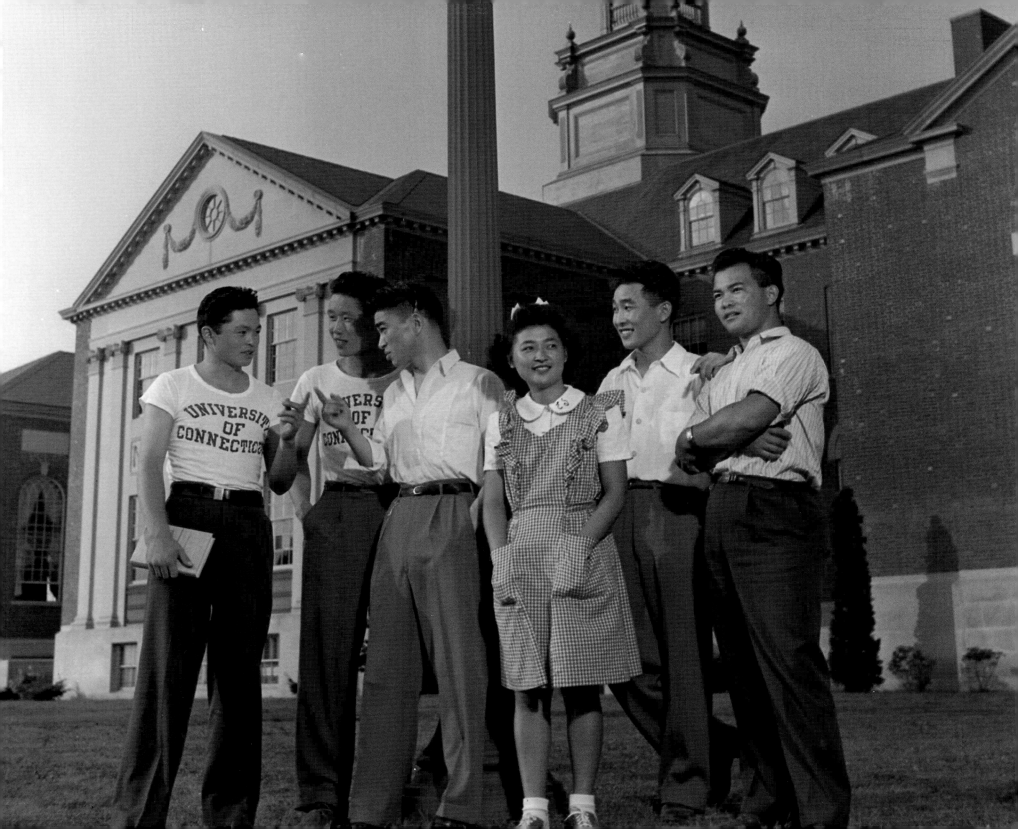

NISEI STUDENTS AT THE CONCORD BATTLEFIELD

Mr. and Mrs. Kosaku Steven Tamura (Granada), Ben Yashikawa (Tule), and Tsetsu Morita (Minidoka) visit the historical battlefield at Concord, Massachusetts. Mr. Tamura is a lawyer by profession, is a member of the California bar, and had a private practice at Santa Ana, California. He received his education at Pomona College, and LL.B. from the University of California. At Granada he was employed in the project attorney's office. Mrs. Tamura is a graduate of the University of California, and at Granada she worked as librarian. Mr. and Mrs. Tamura arrived in Boston in October 1943. Mr. Tamura enrolled for graduate work at Harvard University and has carried on some research work in addition to his regular studies. Mrs. Tamura is employed at the law library in Harvard University. Inasmuch as both are busy throughout the day they have made their home at 32 Braddock Park, Boston, a boardinghouse with a fine reputation of Japanese and American cooking.—Photographer: Iwasaki, Hikaru—Lexington, Massachusetts. 8/?/44

National Archives photo no. 210-G-I-265

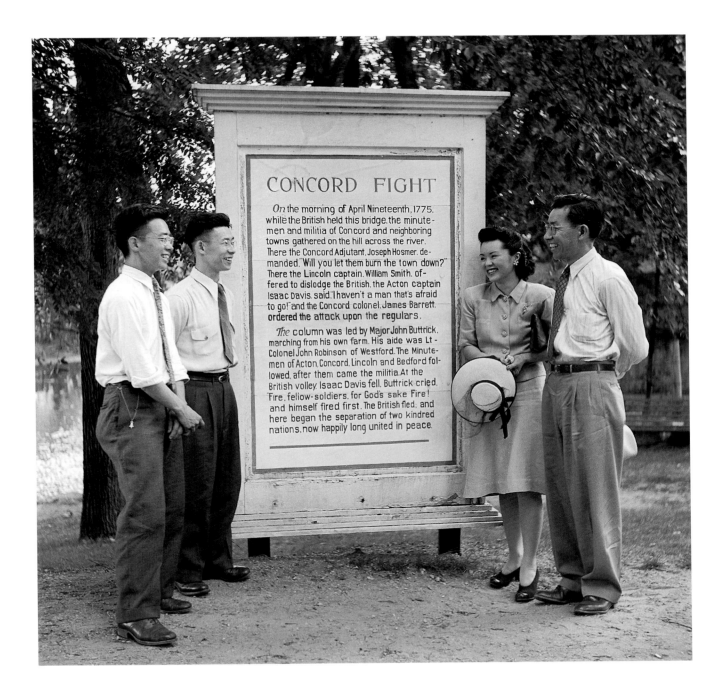

FIVE CHILDREN AT SEABROOK FARMS VILLAGE

This group of evacuee children is shown at the entrance of one of the houses at Seabrook Farms Village, Bridgeton, New Jersey, which were recently constructed by the Federal Housing Administration for the families of employees of Seabrook Farms and the Deerfield Packing Corporation. When this photograph was taken, construction was still under way and the grounds had not yet been landscaped. Over 400 evacuees from most of the relocation centers are employed by Seabrook Farms and the total Japanese American population there is over 500.— Photographer: Iwasaki, Hikaru—Seabrook Farms, New Jersey. 8/?/44

National Archives photo no. 210-G-I-679

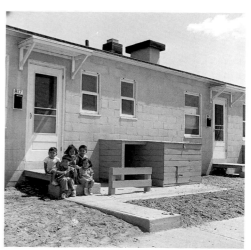

Photo 210-G-I-679, uncropped

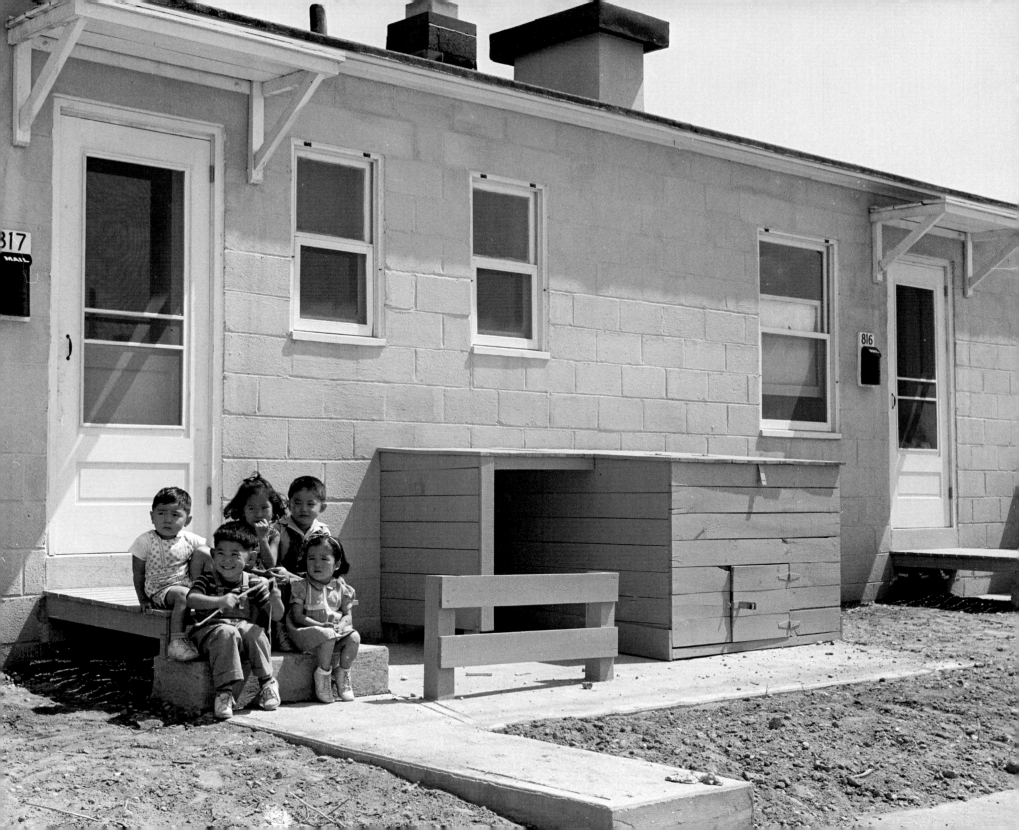

CAFETERIA AT SEABROOK FARMS

In the cafeteria at Seabrook Farms, Bridgeton, New Jersey, two Nisei girls are serving three Nisei boys who are also employed at Seabrook Farms. Behind the counter are the Izumi sisters, Yoshiko (left) and Misao, both from Jerome and Rohwer. . . . Some 400 evacuees from most of the relocation centers are employed at Seabrook Farms.—Photographer: Iwasaki, Hikaru—Seabrook Farms, New Jersey. 8/?/44

National Archives photo no. 210-G-I-688

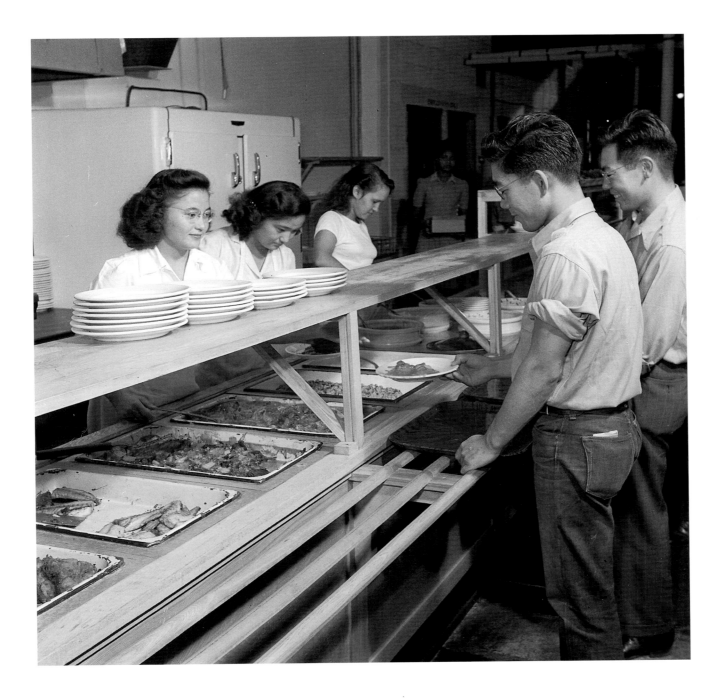

MR. AND MRS. TAY ANDOW AND DOG

Mr. and Mrs. Tay Andow and Michael at their cottage of the Theodore Kreuger farm in Stratford, Connecticut. Michael was one of the first dogs to relocate in the East and has been enjoying himself greatly on the farm, playing with Duchess, the Kreuger dog. Mr. and Mrs. Andow relocated from Granada to Boston to join their daughter, Mabel, in January 1944. They stayed first at the Walker Missionary Home in one of the Boston suburbs. Because of Mr. Andow's desire to be out in the country with a home of their own, they accepted a position on the Theodore Kreuger farm. Mr. Andow has charge of the farm activities and has an excellent garden raised under eastern conditions, which he says are not too different from those of the West Coast. They have a small house of their own at the farm. Mabel is still in Boston and they have another daughter in New York City and a son in the army at Ft. Devens, Massachusetts, so the family has been able to get together quite frequently.—Photographer: Iwasaki, Hikaru—Stratford, Connecticut. 8/?/44

National Archives photo no. 210-G-I-286

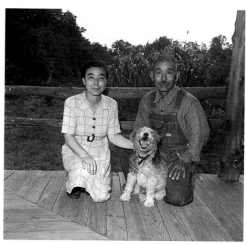

Photo 210-G-I-286, uncropped

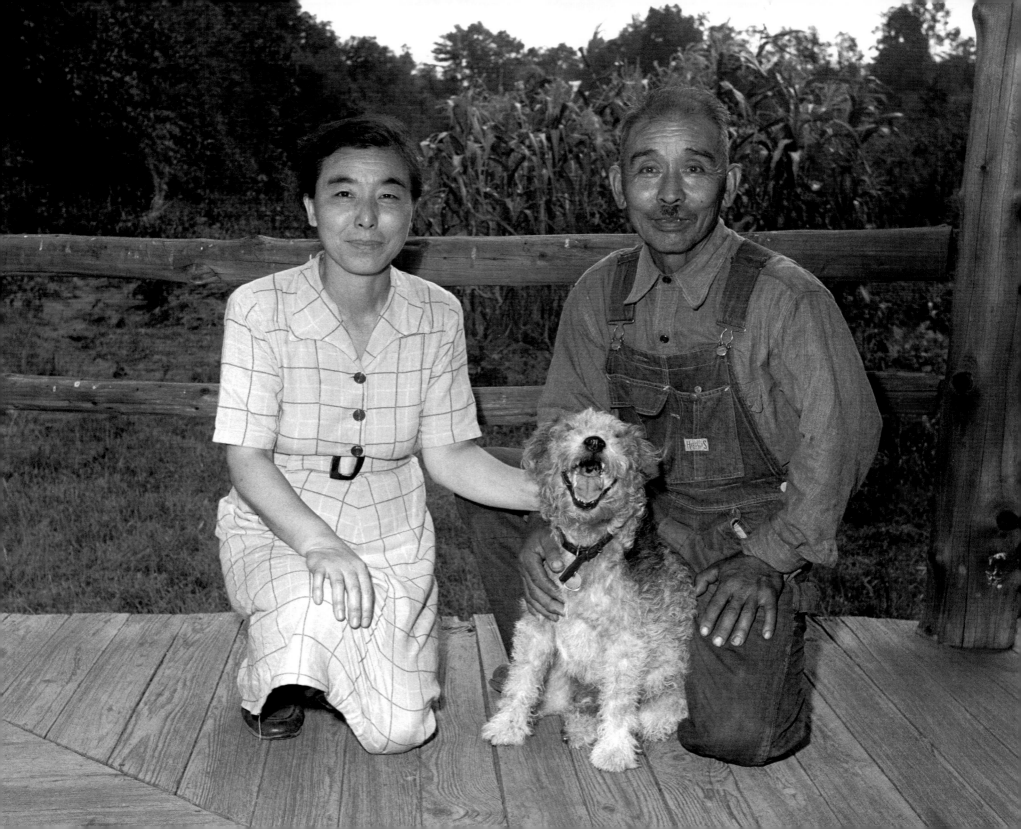

SHIN TANAKA, STUDYING IN THE LAB

Shin Tanaka, sixteen-year-old Issei from the Central Utah Relocation Center, who plans to be a doctor, is receiving training at Mt. Sinai Hospital in New York City during his summer school vacation. He is a junior laboratory assistant to Dr. Joseph H. Globus, the hospital's neuropathologist and associate neurologist. Shin left the center in October 1943 to enter Pennington (New Jersey) Preparatory School. His parents, Rev. and Mrs. Isao Tanaka, are also employed at the hospital—Rev. Tanaka as a technician in the bacteriological department, and Mrs. Tanaka as a nurse's aide in the babies' ward. Shin's parents came to New York last April after visiting friends for several months in Salt Lake City. Prior to evacuation, the Tanaka family lived in Oakland, California, where Rev. Tanaka was associated with the Oakland Junior Methodist Church. At Topaz, he was active in the United Protestant Church, Mrs. Tanaka was supervisor of music and teacher of voice, and Shin worked on the hog farm while attending school. Rev. Tanaka came to the United States as a student in 1916. He has degrees from Duke, Clark, and Yale universities. He returned to Japan in 1924, where for thirteen years he was associated with a missionary college and did field church work.—Photographer: Iwasaki, Hikaru—New York, New York. 8/?/44

National Archives photo no. 210-G-I-402

WRA PHOTOGRAPHS

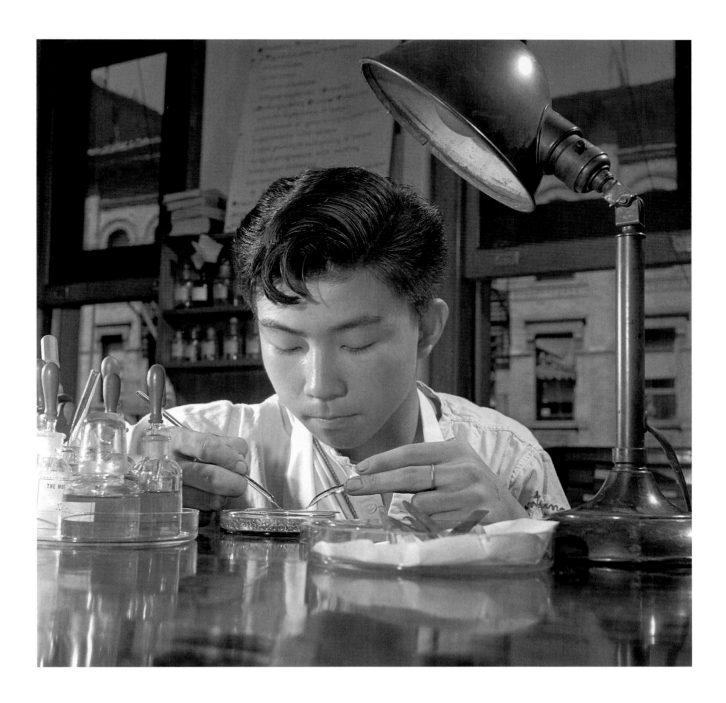

NISEI AT AUTOMAT RESTAURANT

While lunching in one of New York City's famous automat restaurants just off Fifth Avenue, May Tomio, Granada, and Akira Kashiki, Colorado River, are obtaining pieces of pie from the food receptacles.—Photographer: Iwasaki, Hikaru—New York, New York. 8/?/44

National Archives photo no. 210-G-I-385

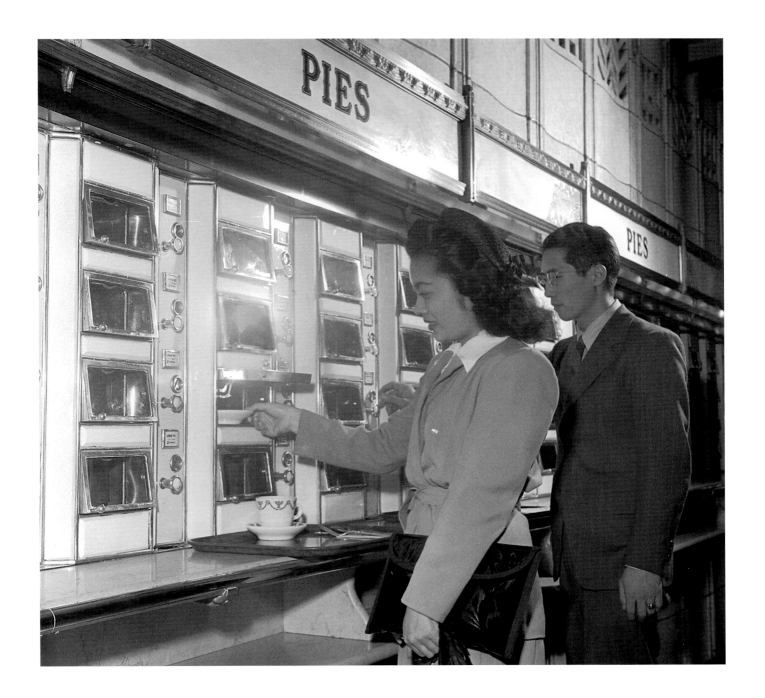

TOM YAMANE AND CHILDREN, PICKING APPLES

Helping their father, Tom Toyoji Yamane, Issei from the Gila River Relocation Center, pick apples in the orchard surrounding their new home in Wilmington, Delaware, are three of the four Yamane children, Masao, two; Mariko, seven; and Michiko, ten. Not shown are Mrs. Yamane and her son Atsushi, thirteen, who was attending a meeting of his Boy Scout troop. The entire family left Gila River together in June 1944 and resided temporarily at the New York hostel while Mr. Yamane worked out the family's resettlement plans with the aid of the WRA relocation offices in New York and Philadelphia. Mr. Yamane is now manager of the produce department in a new food store operated by the Wilmington Cooperative Society, Inc. Members of the co-op helped him find the cottage the Yamanes now occupy, and neighbors lent or gave them many household articles when they moved in. Mariko, Michiko, and Atsushi attend a nearby school. Before evacuation Mr. Yamane had his own produce business for four years at Huntington, California. His brothers Hideichi and Mitsuzo are at Gila River. Mrs. Yamane's mother, Mrs. Taki Fujii, is at Heart Mountain, and her brother Jim is in Denver, Colorado.—Photographer: Iwasaki, Hikaru—Wilmington, Delaware. 8/?/44

National Archives photo no. 210-G-I-315

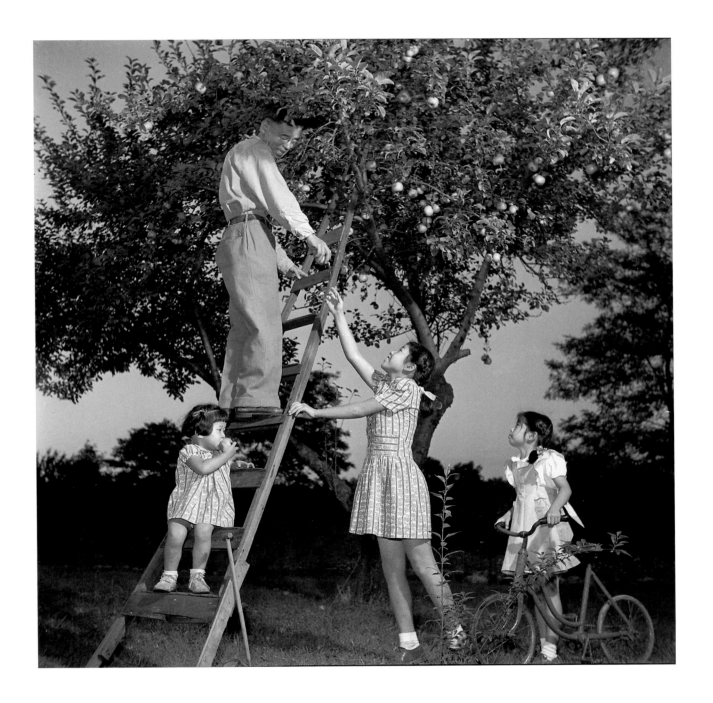

HARVEY SUZUKI AND CHICKENS

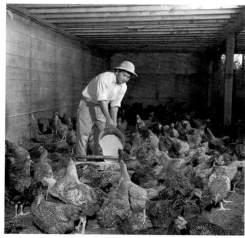

Harvey Suzuki is manager of the poultry farm of L. L. Logan in Kennett Square, Pennsylvania, about twenty-five miles from Philadelphia. With Mrs. Suzuki, the former Grace Takahashi of Berkeley, California, he relocated in December 1943 from the Colorado River Relocation Center to a poultry farm at Ocean View, Delaware. They went from there to the Kennett Square poultry farm in July 1944. Mrs. Suzuki is employed as an optometrist's assistant in nearby Wilmington, Delaware. Both Mr. and Mrs. Suzuki attended the University of California at Berkeley, where Mrs. Suzuki studied optometry and Mr. Suzuki majored in agricultural economics. After graduation Mr. Suzuki did farming and fruit packing in Brawley, California. He was a supervisor of truck crops at Colorado River. Mr. Suzuki is a brother of Rev. Lester Suzuki of the Des Moines Hostel. Mrs. Suzuki is a sister of Dr. William N. Takahashi, formerly on the faculty of the University of California at Berkeley, who is now studying plant pathology at the University of Rochester under a fellowship from the Guggenheim Memorial Foundation.—Photographer: Iwasaki, Hikaru— Kennett Square, Pennsylvania. 8/?/44

Photo 210-G-I-310, uncropped

National Archives photo no. 210-G-I-310

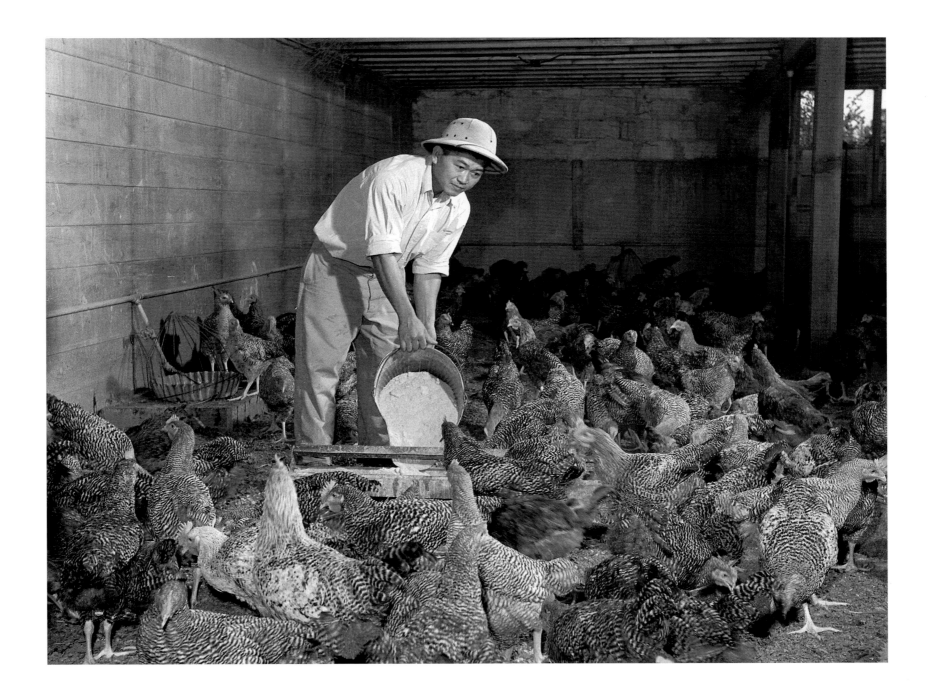

GEORGE YAMAMOTO WITH TOMATOES

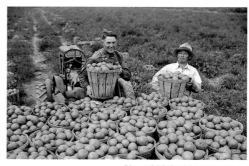

Photo 210-G-I-306, uncropped

George Yamamoto, Issei from the Gila River Relocation Center, is harvesting tomatoes on the farm of Herman S. Heston, Newtown, Bucks County, Pennsylvania. Mr. Yamamoto is the leader of the group of the five Issei who were obliged by neighbors' protests to leave another farm at Great Meadows, New Jersey, shortly after arriving there in April 1944 from Gila River. A few days later the men were employed by Mr. Heston through the WRA relocation office in Philadelphia. The other Issei are Kazumasa Kitagawa, Katsuji Taniguchi, Ted Miyamura, and Torazo Matsumoto. Mr. Yamamoto's son Ayao, nineteen, also worked on the farm for a month but returned to Gila River on being notified of his pending induction into the army. Also at the center are Mrs. Yamamoto and four other children, Kinzo, Tetsuo, Shinobu, and Yuri. Prior to evacuation the family lived in Brentwood, California, where Mr. Yamamoto, who had attended an agriculture college in Japan, was a field foreman on a 1,500-acre farm. At Gila River he was a farmhand until March 1944 when he went to work on a farm at Lewes, Delaware. Shortly thereafter Mr. Yamamoto went to work on the farm at Great Meadow, where the four other Issei soon joined him. Mr. Heston, their employer, speaks well of Mr. Yamamoto and his fellow workers. "I have found them loyal, hardworking, clean, and pleasant to work with," he said. "We like them a lot and have a high regard for them."—Photographer: Iwasaki, Hikaru—Newtown, Pennsylvania. 8/?/44

National Archives photo no. 210-G-I-306

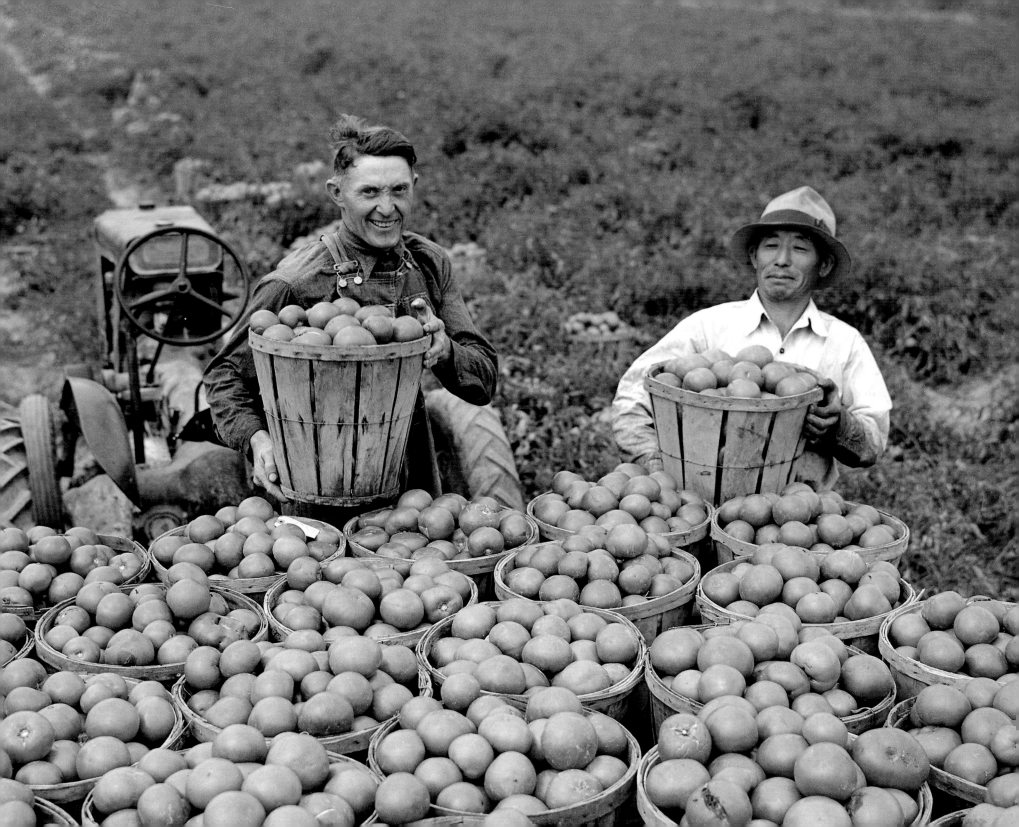

MR. AND MRS. ARTHUR SASAKI, WITH PIANO

Mr. and Mrs. Arthur Sasaki, formerly of the Minidoka Relocation Center, and their five-year-old daughter, Beatrice, came to Ridgewood, New Jersey, in July 1943. Mr. Sasaki is manager of the Ramapo Valley Cooperative Store in Ridgewood, a town of 18,000 people, about twelve miles from New York City. He is a member of the local Chamber of Commerce and singer in the choir of the local Methodist church. The Sasakis have an attractively furnished four-room apartment not far from his place of business. Mr. and Mrs. Sasaki are both natives of Seattle and graduates of the University of Washington. At Minidoka, Mr. Sasaki was supervisor of recreation.—Photographer: Iwasaki, Hikaru—Ridgewood, New Jersey. 8/?/44

National Archives photo no. 210-G-I-380

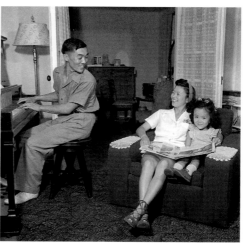

Photo 210-G-I-380, uncropped

YOSHIRU BEFU, WATERING PLANTS

Yoshiro Befu (Granada) from Santa Maria, California, gains experience in eastern horticulture, before continuing his college education, on the Greenough estate in Belmont, Massachusetts.—Photographer: Iwasaki, Hikaru—Belmont, Massachusetts. 8/?/44

National Archives photo no. 210-G-I-299

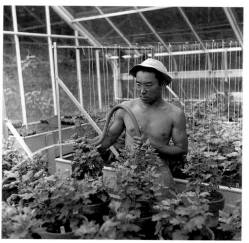

Photo 210-G-I-299, uncropped

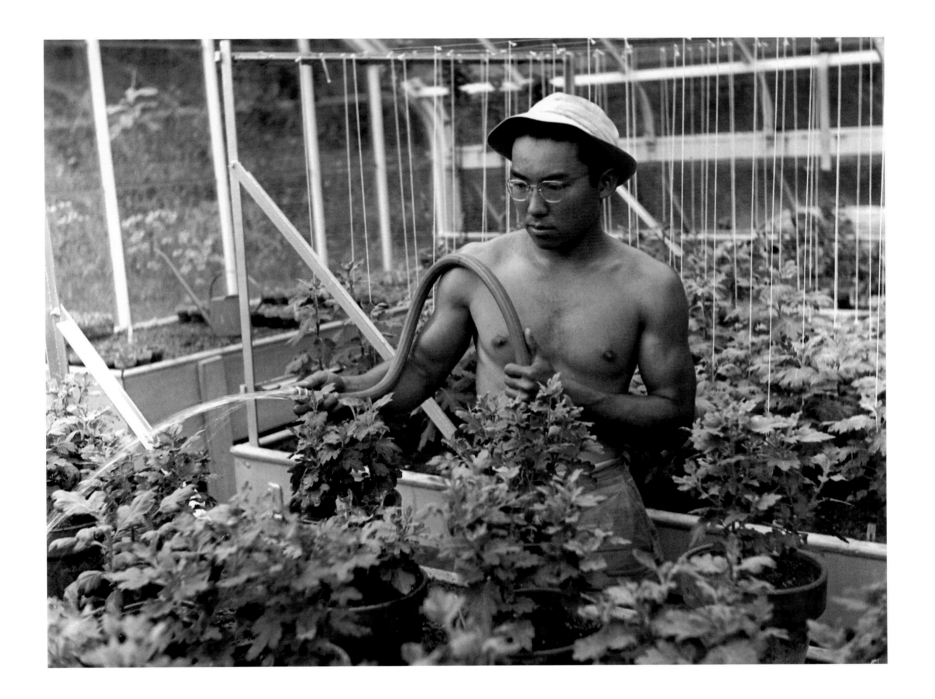

NISEI WOMAN, STUDYING TEXTBOOK

Yanako Watanabe, Gila River, formerly of Pasadena, California, is a
student at the University of Buffalo and is majoring in arts and science.—
Photographer: Iwasaki, Hikaru—Buffalo, New York. 9/?/44

National Archives photo no. 210-G-I-465

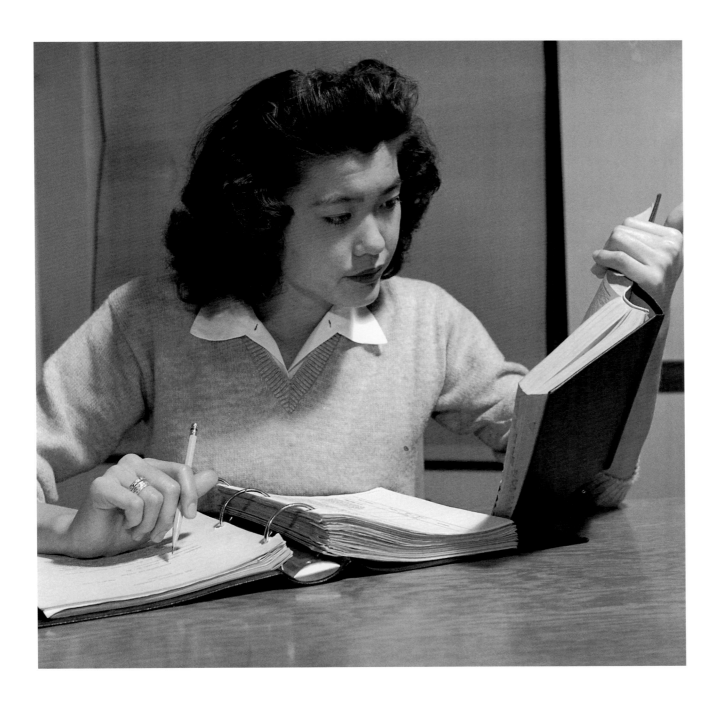

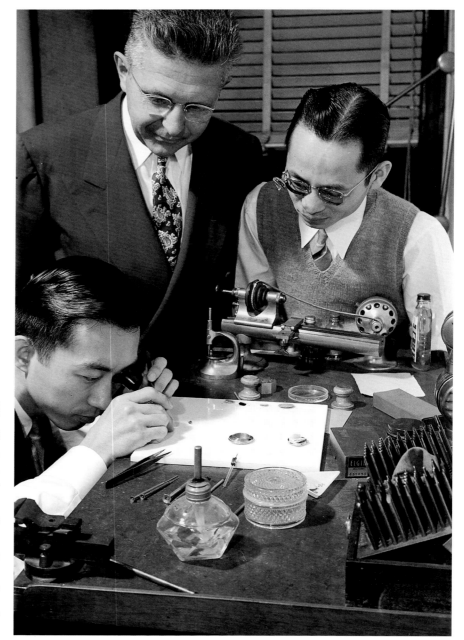

HAJIME YENARI, REPAIRING A WATCH

Watch repairing is the vocation of Mr. Hajime Yenari (left). He is shown giving the detailed touches to a watch while Mr. S. Q. Haines, employer, and Mikio Konishi, assistant watch repairman, look on. Mr. Yenari, age twenty-nine, Nisei, relocated from the Rohwer Center this year in June with his friend, Mr. Konishi, age thirty-two. Mr. Konishi hopes to be able to have his wife join him soon. The employer commends the two boys as being very fine workers. Mr. Yenari is from Los Angeles, California, and Mr. Konishi is from Pasadena, California.—Photographer: Iwasaki, Hikaru—Omaha, Nebraska. 9/?/44

National Archives photo no. 210-G-I-566

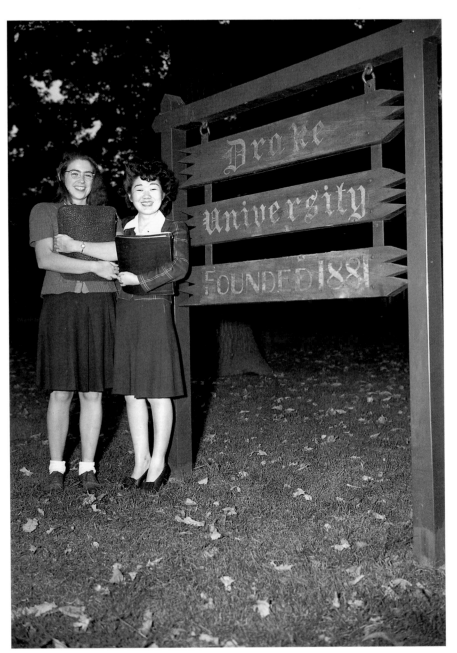

TWO YOUNG WOMEN BY DRAKE UNIVERSITY SIGN

This picture shows Eileen Lynch of 1121 Forty-fourth Street and Hanaye Ota of 3403 Cottage Grove Avenue as they pause for a chat before the Drake University entrance. Miss Ota relocated to Des Moines to attend Drake University from Gila River Relocation Center, Rivers, Arizona, and is majoring in education. Miss Ota has two married sisters, Mrs. Kazuye Yoshimura and Mrs. Sumiye Fukasawa, residing in Des Moines. Mrs. Fukasawa's husband is now serving overseas. There is also another sister, Miss Masaye Ota, who is attending Drake University.—Photographer: Iwasaki, Hikaru—Des Moines, Iowa. 9/?/44

National Archives photo no. 210-G-I-658

FOUR NISEI COEDS AT BUFFALO YWCA

This is a group picture of the Nisei residing at the Buffalo YWCA, Buffalo, New York. From left to right they are Rose A. Sakata, Stockton Assembly Center and Rohwer, formerly of Stockton, California, who is now a secretary in the Buffalo WRA Office on a temporary appointment; Riyo Sato, Santa Anita and Heart Mountain, who is a graduate of the College of Arts and Crafts, Oakland, California, and is now employed as an industrial artist by an airplane plant in Buffalo (she lived in Palo Alto, California, before evacuation); Grace Yoshizaki, Tule Lake and Heart Mountain, who is now secretary to the head of the YWCA in Buffalo; and Yanako Watanabe, Gila River and formerly of Pasadena, California, who is now a student at the University of Buffalo and is majoring in arts and science.— Photographer: Iwasaki, Hikaru—Buffalo, New York. 9/?/44

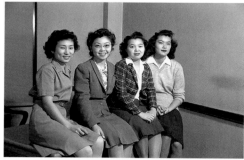

Photo 210-G-I-466, uncropped

National Archives photo no. 210-G-I-466

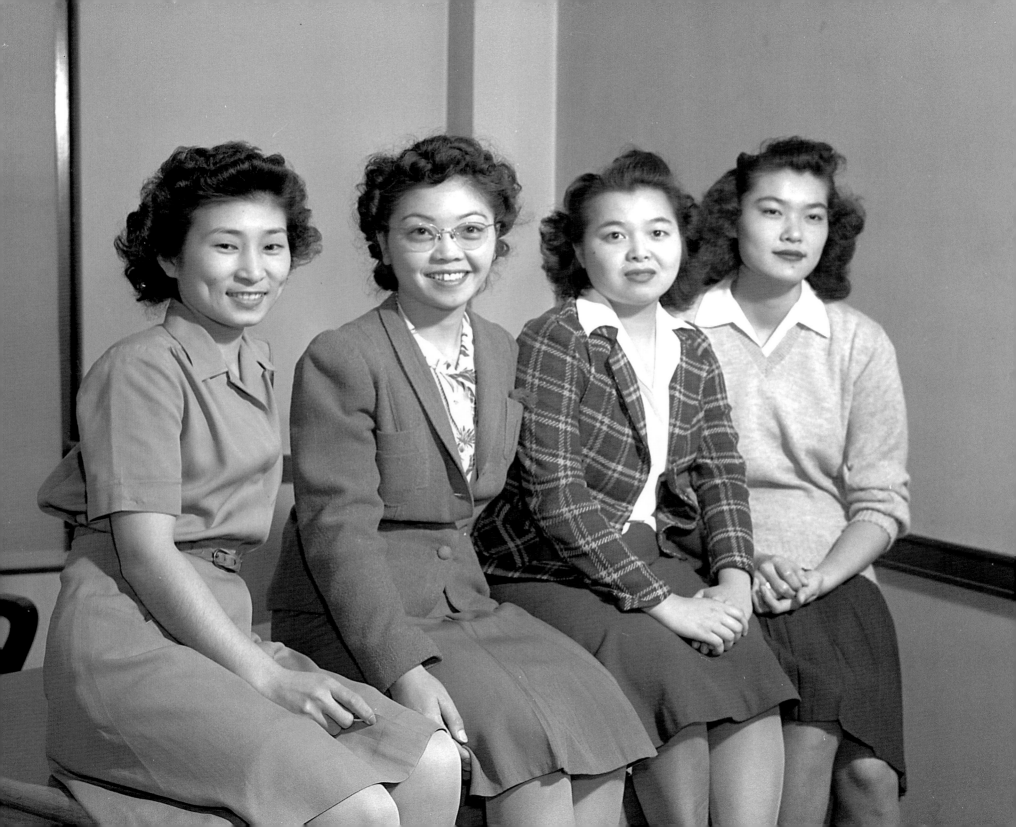

MISS TATSUKO SHINNO AND WOOD CARVING

Miss Tatsuko Shinno relocated to Des Moines from Jerome Relocation Center in January 1944. Miss Shinno has made quite a reputation for herself at wood carving and is shown at her home busily engaged in her work for the Christmas season. Miss Shinno was formerly a resident of Wilmington, California, and is now living in a nice bungalow at 1363 East Thirteenth Street, Des Moines.—Photographer: Iwasaki, Hikaru—Des Moines, Iowa. 9/?/44

National Archives photo no. 210-G-I-660

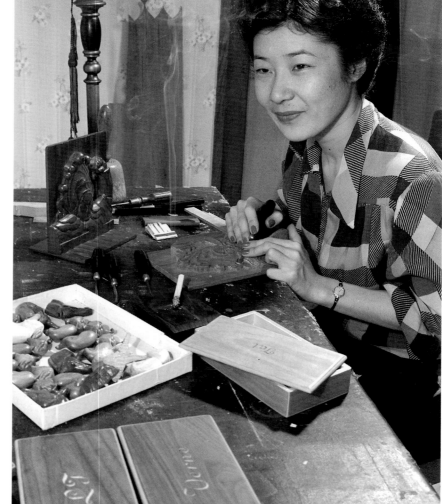

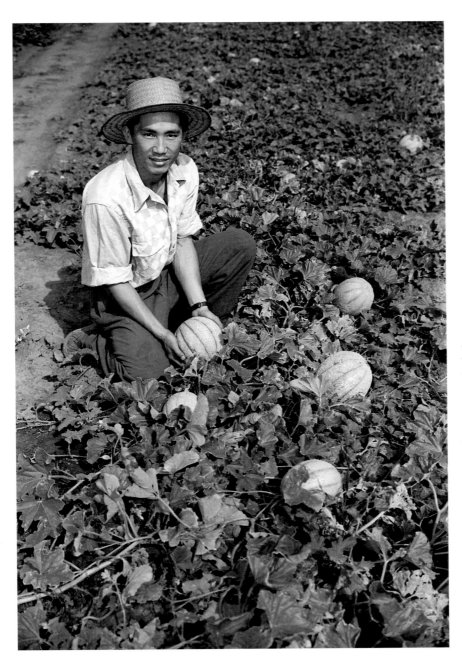

YOSHIMI SHIBATA, INSPECTING CANTALOUPES

Yoshimi Shibata inspects cantaloupes, one of the many truck crops raised under his direction by the Midwestern Farm Company, owned by three resettlers, which raised 100 acres of truck crops on three pieces of farmland near Bartlett, Lombard, and Melrose Park, Illinois. The land was leased from the three farm owners on a share-rental basis. Crops included tomatoes, melons, carrots, onions, beans, and pickles. The pickles were the most successful crop and onions proved the least financially successful. On the whole, Mr. Shibata and the twelve regular men who worked with him throughout the season were pleased with the venture. Sometimes as many as twenty extra workers were hired to assist at the peak of the harvest. Mr. Shibata was a greenhouse man and a farmer at Mt. Eden, California, prior to evacuation and came to Chicago from the Tule Lake Relocation Center.—Photographer: Iwasaki, Hikaru—Melrose Park, Illinois. 9/?/44

National Archives photo no. 210-G-I-634

BILL HOSOKAWA AND CHILD

Mr. Bill Hosokawa is on the lawn before the house that he purchased last August. With him is his baby, Susan. Mrs. Tora Miyake, mother of Mrs. Hosokawa, lives with them as does their young son, Michael, age four, who was not present for this picture. Mr. Hosokawa is well-known throughout the country for his editorial writings and is employed on the editorial copy desk of *Des Moines Register and Tribune*. He is also the founder of the *Heart Mountain Sentinel* of the Heart Mountain Relocation Center in Wyoming and prior to the outbreak of the war was headed for a brilliant career in the Far East.—Photographer: Iwasaki, Hikaru—Des Moines, Iowa. 9/?/44

National Archives photo no. 210-G-I-638

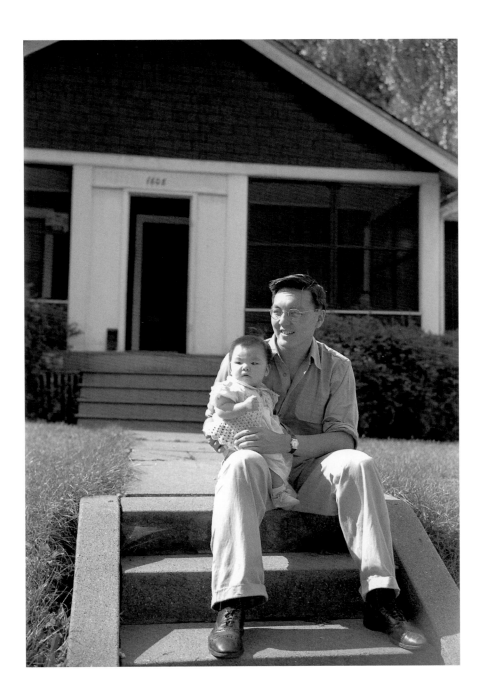

GRACE SUMIDA AND SHIRO MURAOKA, WITH ORANGE JUICE

Miss Grace Sumida and Mr. Shiro Muraoka are shown at their work. Mr. Muraoka, a young Issei, is filling bottles with an orange juice preparation and Miss Sumida, who works in the office, is checking it. This has been an interesting development from the first since a large percentage of Negroes are employed as well as Caucasians and Nisei. Relations are very friendly. Both are well liked and well paid. Miss Sumida, formerly of Rohwer and Los Angeles, lives at the hostel where her mother acts as assistant to the director. Mr. Muraoka, also of Rohwer, came to Cincinnati with his family to join other members of his family who were relocated here.—Photographer: Iwasaki, Hikaru—Cincinnati, Ohio. 9/13/44

National Archives photo no. 210-G-I-431

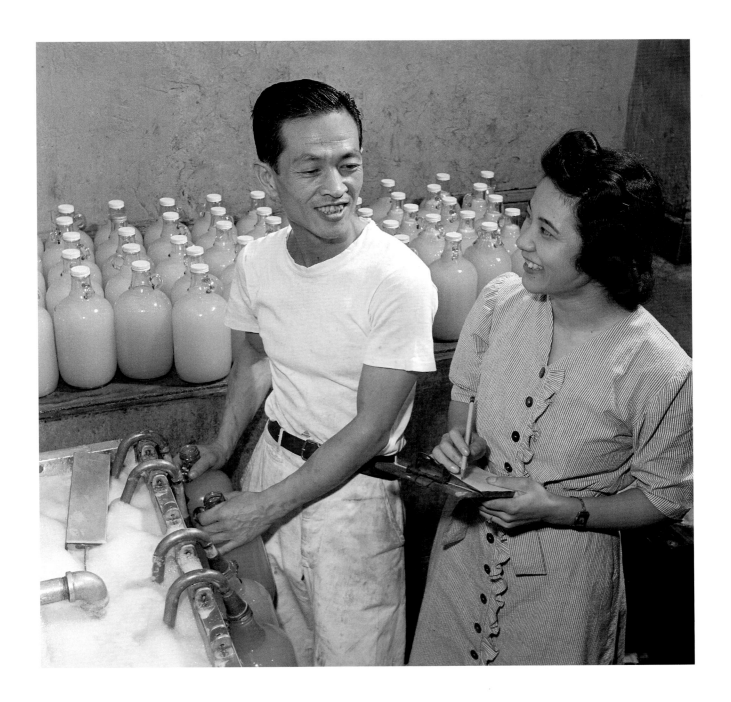

KENJI MURAOKA, AT WORK IN DENTAL LABORATORIES

Mr. Kenji Muraoka, formerly of Los Angeles, California, and more recently of the Rohwer Relocation Center, is shown at work in his laboratory with Mrs. F. Brown. Caucasian relationships are very good in this office. Mr. Muraoka has been in Cincinnati for over a year and is well established in professional and community circles. He is the chairman of the Issei group that meets at the hostel the first Thursday night of every month. He has instructed several Nisei boys in dental technician work, most of whom are now employed on their own in other laboratories of the city.— Photographer: Iwasaki, Hikaru—Cincinnati, Ohio. 9/13/44

National Archives photo no. 210-G-I-433

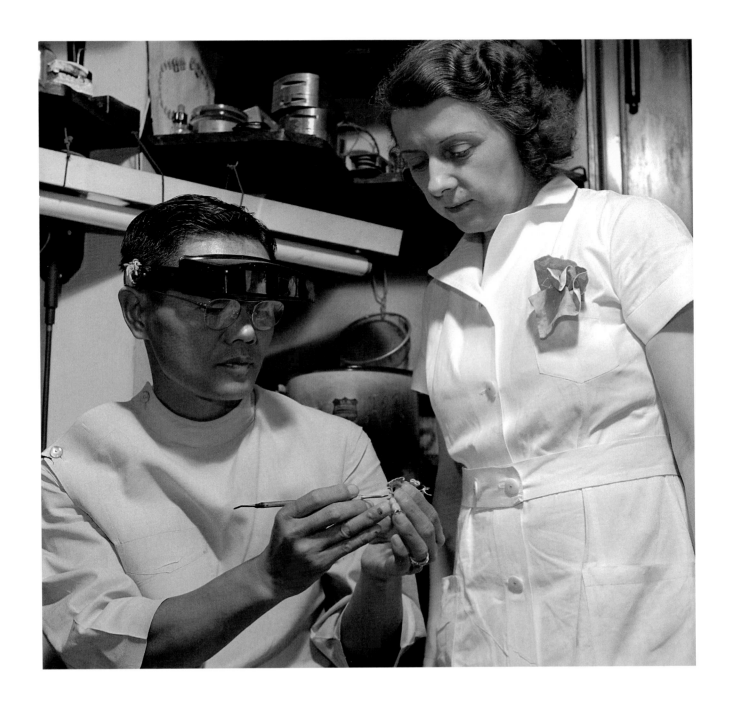

ICHI KAWAJIRI AND OTHERS, WASHING CARROTS

Ichi Kawajiri (left) and Takeo Yoshino (right), Issei resettlers from Rohwer, are shown with Wilfred Johnson, a Jamaican, filling sacks with carrots that are moving toward them from a washing machine in the Vegetable Packing House on Chicago's west side. Many Issei and Nisei as well as a number of Caucasians and Jamaicans are employed in this large packing plant, which operates on a year-round basis.—Photographer: Iwasaki, Hikaru—Chicago, Illinois. 9/16/44

National Archives photo no. 210-G-I-618

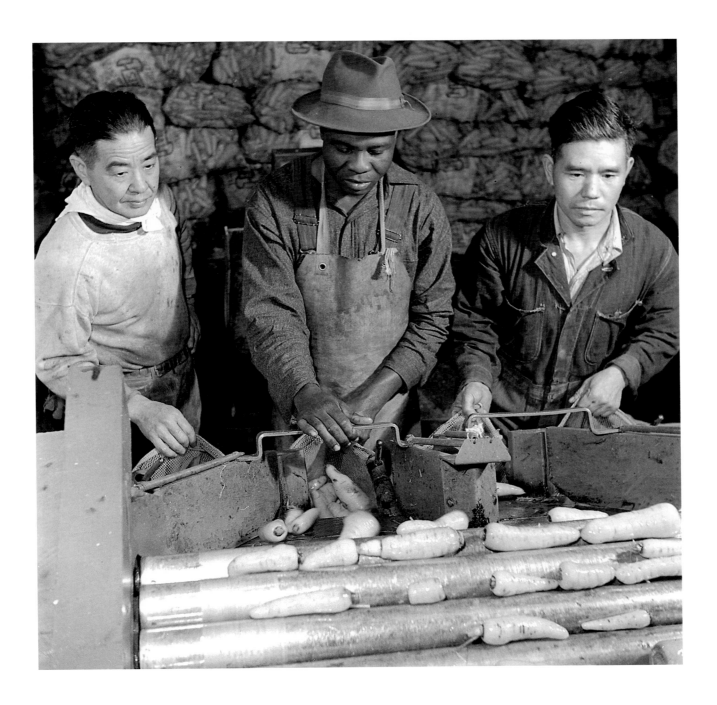

GEORGE SHOJI AND OTHERS, THROWING CABBAGE

George Shoji is shown on the tractor and Joseph Sakamoto and George Ike are throwing cabbage onto the truck. The three families, related by marriage, came to this farm near Elkhorn, Wisconsin, from Rohwer Relocation Center. They operate the farm on shares and live in two houses on the farm. They have 120 acres of land, of which 50 acres are in cabbage, 10 in potatoes, 15 in corn, and 10 each of onions and carrots. Crops were good this year except for the onions and carrots, which did not do well. The Shoji, Ike, and Sakamoto families came to Wisconsin from Rohwer Relocation Center. Prior to evacuation, Shoji was a vineyard and cotton farmer near Fresno, California. Joseph Sakamoto had been farming for many years near San Martin, California, and George Ike was in the cleaning business in Isleton, California.—Photographer: Iwasaki, Hikaru—Elkhorn, Wisconsin. 9/17/44

National Archives photo no. 210-G-I-494

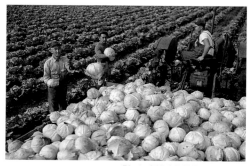

Photo 210-G-I-494, uncropped

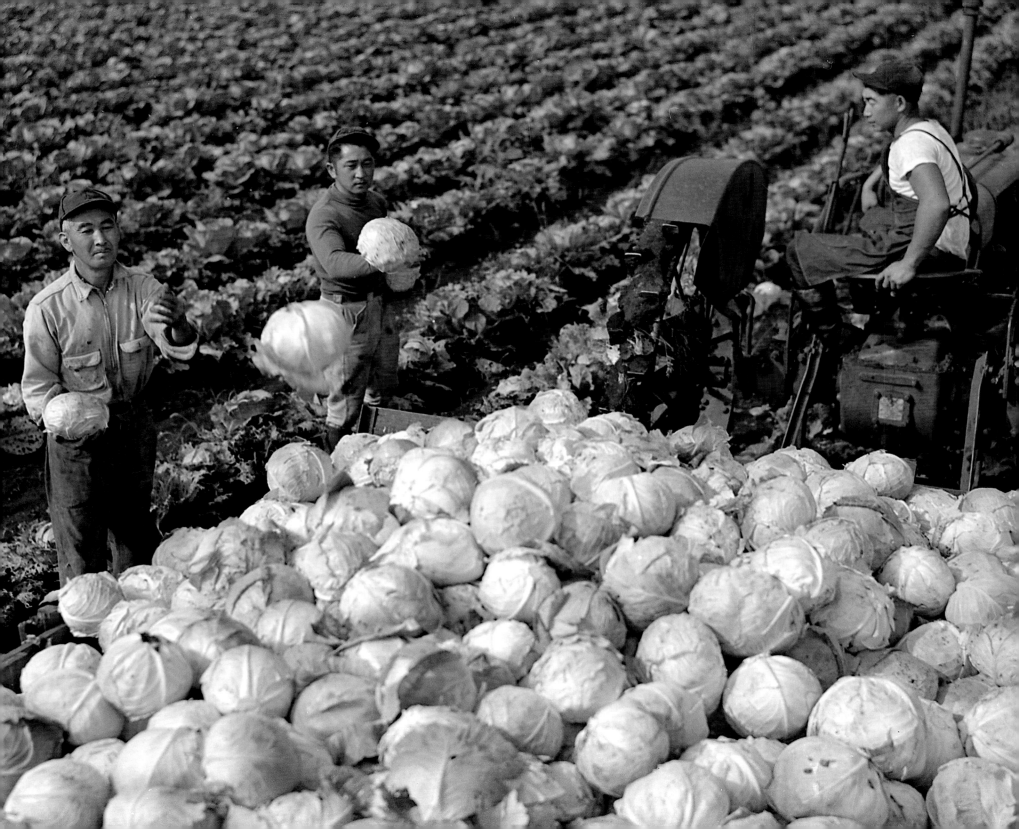

TWO NISEI STUDENTS IN FRONT OF LINCOLN STATUE

Keith Nakamura, honorably discharged army veteran, and Toru Iura are shown in front of the statue of Abraham Lincoln at the entrance to Bascom Hall, the administrative building at the University of Wisconsin in Madison. Nakamura was in the army at the time of evacuation, having been inducted from Blackburn College at Carlinville, Illinois. He was born in Hawaii. His sister, Mrs. Harry Funatsu, is a resident in Heart Mountain. He has had various jobs in Chicago and in Madison since his discharge from the army late in 1942. He enters the University of Wisconsin as a sophomore in commerce. Toru Iura started at the University of Wisconsin in November 1943. He left Los Angeles during the voluntary evacuation period. He is starting his junior year at the university and is taking mechanical engineering courses.—Photographer: Iwasaki, Hikaru—Madison, Wisconsin. 9/17/44

National Archives photo no. 210-G-I-516

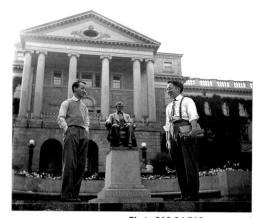

Photo 210-G-I-516, uncropped

94

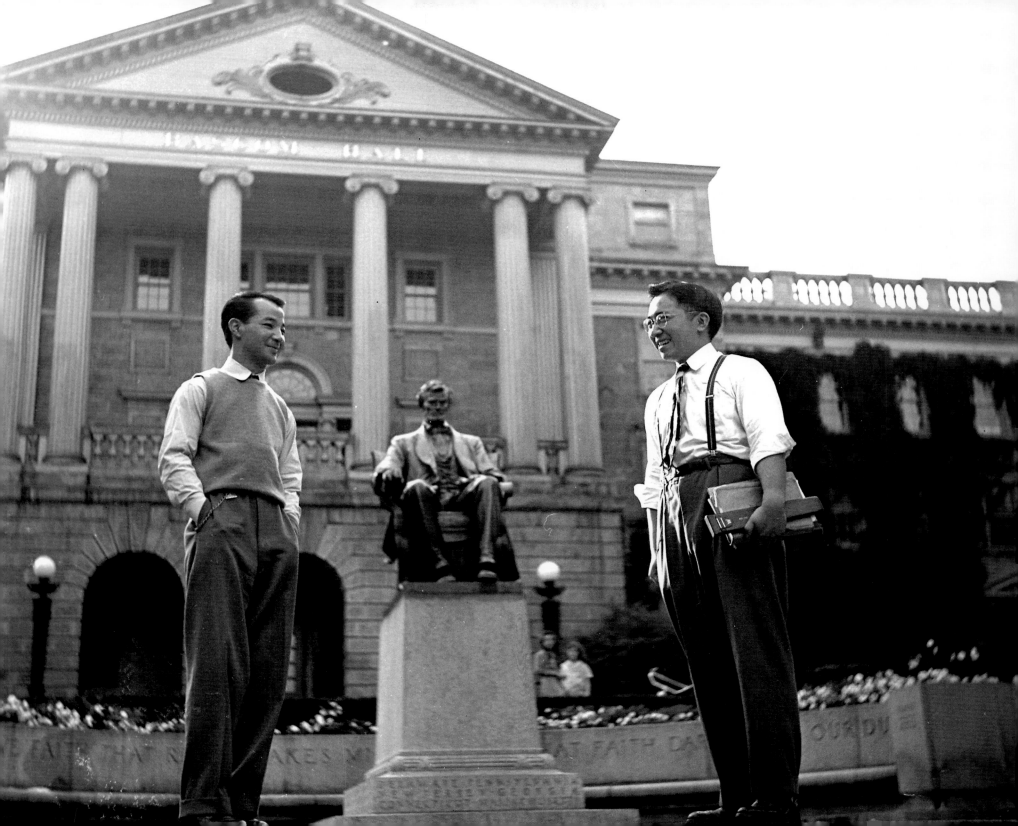

MRS. JOHN M. SAKAI WITH HUSBAND'S MEDAL

Mrs. John M. Sakai admires her husband's picture and looks at the Purple Heart medal that he sent to her from Italy. "I love my husband and am very proud that he is an American fighting for America," said Mrs. Sakai. "I also know my mother-in-law in the Gila River Relocation Center is just as proud." She is a typical American wife who is patiently waiting for her husband's return. Mrs. Sakai is from the Gila River Relocation Center.— Photographer: Iwasaki, Hikaru—St. Louis, Missouri. 9/20/44

National Archives photo no. 210-G-I-524

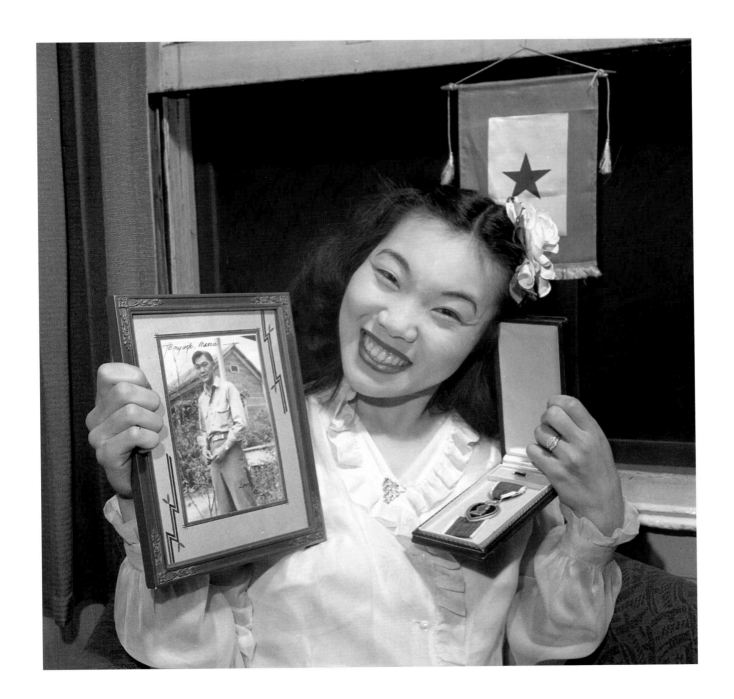

YEIKI TASHIRO, HOLDING BUST

Here Yeiki Tashiro of Poston, Arizona, asks Miss Wilma Smith, hand painter, to color the lips of the model she had painted a little deeper.— Photographer: Iwasaki, Hikaru—St. Louis, Missouri. 9/21/44

National Archives photo no. 210-G-I-535

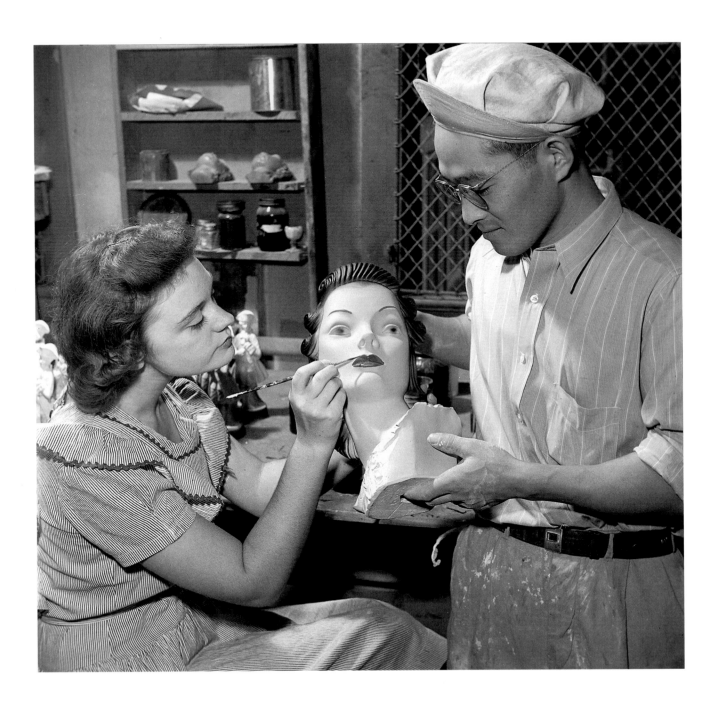

NISEI WOMAN SODA JERK

Virginia Matsumoto, an evacuee from the Gila River Relocation Center, is shown at work at Gumbo Inn, where she and her father, Itsuji Matsumoto, a World War I veteran, are employed. In her position as waitress, Virginia has met and made friends with many people.— Photographer: Iwasaki, Hikaru—Chesterfield, Missouri. 9/21/44

National Archives photo no. 210-G-I-545

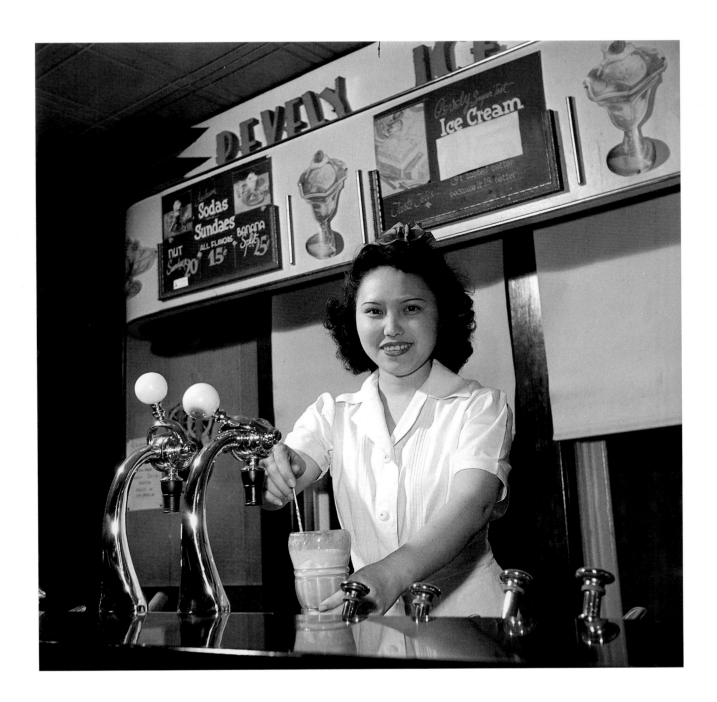

PROFESSOR OBATA AND FAMILY

Here are Professor Obata and his family in the living room of their home in Webster Groves. At the left is Lily, a senior in high school, who is soon planning on entering the university. Seated on the floor is Gyo, a student of Washington University in the Architectural Society. Mrs. Obata and Professor Obata complete the family group. The Obatas are from the Central Utah Relocation Center.—Photographer: Iwasaki, Hikaru— Webster Groves, Missouri. 9/21/44

National Archives photo no. 210-G-I-529

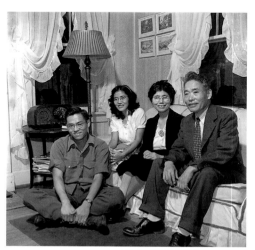

Photo 210-G-I-529, uncropped

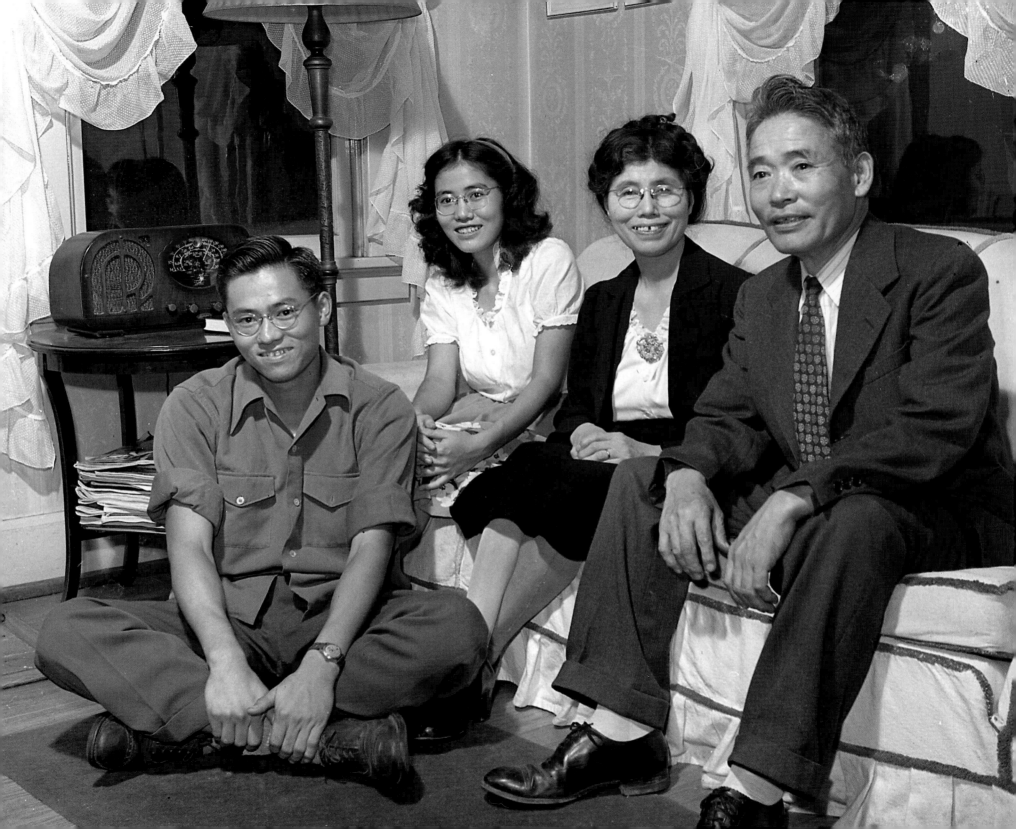

MRS. KIM OBATA AND GIRL SCOUT POSTER

Mrs. Kim Obata, daughter-in-law of Professor C. Obata, is employed with the Girl Scouts as registrar. She is shown at work with Miss Helen Lee Epstein (*left*) and Miss Eunice Priem (*right*), executive secretary. Mrs. Obata is liked by her co-workers and is regarded as a very efficient registrar.—Photographer: Iwasaki, Hikaru—St. Louis, Missouri. 9/21/44

National Archives photo no. 210-G-I-520

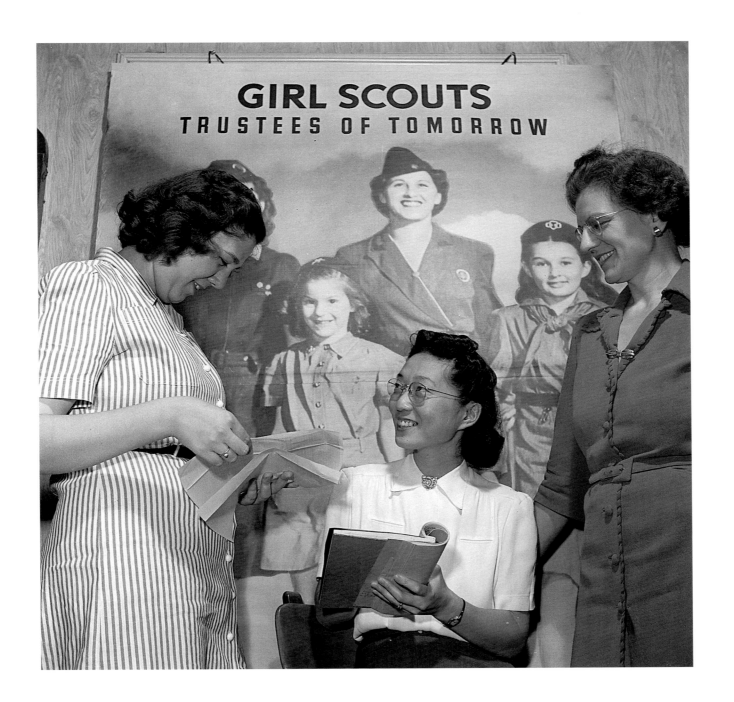

GEORGE HIRAMOTO AND CHAINS

George Hiramoto is shown looking over the chain with Miss Nelly Lynch, also an end welder at the Nixdorf Krein Manufacturing Company. Nelly commented that not only is George very capable, but he gets along well with his co-workers. George is from the Colorado Relocation Center.— Photographer: Iwasaki, Hikaru—St. Louis, Missouri. 9/21/44

National Archives photo no. 210-G-I-526

Photo 210-G-I-526, uncropped

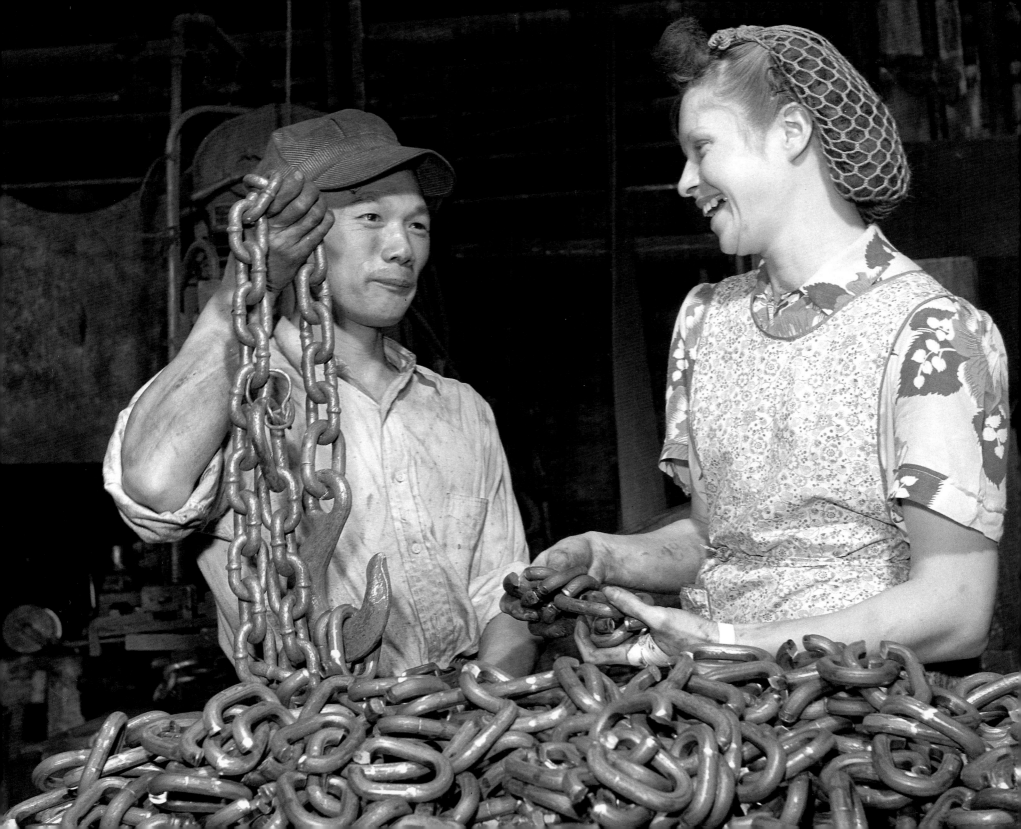

SHIZUTA NAMBA, WASHING DISHES

Stripped to the waist is Mr. Shizuta Namba, former resident at the Rohwer, Arkansas, Relocation Center, now employed as a dishwasher at the Elms Hotel in Excelsior Springs, Missouri. Mr. Namba first relocated to Ottawa, Kansas, on seasonal leave to secure employment as a trackhand with the Santa Fe railroad. When track work came to an end, Mr. Namba, rather than return to the center, decided to convert his leave to indefinite leave. Through the assistance of the WRA office in Kansas City, he was placed at the above hotel, where he has been employed since March 1944. He claims Fresno, California, as his home.—Photographer: Iwasaki, Hikaru—Excelsior Springs, Missouri. 9/22/44

National Archives photo no. 210-G-I-478

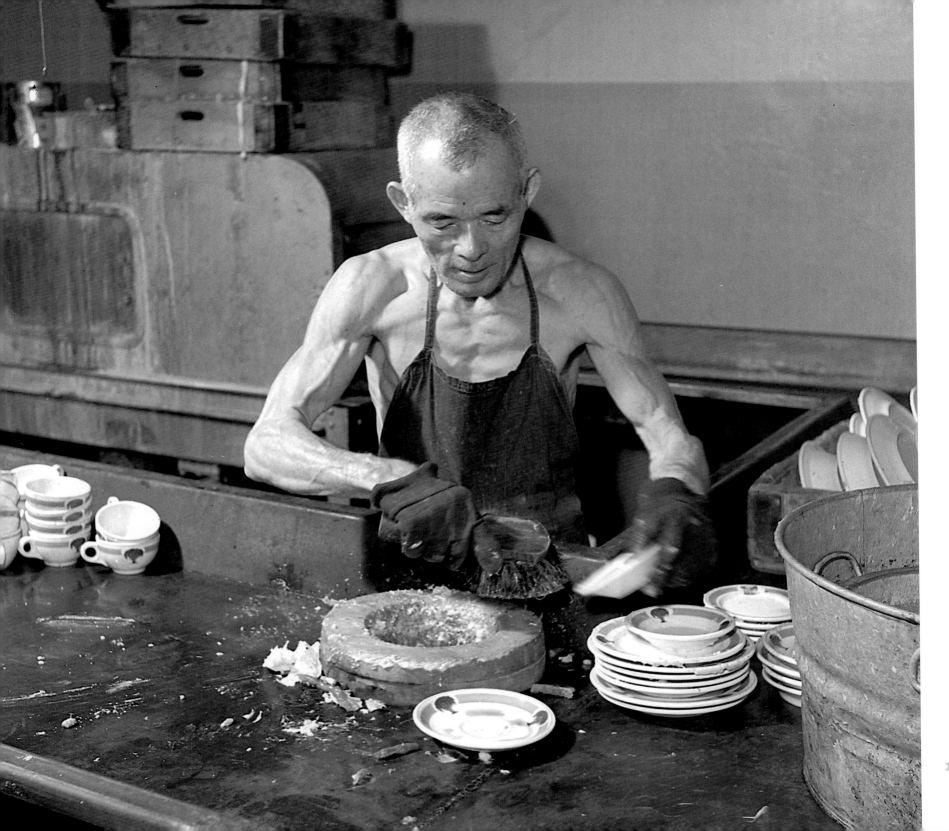

SEVEN NISEI WAITERS

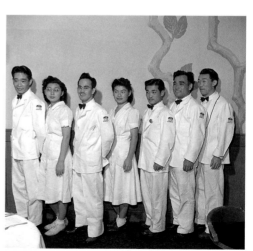

Photo 210-G-I-477, uncropped

Seven Nisei waiters employed at the Elms Hotel resort center, about thirty miles north of Kansas City, are standing as follows from left to right: Henry Mayeda, from the Granada Center; Mrs. Henry (Dorothy) Mayeda; Tom Ogata, from Topaz; Miss Yo Muranaga, from Rohwer; Mas Takanishi, from Poston; Frank Kamada, from Granada; and Jimmy Sakata, from Rohwer. The Mayedas are formerly of San Jose, California; Tom Ogata is a chick sexer, employed near Birmingham, Alabama, during the chick-sexing season. Miss Muranaga hails from Montebello, California. Frank Kamada is formerly of Los Angeles. His wife and year-old daughter, Patricia, are also with him. Missing from the picture are several other Nisei employed as waiters.—Photographer: Iwasaki, Hikaru—Excelsior Springs, Missouri. 9/22/44

National Archives photo no. 210-G-I-477

FOUR BELLHOPS

The Poston, Arizona, Center is the former residence of the four bellhops shown in this picture. They are employed at the exclusive resort hotel, the Elms, located just north of Kansas City, Missouri. Left to right, they are Ben Matsunaga; his brother, Tom; Bob Nishimura; and Frank Sugiura. Frank, although an Issei, is bell captain. Other members of the Sugiura family employed at the hotel include Frank's father and his brother, Fred, also a bellhop. All of the boys pictured are from southern California.—Photographer: Iwasaki, Hikaru—Excelsior Springs, Missouri. 9/22/44

National Archives photo no. 210-G-I-481

Photo 210-G-I-481, uncropped

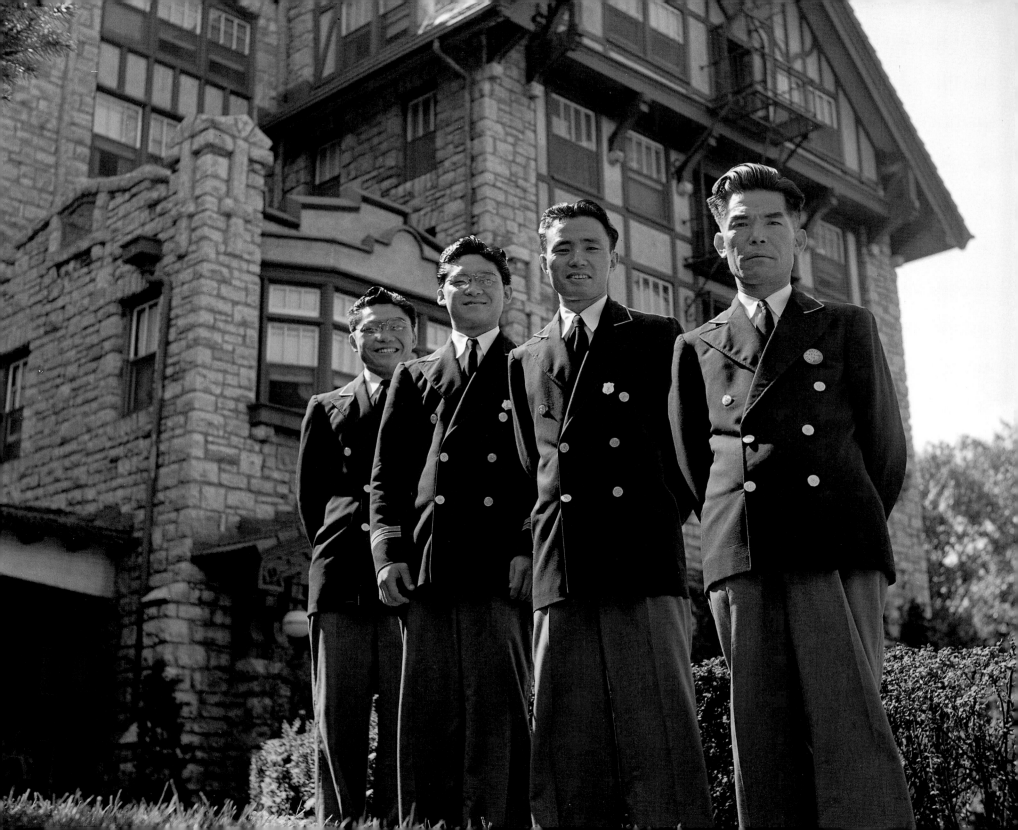

HENRY MAYEDA, WAITER

Shown waiting on a patron is Henry Mayeda, formerly of San Jose, California. His wife, Dorothy, is likewise employed as waitress. They are from the Rohwer Center. There are two other couples and over twenty single Issei and Nisei employed at the Elms Hotel in Excelsior Springs, Missouri. Henry and his wife have seen much of the country, having relocated at their earliest opportunity in 1942. Henry was at one time employed at Fort Robinson, Nebraska, with the post engineers.— Photographer: Iwasaki, Hikaru—Excelsior Springs, Missouri. 9/22/44

National Archives photo no. 210-G-I-476

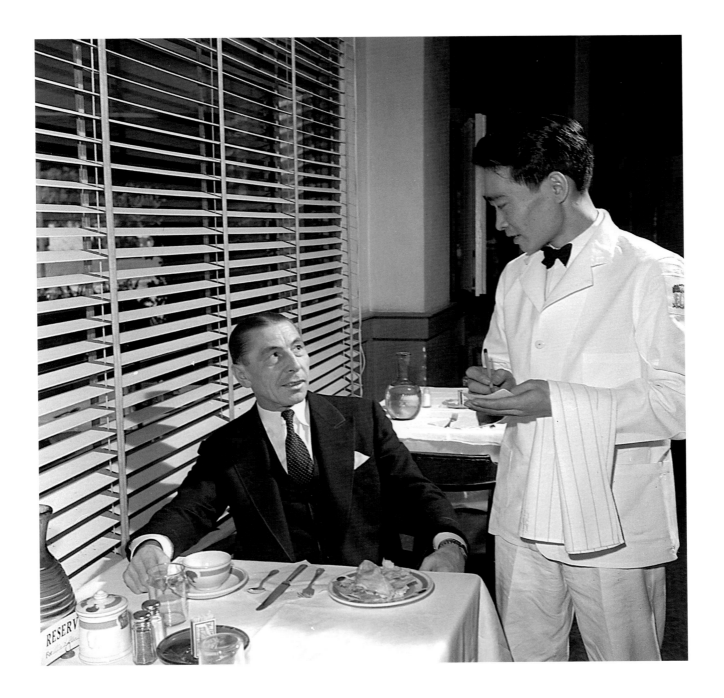

MASAMI HATA, TRIMMING BUSHES

Masami Hata, an Issei, age forty-four, was for many years a gardener in San Mateo, California. At the time of evacuation he was sent to Topaz, Utah. In September 1944 he came to Louisiana in search of employment and new opportunities. He settled immediately in Baton Rouge where he is taking care of several gardens. He has found people kind and considerate and likes the community. He says the soil is rich and you can grow anything. He does not plan to return to California. In this picture Mr. Hata is at work in one of the gardens near the campus of Louisiana State University. Cold weather never interferes with outdoor work here.—Photographer: Iwasaki, Hikaru—Baton Rouge, Louisiana. 1/9/45

National Archives photo no. 210-G-I-726

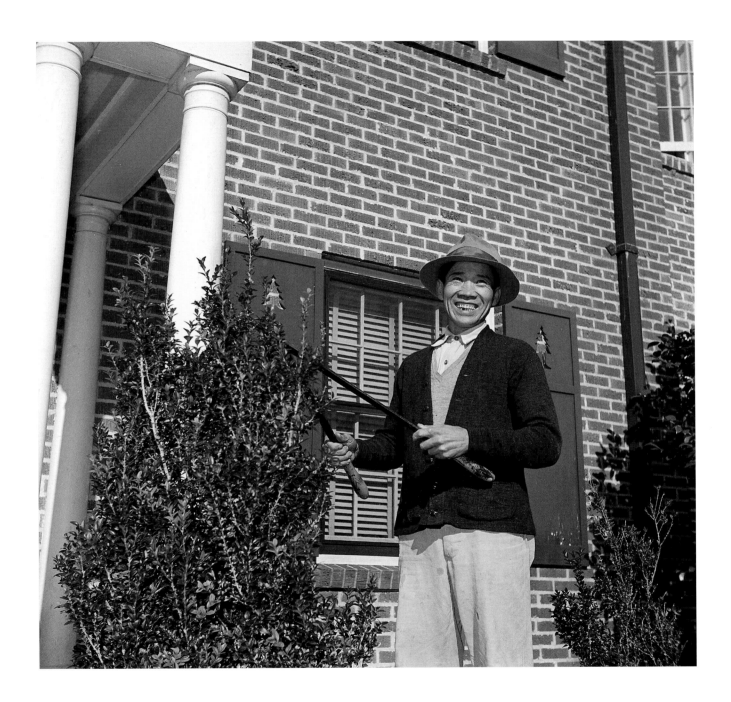

MRS. GLADYS MITA, PLAYING PIANO FOR CHILDREN

While Cpl. Roy Mita is in England with the army, his wife, Gladys, is making her contribution to community welfare, working with the children at St. Marks Community Center, 1030 North Rampart Street, New Orleans. This community center is maintained by the Methodist Church and serves the neighborhood. This picture shows Mrs. Mita with a group of children at the piano.—Photographer: Iwasaki, Hikaru—New Orleans, Louisiana. 1/12/45

National Archives photo no. 210-G-I-711

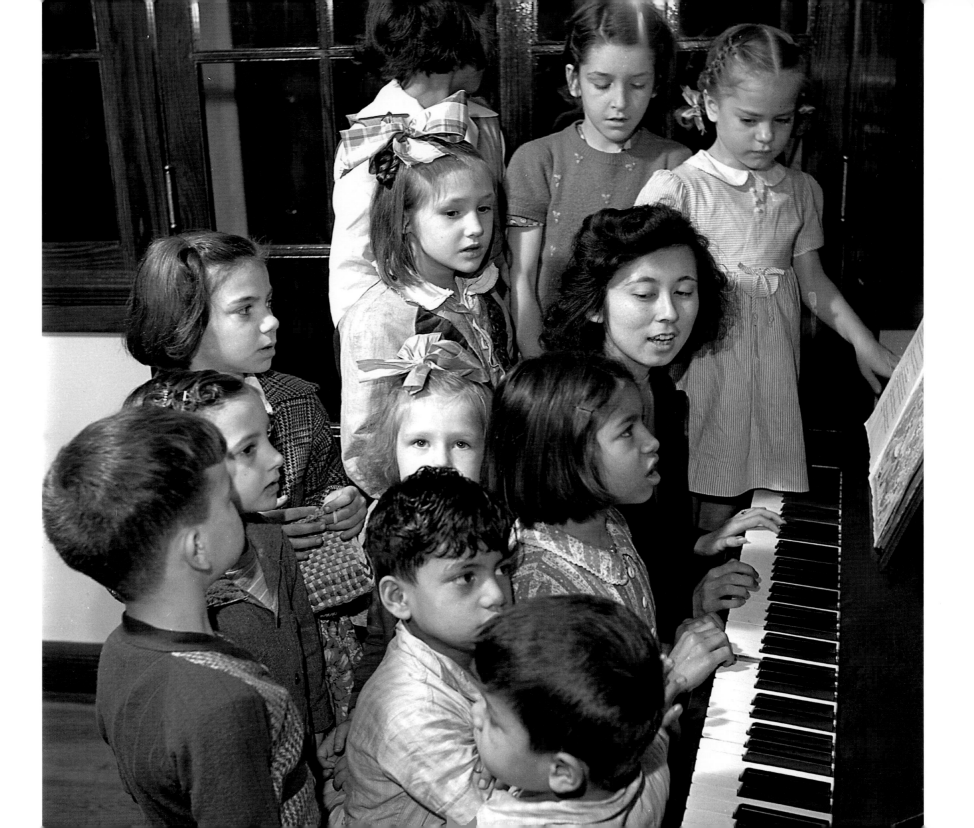

TED IWAI, WITH CHICKS AT HATCHERY

Ted Iwai is a Kibei [author's note: a second generation Japanese American, born in the United States but educated in Japan] who has been employed for the past three years by the Louisiana Hatchery, the largest of its kind in the state, as a chick sexer. Ted came to Louisiana from Los Angeles, California, and likes this part of the country. This picture shows him at work in the hatchery.—Photographer: Iwasaki, Hikaru—New Orleans, Louisiana. 1/12/45

National Archives photo no. 210-G-I-715

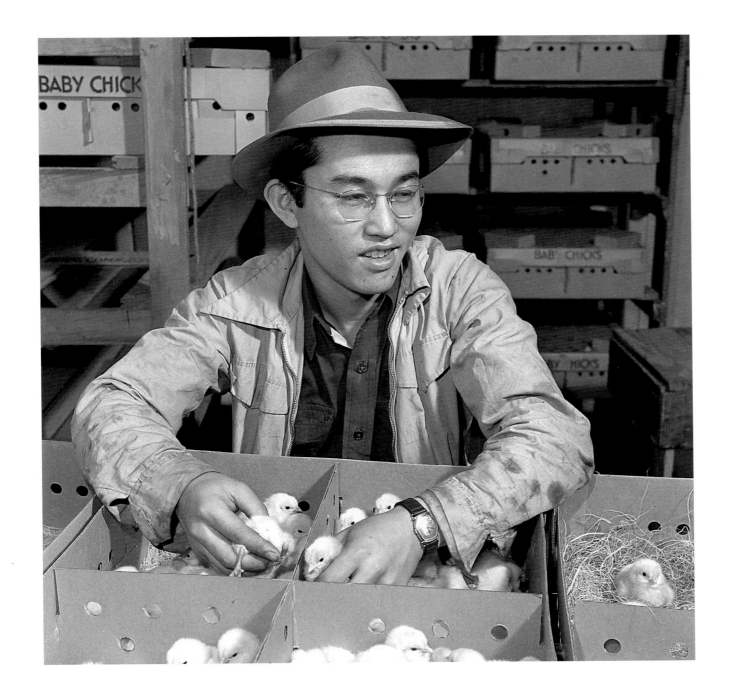

121

NISEI GIRL STUDIES HER BOOK WITH THREE FRIENDS

More than forty Nisei girls have used the National Training School for Christian girls in Kansas City, Missouri, for temporary housing. The school for church workers has accommodations for 100 students, but only 40 students are enrolled at the present time, among whom are three Nisei girls. They are Yuri Shimokoshi (front), formerly of Los Angeles and Heart Mountain; Miriko Nagahama (left), formerly of Hollywood, California, and the Heart Mountain Center; and Fumi Kobayashi (right), of Los Angeles, California, and the Colorado River Center, who is secretary to the president of the National Training School. Miss Shimokoshi's parents have resettled in Cleveland; Miss Nagahama hopes her parents will come to Kansas City; Miss Nagamori's [Kobayashi's] family has returned to Los Angeles. As part of their four-year training, the girls visit small towns nearby to assist with church services. Following their examinations, the girls will be eligible for the rank of deacon.—Photographer: Iwasaki, Hikaru—Kansas City, Missouri. 3/2/45

National Archives photo no. 210-G-I-776

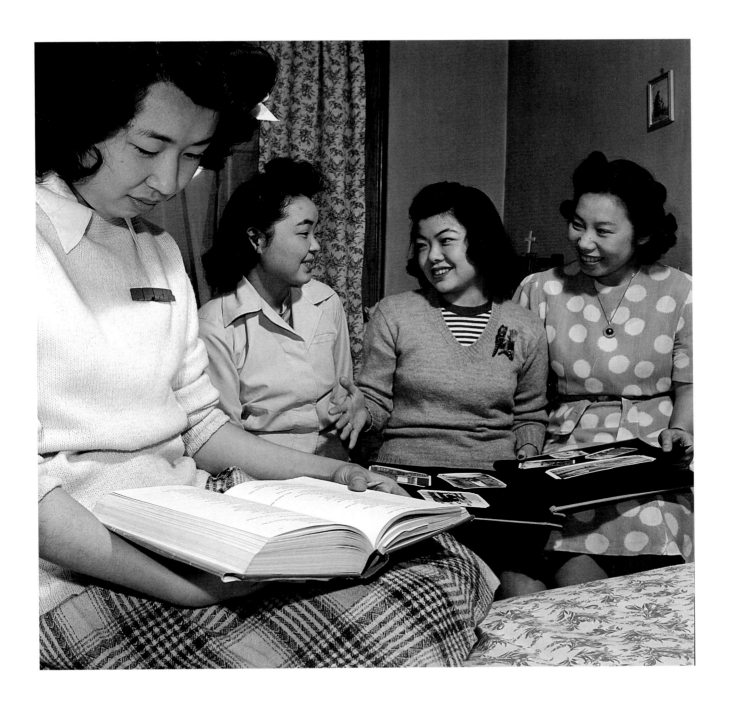

NISEI WOMEN ON BED

Photo 210-G-I-798, uncropped

Alice Yamaoka, formerly of Poston; Marci Sakai, formerly of Gila River; and Florence Abe, formerly of Tule Lake, in Alice and Florence's apartment in St. Louis, Missouri. Alice and Florence are secretaries who, tired of living in single rooms, wanted an apartment where they could use all their domestic talents. They managed to secure a cozy two-room apartment, completely furnished, including heat and utilities. The rent is $8.50 per week. Apartments like this one can be rented in St. Louis, particularly if a person uses the energy to make the place more homelike and cheery by doing some painting and renovating. Mrs. John Sakai, who lives downstairs in the same building, helped the girls decorate their apartment. Alice says, "Our home is exactly the way we want it—peach walls in the living room and green in the kitchen. Our pictures and plants are also arranged to suit our tastes. Some people speak of returning to the West Coast as going home, but I feel that I am already home." Alice and Florence invite you to see their home at 3950 McPherson Street, St. Louis, Missouri.—Photographer: Iwasaki, Hikaru—St. Louis, Missouri. 3/5/45

National Archives photo no. 210-G-I-798

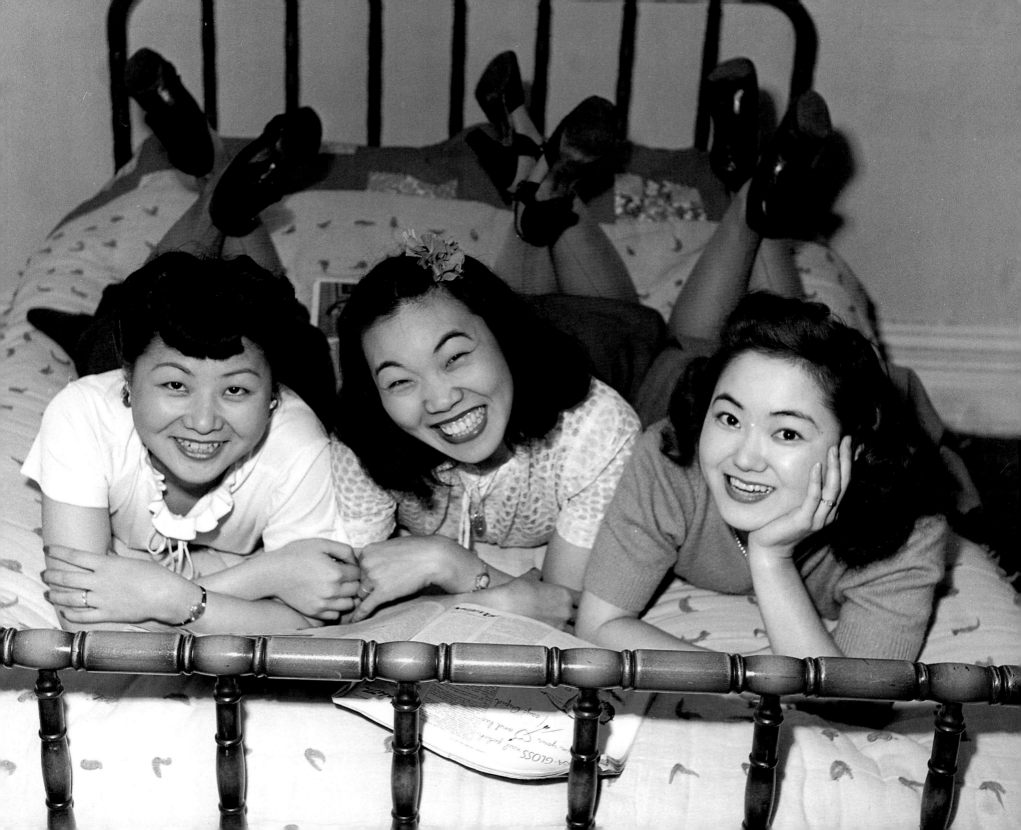

MR. AND MRS. SASAKI, IN THEIR APARTMENT

Mr. and Mrs. Sakuichi Sasaki, formerly of Marysville, California, and Granada, came to Rockford in March 1944. The Sasakis, who are employed as domestics, insisted on taking the photographer to their room, which was very large and furnished with modern maple furniture that also included several easy chairs and a davenport. Mrs. Sasaki said, "Our employers treat us as if we were members of their family. The work is not difficult and we have time to visit often with our Issei friends."— Photographer: Iwasaki, Hikaru—Rockford, Illinois. 3/13/45

National Archives photo no. 210-G-I-819

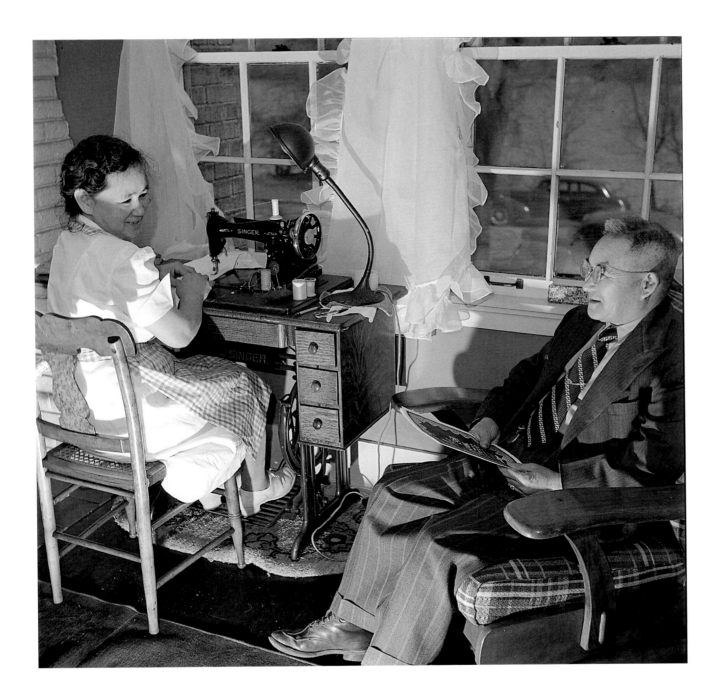

PAUL NAKAMOTO, AT MACHINE

Paul N. Nakamoto, a maintenance man at the St. Joseph Home, Peoria, Illinois, originally lived in Los Angeles. He came to Peoria in December from the Manzanar Relocation Center. "I am pleased to be living in such a friendly place. The Midwest is certainly different from what I expected. If the Issei that are still in the centers could only see and know how good the Issei that are relocated are getting along, I am sure they would leave the camps soon," Mr. Nakamoto said.—Photographer: Iwasaki, Hikaru—Peoria, Illinois. 3/14/45

National Archives photo no. 210-G-I-826

WRA PHOTOGRAPHS

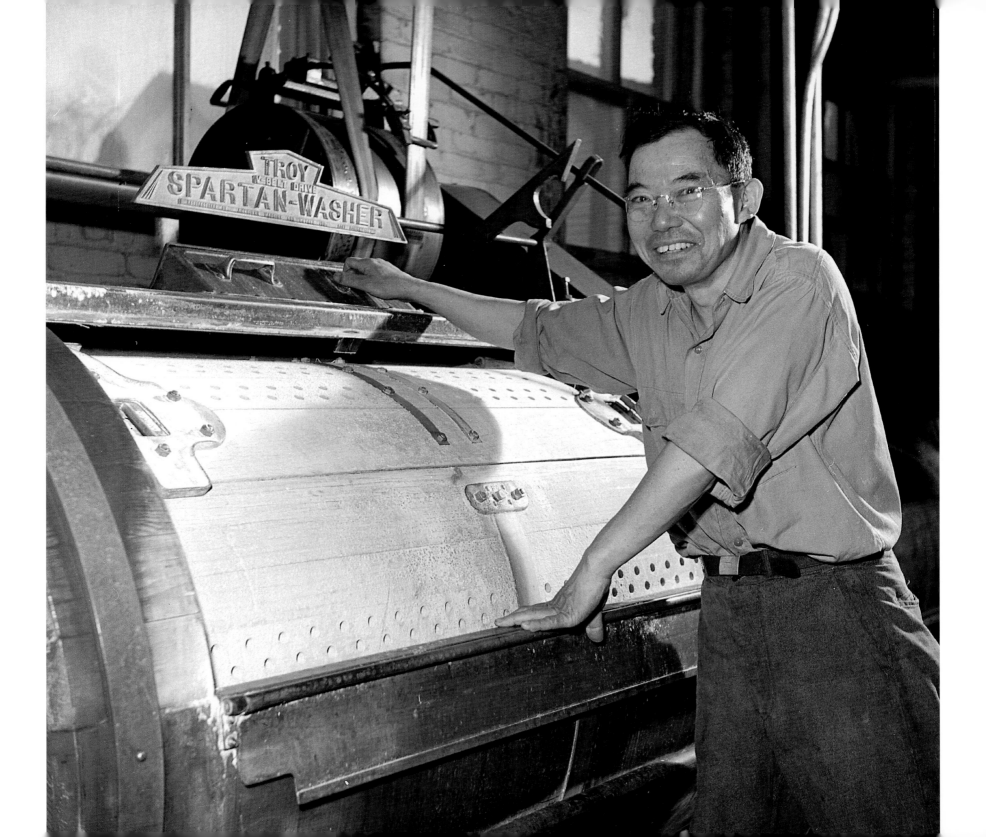

DR. SAM KURAMOTO, TAKING A PULSE

Dr. Sam Kuramoto, osteopath, formerly had a medical practice in Los Angeles and came directly to Des Moines, Iowa, where he enrolled at the Still College of Osteopathy instead of going to a relocation center. In November 1944 he opened medical offices in Webster City, a town of 7,000 about eighty miles from Des Moines. "I've been busy from the very first day," Dr. Kuramoto said, "and I'm having to work night and day." Most of Dr. Kuramoto's patients are Caucasian, and when the WRA photographer visited him on March 17, 1945, he had to wait a long time to take his picture—so many patients were waiting to see Dr. Kuramoto. His office is located at 713 Wilson Avenue, Webster City, Iowa. Dr. Kuramoto and his wife, Ayeko, live at 717 First Street.—Photographer: Iwasaki, Hikaru—Webster City, Iowa. 3/17/45

National Archives photo no. 210-G-I-830

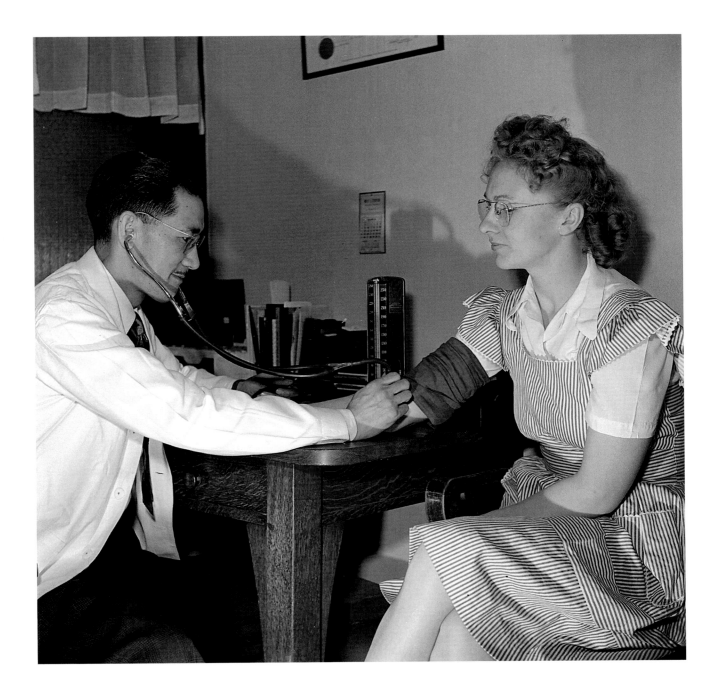

S/Sgt. Henry H. Gosho served sixteen months in the Burma-India theatre attached to Army Combat Intelligence with General Frank Merrill's Marauders until April 1945, at which time he returned to the United States and is now convalescing at Fitzsimons General Hospital preparatory to being given a medical discharge. He volunteered for duty at Camp Savage in November 1942, while living at the Minidoka Center, and volunteered for the Marauders in August 1943. His was the first unit to be created from Camp Savage, which left the United States in June 1943. He wears the Presidential Citation, the Bronze Star, the Pacific Ribbon with three campaign stars, the Combat Infantry Badge, and the shoulder patch of Merrill's Marauders. General Merrill said to his Nisei outfit, "I don't know how we would get along without you boys." Sgt. Gosho was affectionately nicknamed Horizontal Hank because he hit the ground so much he wore it out. The doctors had declared him to be flat-footed and physically not qualified for combat. Despite these handicaps he wore out four pairs of shoes in walking 1,030 miles and contracted malaria seven times in addition to other tropical diseases. Prior to evacuation to Minidoka, his parents operated a drugstore in Seattle.—Photographer: Iwasaki, Hikaru—Denver, Colorado. 4/25/45

National Archives photo no. 210-G-I-868

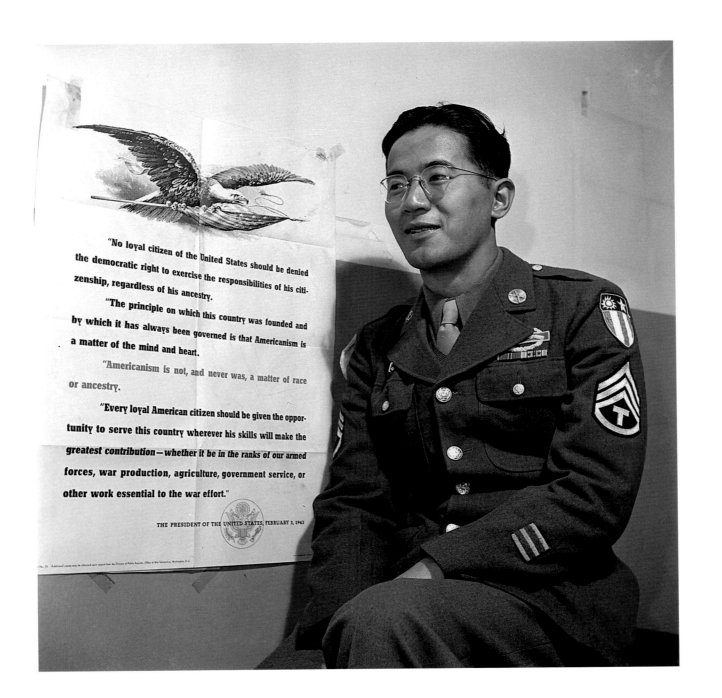

HIDEO YABUKI AND KIYOSHI YABUKI

Hideo Yabuki displays the products of his toil since coming back home to Hunt's Point to his brother, Kiyoshi, a Pfc., returned from overseas service with highest honors received in Italy and France, who is now a discharged veteran due to wounds received. Three times a week top quality cukes go to market in Seattle from the Yabuki hothouses and find ready market. Hideo recently returned from Minidoka.—Photographer: Iwasaki, Hikaru—Bellevue, Washington. 5/17/45

National Archives photo no. 210-G-I-929

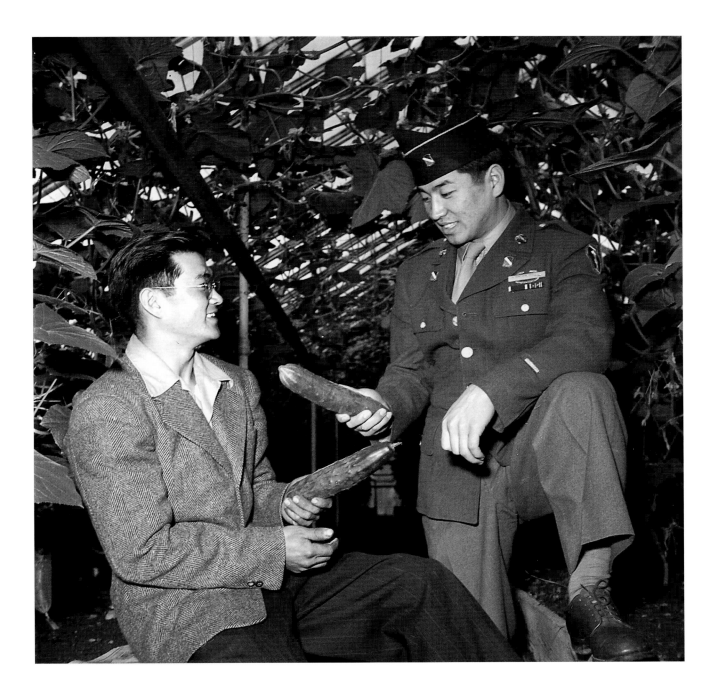

SUKEMON ITAMI AND FOUR-STAR FLAG

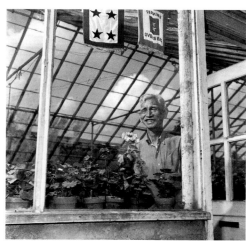

Sukemon Itami, sixty-nine-year-old father of Meddy and Shigeo, has his picture taken by the service star flag in the greenhouse window. Three sons and a son-in-law have been in the service, one recently receiving a medical discharge. Caucasian neighbors have been very friendly since the Itamis returned, and while these pictures were being taken, the woman stopped to ask for the addresses of the boys overseas. Mr. Itami reports that many sailors, sons of neighbors, have stopped in to inquire about his sons, so that they may write to them. The two boys who are overseas met in France and wrote home that they were able to get together for a good chinfest on family news. Neither son knew the other was in the vicinity. The Itamis were at the Heart Mountain Center.—Photographer: Iwasaki, Hikaru—Portland, Oregon. 5/19/45

National Archives photo no. 210-G-I-902

Photo 210-G-I-902, uncropped

AMY WATANABE AND JAMES MAEDA, DANCING

Amy Watanabe of Denver and Pfc. James Maeda, Fitzsimons General Hospital, Denver, at an annual semi-formal dance sponsored by the Young People's Society of Denver, which was held in the Y.W.C.A. Auditorium. Informal dances are held at the Y.W.C.A. once a week, which is just one of the recreational programs for young relocatees in Denver. Pfc. Maeda is from Hawaii and trained at Camp McCoy, Wisconsin, and then was transferred to Camp Shelby, Mississippi, where he completed his training before going overseas and serving with the famed 100th Battalion in Italy for eighteen months.—Photographer: Iwasaki, Hikaru—Denver, Colorado. 6/14/45

National Archives photo no. 210-G-I-930

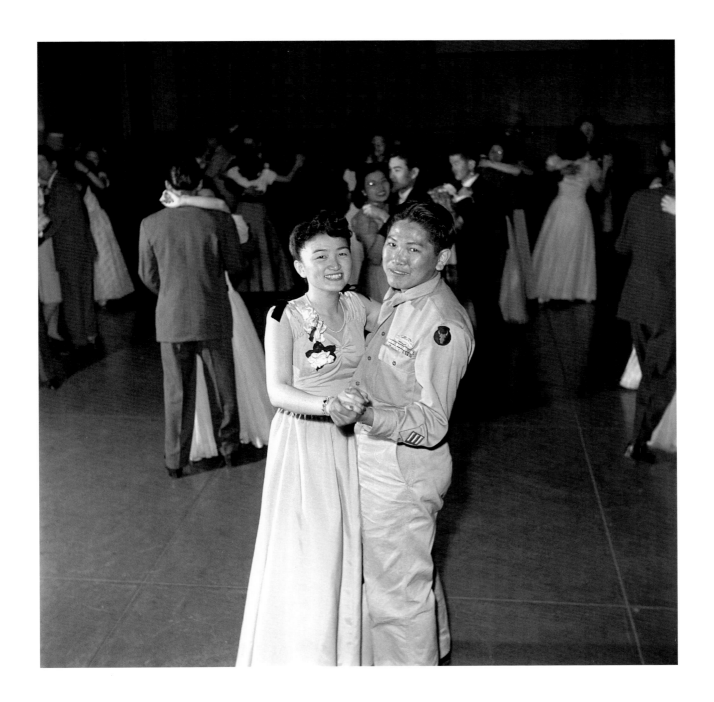

TOSHIHIRO MASADA, WITH GRAPES

Toshihiro Masada is showing some of his Thompson seedless grapes, which he raises on his twenty-acre farm at Rt. 1, Box 46, Caruthers, California, to which he returned from the Rohwer Relocation Center on March 24, 1945, with his sister, Lily. They were later joined by their mother and brothers and sisters on April 24. The Masada home was a target of one of the shooting incidents in the Fresno district on the night of May 19, 1945. Five rifle shots were fired into their home, none of which caused any injury or damage. In spite of the incident, the family is glad to be home again.—Photographer: Iwasaki, Hikaru—Caruthers, California. 6/25/45

National Archives photo no. 210-G-I-950

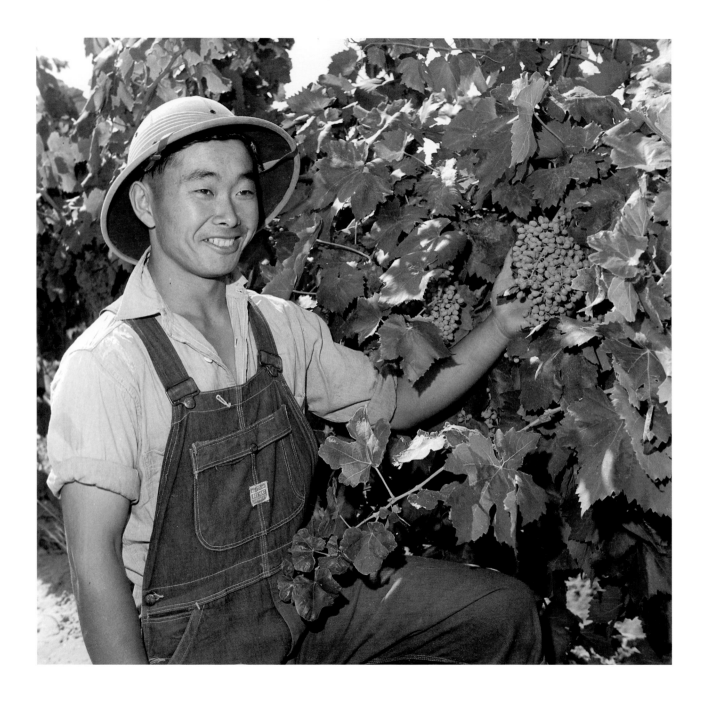

ROBERT YABUNO, OPTOMETRIST

Dr. Robert Yabuno, optometrist, a graduate of the University of California, is shown standing beside his new signpost before his home at 609 East Street, Fresno, where he has just opened his office. Dr. Yabuno returned to Fresno from Chicago, Illinois, where he relocated from the Gila River Relocation Center. He and his family transferred to Gila River when the Jerome Center was closed in June 1944. While in the Center, Dr. Yabuno worked in the hospital as an optometrist. His sister, Yomiye, returned from Gila River to assist him. His parents, Mr. and Mrs. Yabuno, are expected home soon. He reports that business is picking up, being the only Nisei optometrist in the Fresno district.—Photographer: Iwasaki, Hikaru—Fresno, California. 6/26/45

National Archives photo no. 210-G-I-960

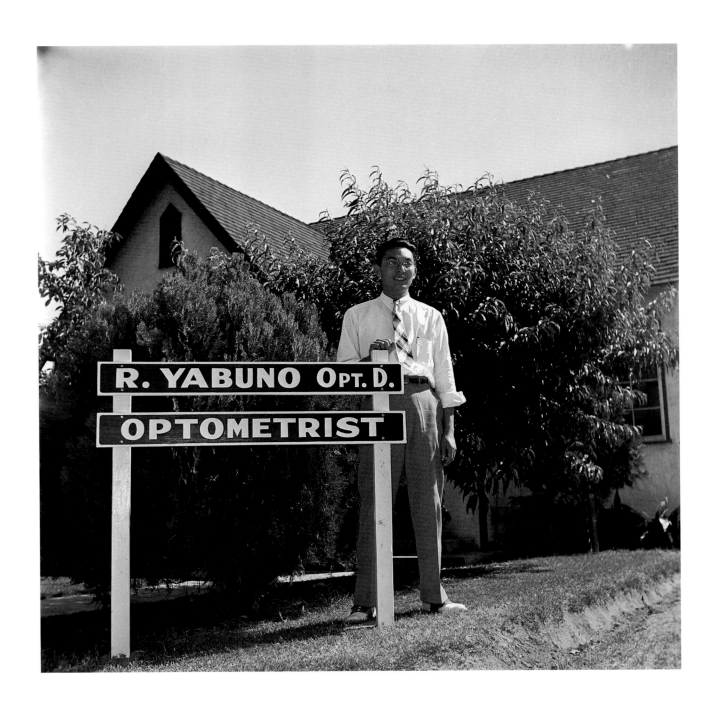

NAGAI AND MIYAKE FAMILIES, IN FRONT OF HOUSE

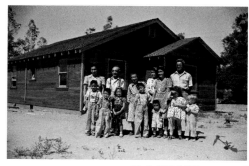

Photo 210-G-K-5, uncropped

Nagai and Miyake families at the new home that they have constructed since April 15. Left to right, front row: Robert Miyake, Gene Sheridan [author's note: this identification is probably incorrect], Margaret Miyake, Gordon Nagai, David Nagai, Patty Sheridan, Tommy Sheridan, neighbors; left to right, back row: Mrs. Kimi Miyake, Mr. Miyake, Mrs. Miyake, Janet Nagai, Yoriko Nagai, Ben Nagai. Their home is located at Rt. 1, Box 114, Atwater, California, and they returned from the Granada Relocation Center in January and February. The Nagai family operates a 60-acre farm and the Miyakes 100 acres including almonds, peaches, and grapes. This is leased until 1945 on the share basis, but they will take over at the end of the crop season. Their new five-room home was constructed entirely by the members of the family, with the exception of sanding the floor, and was built in about two and one-half months. Most of the carpentry work was done by Ben Nagai and Hidekichi Miyake. George Miyake is in the armed forces stationed in France and has recently recovered from wounds but is back on duty now. Kimi Miyake reported that they recently secured priority to purchase a 1942 model automobile and that they have purchased a 1942 Plymouth. Gordon, Robert, and Janet have been attending grammar school near their new home since returning in January and report that they like school fine and that they all passed. Other members of the above family include Satoru, who is with the U.S. Army in France.—Photographer: Iwasaki, Hikaru—Atwater, California. 6/29/45

National Archives photo no. 210-G-K-5

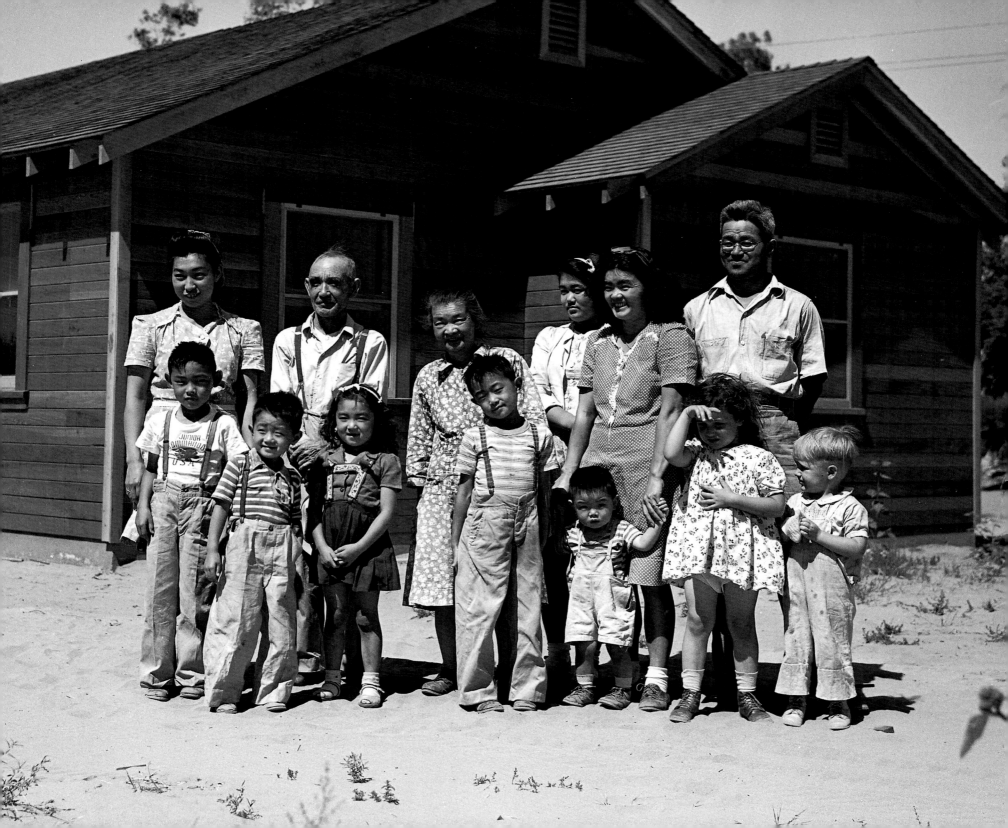

WOMEN SORTING CELERY PLANTS

Pitching right in to help the man-power shortage that has hit the former Rohwer group at Camp #5, Bacon Island, Stockton, California, are, from left to right, Shizuye Tsutaoka, Mary Furuoka, H. Takechi. They are planting celery plants on a large ranch at Camp #5, Bacon Island. The four recently returned from the Rohwer Relocation Center early in June. . . .—Photographer: Iwasaki, Hikaru—Stockton, California. 6/30/45

National Archives photo no. 210-G-K-10

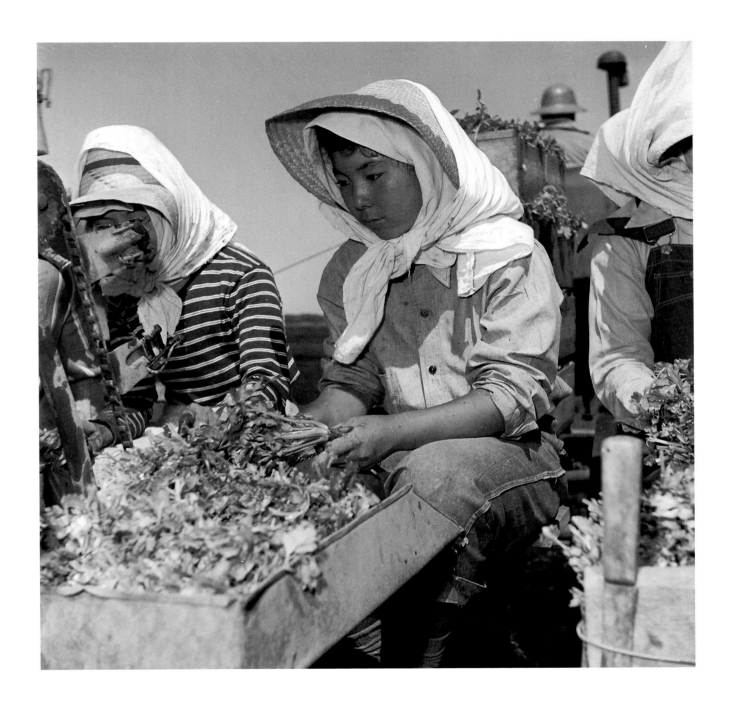

JIMMY NAKATSU, AT WATER TROUGH

Photo 210-G-K-152, uncropped

Jimmy Nakatsu, son of Mr. and Mrs. Itaru Nakatsu, recent relocatees from Gila Center, is one of the younger hands on the vegetable farm of his uncle, Sam Isamu Uchiyama, adjoining the town limits of Mountain View, California. Jimmy and his two brothers, Herbert and Kenneth, and his sister, Naomi, have discovered there is a lot of work to growing vegetables for the nation's food basket and that a great deal of it can be done by smart and ambitious youngsters. Uncle Sam is more than a nickname for a tall man with chin whiskers and wide-striped pants to Jimmy. To him Uncle Sam is his vegetable-growing real uncle who established the business a few months back, built houses, repaired others, and brought out of Gila and Poston Center fifty people—all relatives—to grow food. Although Jimmy and the other youngsters are busy with their jobs this harvesting season, he still finds time for baseball—there are almost two full teams in the four families relocated together—and an occasional picture show.—Photographer: Iwasaki, Hikaru—Mountain View, California. 7/5/45

National Archives photo no. 210-G-K-152

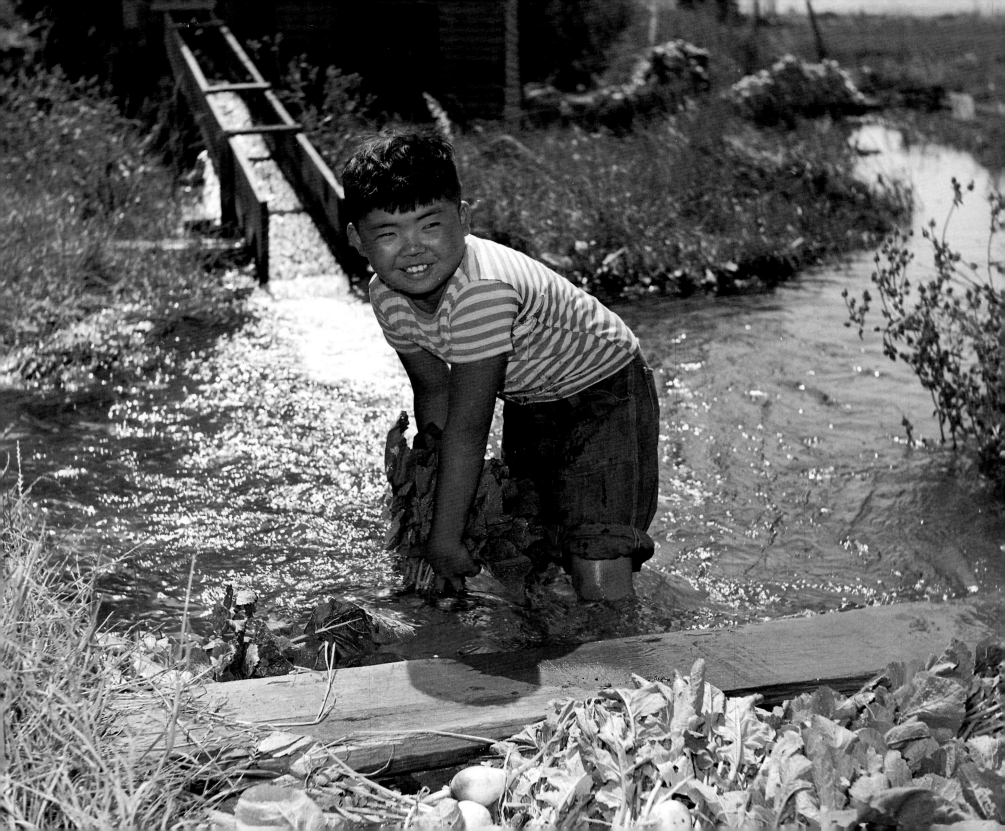

KID CLIMBS ON HIS GRANDPA

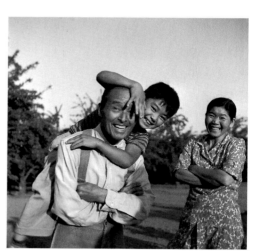

Photo 210-G-K-139, uncropped

There is work in the fruit harvest for everyone in Santa Clara County, California, but the Ichikawa youngsters also find time for play. Shown here, Toshiro and Richard are taking time out for a bit of fun on the Tuso brothers' ranch near San Jose, where the entire Ichikawa family, except James and Tom, was recently relocated by big brother, Akira. James and Tom are employed in defense work in Detroit and sister, Rose, is working in nearby Palo Alto. Prior to evacuation to Heart Mountain, the Akira Ichikawas resided in the Watsonville section over the hill from San Jose on Akira's vegetable farm. Now they plan to remain in this district, where all of the family may find profitable and healthful work in the orchards during the entire school vacations. With Akira are Mr. and Mrs. Toshiro Ichikawa, Richard, May, Ben, and Akira. The Ichikawas have several Japanese neighbors nearby.—Photographer: Iwasaki, Hikaru—San Jose, California. 7/8/45

National Archives photo no. 210-G-K-139

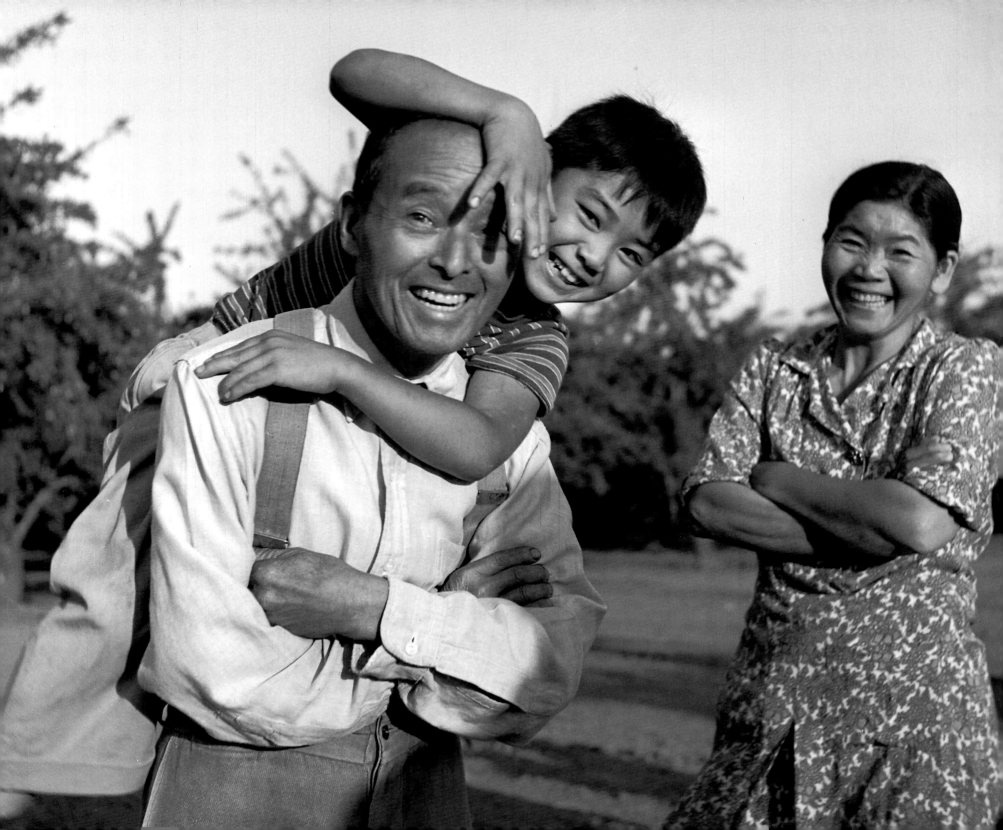

SHIBUYAS, SON AND DAD, WITH JAPANESE IRIS

Ryohitsu Shibuya, widely known Mountain View florist and King of the Chrysanthemum growers, and his son, Maremaro, on the grounds of the Shibuya Company, Grant Road, Mountain View. Mr. Shibuya returned to his beautiful home from Denver several months ago. He is from the Heart Mountain Center. Mr. Shibuya came to the United States when a young man, and after trying his hand at various jobs, found his way into floral culture near Palo Alto. After many years of painstaking labor, he developed the Shibuya strain of chrysanthemum from which he prospered and built one of the most beautiful homes in the Mountain View district. With him at the time the picture was taken were his charming daughter, Masago (M. A. Stanford), now employed at her alma mater; Maremaro, a son, until recently a high school student in Minneapolis; and T/S Yoshimaro, recent graduate from the University of Nebraska in civil engineering and on leave from Camp Snelling, Minnesota. Another daughter, Madoka (with an M.A. from Stanford in chemistry), is now a student in Stanford Medical School in San Francisco. A third son, Takeshi, also a college graduate, has a responsible position in Minneapolis. Mrs. Shibuya passed away during evacuation. Before long Mr. Shibuya plans to be back in the production of the famous fall blooms that are a part of football to the coed.—Photographer: Iwasaki, Hikaru— Mountain View, California. 7/6/45

National Archives photo no. 210-G-K-125

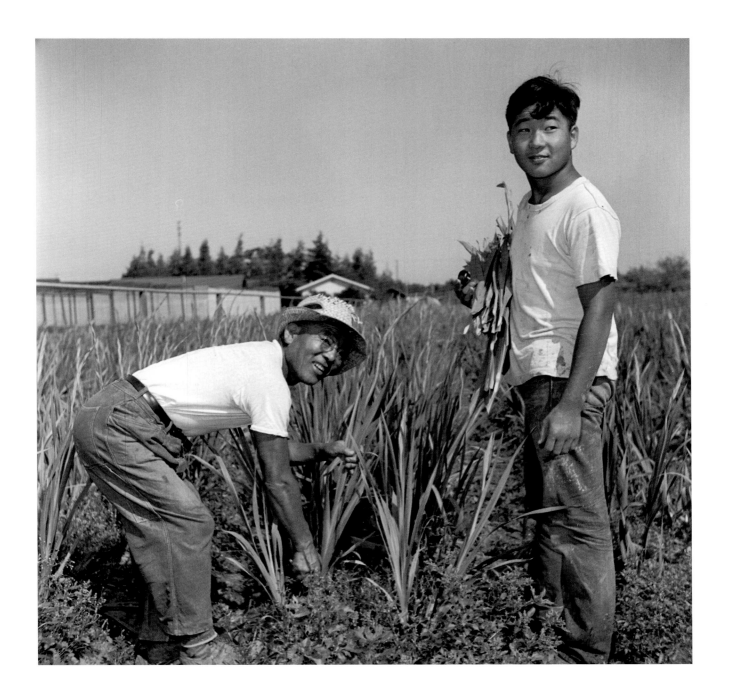

TOZABURO OKA, SITTING ON STONE FENCE

Tozaburo Oka and family, at Route 1, Box 265, Los Gatos, California, are not only pioneers of relocation but with the return of their son, Isamu, Purple Heart veteran of the Italian campaign, relocation is complete. The Okas are from Heart Mountain. Almost immediately after the lifting of the ban, Mr. Oka set in motion the wheels of relocation and in January of this year the family headed westward for their orchard home near Los Gatos. Somewhat later the family was joined by Isamu after his discharge from a hospital, and later still, Tomiko joined the family from Detroit, Michigan, and Toyoko followed from Chicago. Mr. Oka brought with him from Heart Mountain his old friend and employee, Takejiro Midoshima. The Okas are prune growers and when the cameraman caught Mr. Oka, the family was getting ready to prepare to harvest a heavy crop of Santa Clara County prunes. The many friends of the family will be glad to learn that Isamu, while a long way from complete health, is constantly improving under the care of a nearby veterans hospital which he visits regularly for checkups.—
Photographer: Iwasaki, Hikaru—Los Gatos, California. 7/12/45

National Archives photo no. 210-G-K-88

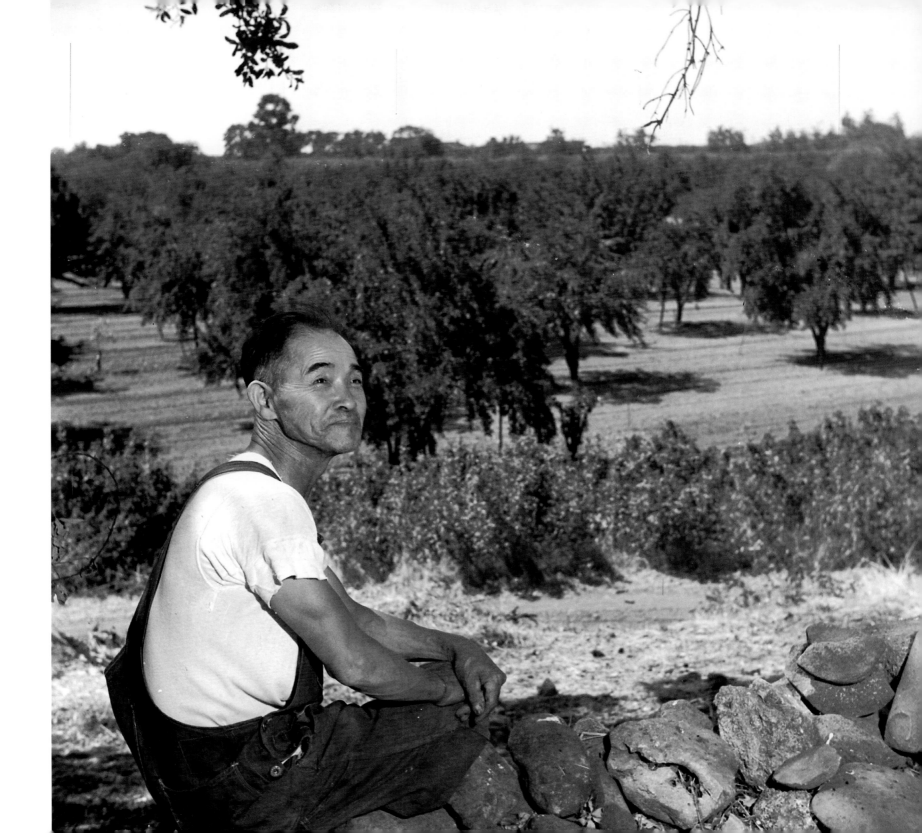

MR. AND MRS. HARRY J. IWAGAKI WITH SON KENNETH IWAGAKI

Mr. and Mrs. Harry J. Iwagaki, from the Heart Mountain Center, are mighty proud of their two soldier sons, both of whom are Sergeants and six footers. They are shown here with Sgt. Kenneth on furlough from Camp Snelling and about to go overseas. Their other son, Sgt. Duncan Iwagaki, embarked from the East coast for Europe recently. The Iwagaki family are pioneers of relocation in the San Jose Area. Within a week after the lifting of the ban, Mr. and Mrs. Iwagaki and their daughter, Mrs. Amy Higuchi, were on their way to their home in San Jose. The Iwagakis live at 514 Boynton Avenue in San Jose. They have a prune orchard which was not under lease this year, and they are operating it at this time. Mr. Iwagaki reports a heavy crop and anticipates satisfactory prices.—Photographer: Iwasaki, Hikaru—San Jose, California. 7/11/45

National Archives photo no. 210-G-K-115

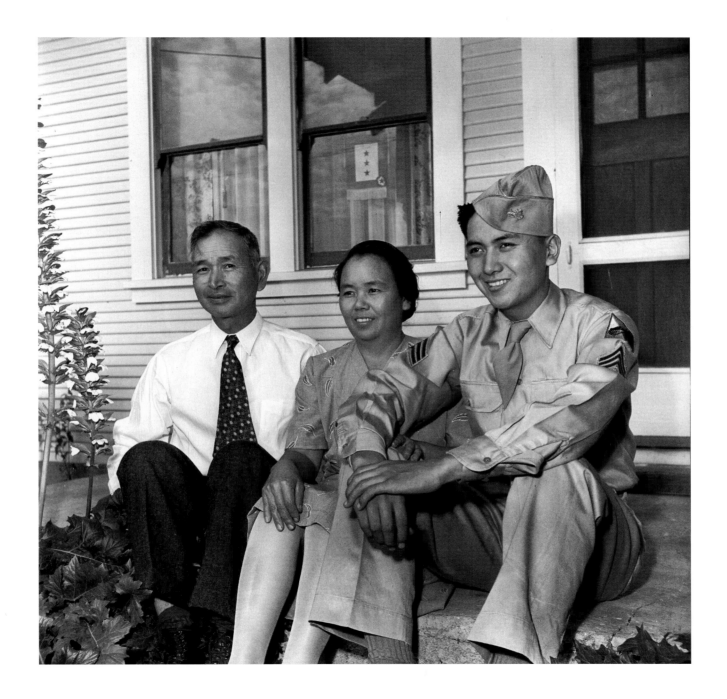

YONEKICHI NAKATA, ARRANGING FLOWERS

Mr. Yonekichi Nakata is shown arranging a bowl of flowers in the dining room of the Livingstone estate. Mr. Nakata is seventy years old and, except for the evacuation period, has worked as chauffeur and butler for the Livingstones for thirty years. He returned to his employment from Topaz in March 1945.—Photographer: Iwasaki, Hikaru—Hillsborough, California. 7/19/45

National Archives photo no. 210-G-K-260

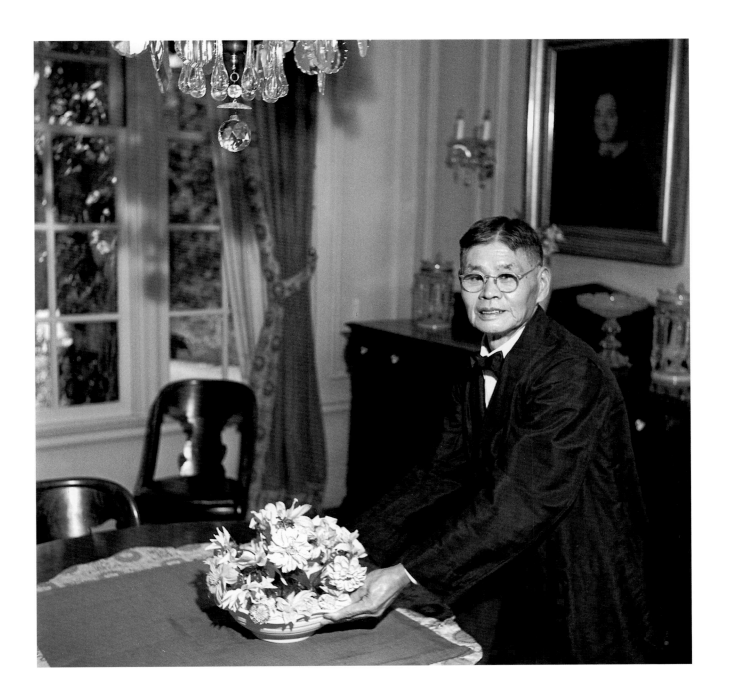

159

YASU SHIROTANI, IN KITCHEN OF ESTATE

Mr. Yasu Shirotani is shown working in the kitchen of the Livingstone estate. Mr. Shirotani, who is seventy-seven years old, returned from Topaz four months ago to resume his employment at the Livingstones' where, except for evacuation, he has worked since 1923.— Photographer: Iwasaki, Hikaru—Hillsborough, California. 7/19/45

National Archives photo no. 210-G-K-259

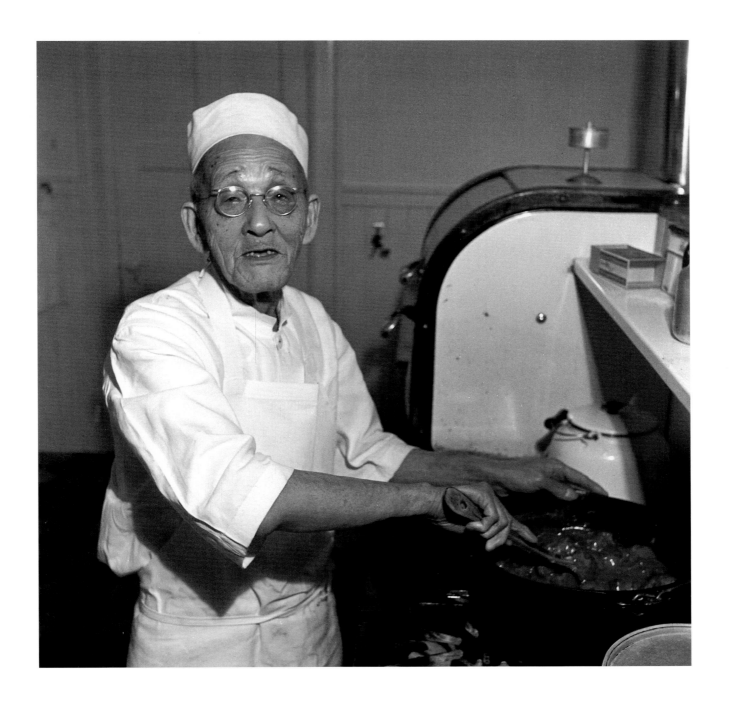

MRS. HIROSHI KAWAHARA AND HER TWO CHILDREN

Mrs. Hiroshi Kawahara and her children, Seichi and Seiko, in their garden at Route 3, Box 389, Petaluma, California. Mr. Kawahara is working for Mr. Polonisky, a grower in the vicinity. The Kawaharas are former residents of Granada.—Photographer: Iwasaki, Hikaru—Petaluma, California. 8/8/45

National Archives photo no. 210-G-K-178

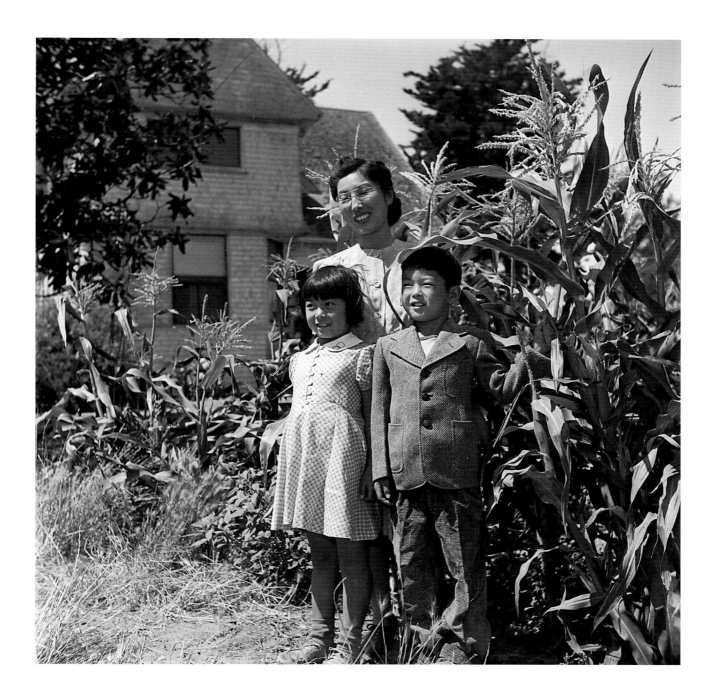

ROKUTARO NAKAMURA, IN FRONT OF NAKAMURA BROS. STORE

Mr. Rokutaro Nakamura (formerly of Granada) is standing in front of his newly opened furniture and hardware store at 1317 Fourth Street, Sacramento, California. Mr. Nakamura and his son, Shig, also operate a similar store at Woodland, California. Mr. Nakamura states that business is fine.—Photographer: Iwasaki, Hikaru—Sacramento, California. 8/8/45

National Archives photo no. 210-G-K-202

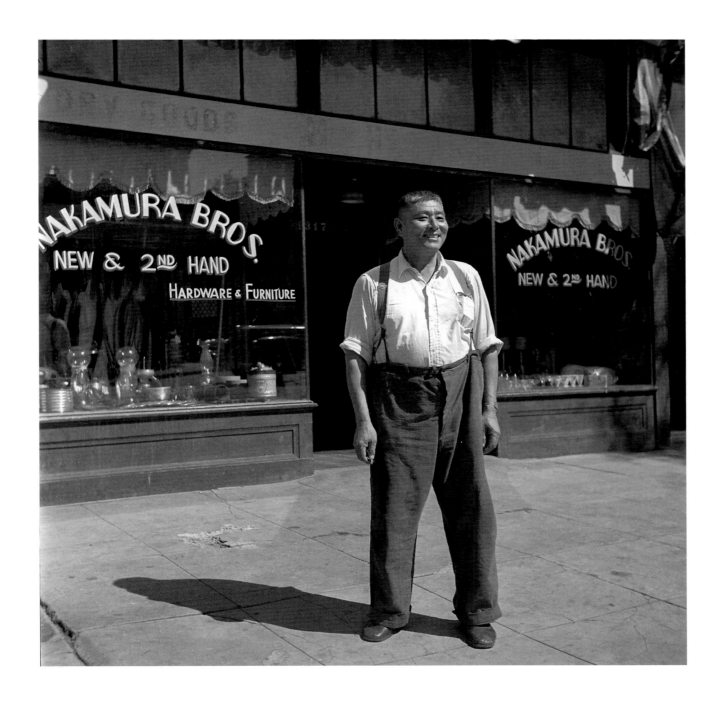

CHAPTER FOUR

Assessment
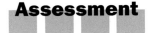

SHORT-TERM IMPACT OF THE WRAPS PHOTOGRAPHS

Although resettlement was the key mission of the WRA by 1943, it is significant that the Authority made no effort during its lifetime to highlight the way that it was using public relations, including photography, to implement its policies. Nor, in fact, did the WRA make a serious effort, either during the war or after, to evaluate how the WRAPS photos were received by Japanese Americans and the public at large.[1] In retrospect, however, we can use measures to at least partially assess the impact of the WRA photo campaign. Although these indices are indirect, they offer relevant evidence for assessing the impact of the WRA's efforts from 1943 to 1945.

In 1946, the first year after the end of the war, the authoritative National Opinion Research Center (NORC) conducted a scientifically sampled poll. This poll, published under the title *Attitudes toward "the Japanese in Our Midst,"* was designed to measure popular sentiment with regard to people of Japanese ancestry in the United States.[2] Although this poll was conducted after the total defeat of Japan and after almost all of the Japanese Americans had returned to society, the findings reveal that there was still a great deal of suspicion toward people of Japanese ancestry immediately after the end of the war. The poll indicated that two-thirds (66 percent) of persons interviewed believed that "Issei and Nisei in this country had acted as spies

for the Japanese government."[3] Regarding the right of persons of Japanese ancestry to return to the Pacific coast, when the public was sampled in the five western states of California, Oregon, Washington, Nevada, and Arizona, almost a third (31 percent) said that they "would allow none to return."[4] And the general public's attitude toward employment opportunities for persons of Japanese descent, particularly Issei, was marked by hostility. Over half (56 percent) thought that Issei should not be given equal employment opportunities, and another third (33 percent) responded that Issei should simply be "sent back to Japan." Four out of ten persons surveyed were not in favor of equal employment opportunities even for the American-born, second-generation Nisei, who were U.S. citizens by birth.[5]

Another way to gauge the impact of the WRA's resettlement campaign is to note that only some 36,000 Japanese Americans—about one of every three persons in confinement—opted to leave the camps while the war was still in progress.[6] And although the photos (see, e.g., pp. 28–32) imply that WRAPS photo work influenced some Japanese Americans to leave camp, I have never read or heard a single person mention that these resettlement pictures were influential in making the decision to leave. Nor do I know of one case in which a Japanese American decided to go to the Midwest, the South, or the eastern seaboard because of a WRAPS image or photo display.

In fact, as far as the incarcerated Japanese Americans were concerned, only certain sectors of the population were willing to leave the WRA camps before 1945. One research study found that the second-generation Nisei, who were young, educated Christians from urban backgrounds and were single or recently married, were most often the ones to leave camp before the war was over.[7]

Probably more significant in shaping Japanese American perceptions of the situation on the outside than any WRAPS photos the camp authorities put on display was the Authority's lack of acknowledgment of resettlers' demands for reparations and guarantees of protection. Richard S. Nishimoto, an Issei community leader, observed popular discontent in this regard in the WRA camp in Arizona known as Poston. As Nishimoto noted in a report to the Japanese Evacuation and Resettlement Study, similar discontent evolved into an "All Center" conference, where representatives from nine of the WRA camps met to hammer out demands that were eventually presented to Dillon S. Myer and other political notables. These demands had to do with conditions that the representatives wanted the WRA to meet to ensure that the people leaving the camps would be treated fairly.[8]

Thus, in spite of the WRA's extensive publicity efforts, which included newspaper and magazine articles, speeches and presentations, movies, slides shows, and picture displays featuring "successful" Japanese Americans such as students and soldiers, the American public still harbored significant antipathy toward Issei residents and Americans of Japanese ancestry. In other words, however well construed its intentions were, the WRA failed over the short term. All of the time and money it had spent on its massive publicity campaign to convince the denizens of the dominant society that the members of this tiny ethnic minority were "loyal Americans" had, at best, only limited success during and immediately after the end of World War II.

ANALYSIS: THE PERFORMATIVE WORK OF WRAPS PHOTOGRAPHS

Because the WRAPS resettlement photos were taken solely of loyal Japanese Americans who were released before the war was over, they do not represent a random sample of—and thus cannot be considered an accurate or complete record of—Japanese Americans' resettlement experiences between 1942 and 1946, let alone during the long period of readjustment that followed.[9]

The WRAPS images of smiling Japanese American resettlers taking advantage of their newfound freedom in order to live, work, and prosper were meant to put Euro-Americans at ease while at the same time encouraging the Japanese Americans still in the WRA camps to resettle and resume their "normal" lives. Photographs of resettlers resuming productive lives in the larger society could be used in newspapers, magazines, books, and exhibits in order to educate the larger public and convince that public that the resettlement process was salubrious. It was good for the economy, good for the war effort, good for democracy, and, at least in terms of the loyal Japanese Americans involved, it did not put the nation at risk. But how were the WRAPS pictures supposed to accomplish these goals?

In identifying the broader implications of this fairly delimited historical research, it is necessary to locate WRAPS photo production within a matrix of power. As Geoffrey Batchen insists, "power inhabits the very grain of photography's existence as a modern Western event."[10] Specifically, historian John Tagg posits that photographic "meaning" is always "deferred and displaced" to power structures and the kinds of institutional practices that these inculcate if not enforce.[11] These theorists thus demand that we seek out exactly how institutional photography does its political and ideological work.

Charles Mace's "mug shot" invention—a portable folding device of fixed focus, comprising indirect lighting, an inexpensive camera, and a roll-paper nameplate panel. Photographer: Hikaru Iwasaki, November 22, 1943.

National Archives photo no. 210-G-G-230

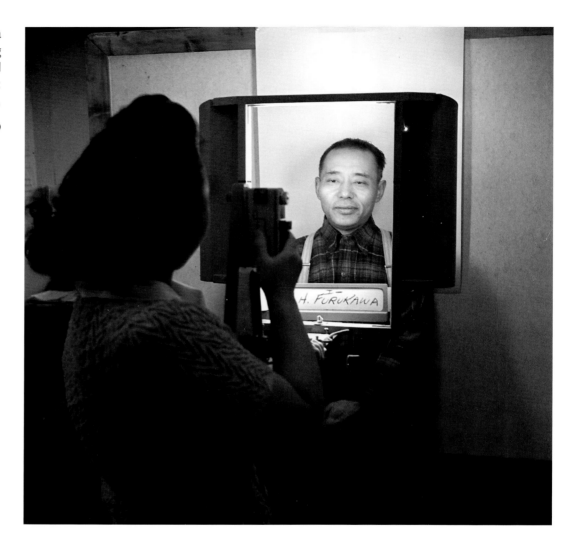

In terms of explicit institutional practices of surveillance, it is clear that government photography in the camps went well beyond simple PR photos designed to convince the public that conditions were tolerable and humane. The clearest example in the WRAPS corpus is the chilling photo of Charles Mace's "mug shot" device, designed to facilitate the Authority's ability to record the faces of Japanese American prisoners for its multifaceted identification and registra-

tion purposes. The WRAPS resettlement photo work is documentary insofar as it is referential, such that the photo operates an as index of the real (in Peirce's terms, the photograph's indexicality).[12] In retrospect, it is readily apparent that the portrait took pride of place in WRAPS resettlement photo work.[13]

In Phase Two production, the detailed narrative text appears at first glance to be a matter of empirical description, including place, time, and name(s) and supplemented in many cases by resettlers' firsthand statements and accounts. The combination of resettlement portrait and caption works as a kind of testimonial. As such, the WRAPS images with their captions seem to bear witness to a process (i.e., resettlement) that was by implication inciting public concern if not anxiety and controversy. The WRA, however, wanted everyone—Japanese Americans and Euro-Americans alike—to understand and support its resettlement policies. In fact, photo shoots and texts were conceptualized and executed by WRA bureaucrats in Washington in tandem with regional resettlement officers who were in charge of the local WRA field offices. Thus, the narratives cannot and should not be taken at face value any more than the photos should be.[14] The point is that the overall effect of the official WRAPS photos and captions is effectively conceptualized as performative.[15]

In this sense, the image may be what first captures our attention, but the caption is key to the overall effect on the viewer. The caption plays an indispensable role in overdetermining a given WRAPS photo's meaning since, epistemologically speaking, a photo is necessarily and inherently incomplete; it is "incapable of taking into account an entirety," as Michel Frizot puts it.[16] Thus, according to Frizot, in a commentary that is quite applicable to the WRA photos as a whole,

> the photographic image needs to be supported by a caption that inscribes it in the field of meanings and associations for the observer. Otherwise, it is unintelligible; it evokes no interest, it does not speak to us. The dependence on a caption if the observer is to develop hypotheses about its meaning clearly shows that the photographic image is a physical object that rearticulates human relationships. When it is made, this artifact is already the meeting point of facts, intentions, and the photographer's relationships with others; and when it circulates and is recorded via observation, text, and thought, these facts, intentions, and relationships are rearticulated by the observer's understanding and intellectuation [sic].[17]

From this analytic standpoint, we can now conjecture how the WRAPS photos were set up in the sense of how they were supposed to work. The WRA's intention was that the portrait

in tandem with a personalized resettlement narrative interpolated the viewer as an active subject willing to support the benighted Japanese Americans and thus the government agency working on their behalf.

To recapitulate in a slightly different fashion, as a construct, WRAPS work is performative because it is produced intentionally to generate the maximum possible supportive response from any given viewer and thus with a specific set of policy aims in mind. As such, the WRA bureaucrats intended for the WRAPS images to fully complement the (ostensibly firsthand) testimonials that the local WRA field officers generated.

The central, defining characteristic of the WRAPS performative public relations package then was the combination of portraits along with seemingly firsthand resettlement narratives bearing witness to aspirations and resettlement experiences of Japanese Americans reentering society from 1943 to 1945. The ideological construct of the WRAPS photographs is a dual product of image/portrait plus text.[18] In this package, the institutional matrix of the agency overdetermined the subjectivities implicit at both the level of the image and the level of the accompanying narrative.

An even more subtle dimension of the WRAPS photographs deserves mention here, if only to mark the possibility of further exploration at another time. Almost all WRAPS resettlement photos normalize the resettlers in terms of their jobs, activities, pastimes, homes, relationships, and the like. Here we should remember that most Japanese Americans who were released from WRA camps before the end of World War II were obliged to sign oaths swearing that they would comport themselves as model citizens. At this level, the WRAPS photos can be seen as prescriptive. By showing average Issei, Nisei, and Sansei as normal people pursuing the normal course of daily life, the photos articulate a standard for all Japanese Americans to emulate and uphold for the good of all.

In sum, the WRAPS photos were definitely used to promote assimilation and combat racism, but they also tacitly served to mitigate against deviance in the Japanese American community, if only through what was *not* being depicted. As such, it is useful to consider the prescriptive qualities of the resettlement photos, even if their precise impact on each generation and gender cannot easily be measured.[19]

This approach unpacks the inherent ideological nature of WRAPS work as a manifestation of the WRA's favored policies, and it also opens the door for creative, vernacular appropriations that go far beyond the Authority's intentions as manifest in the 1940s during World War II.

Reflections

THE PAST AS PROLOGUE

Beyond heightening the possibilities for critical evaluation of the WRAPS photos, what ramifications does this analysis offer? There may in fact be an enduring value to the WRAPS photographs, whatever their historical origins were. If my analysis of the performative nature of WRAPS work is accurate, then I submit that the photos by themselves have no necessary or inherent meaning.

Even if the WRAPS images bear the traces of power that overdetermined their social relations of production in the first place, there is no reason the photos cannot be appropriated and redeployed for new purposes and with new visions in mind. That much has happened already, albeit selectively. In fact, the wholesale reappropriation of WRA photographs has been going on since at least the 1970s. In the pre-Redress context the manifestations of this reappropriation had largely to do with the use of the WRA's own photos to illustrate the injustices that mass incarceration entailed.[1] If this is so, also possible are additional configurations of meaning far beyond what the WRA and its postwar critics intended or even anticipated.

Given their history, what possible uses of the WRAPS photographs exist today? There are already clear signs that WRAPS photographs can be appropriated and put to other ends than the WRA had originally intended.

Zori (straw sandals) and geta (wooden sandals) made at the WRA camp near Granada. Photographer: Hikaru Iwasaki, October 15, 1945.

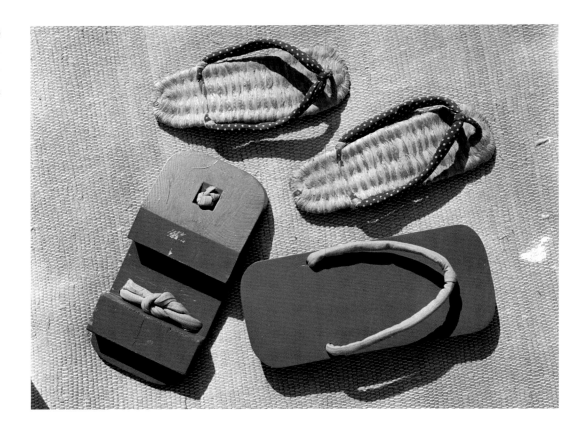

REAPPROPRIATION ONE: ASSERTIONS OF HUMANITY, COURAGE, AND PERSEVERANCE IN THE WRA CAMPS

Going through Iwasaki's 1,300 online photographs, I was struck by the themes of the daily passage of life and the daily acts of creative, subjective assertion. I have picked out a number of my favorite shots in this regard to show the potential they might hold for exploration of these themes.

First, Iwasaki took a number of photographs of artwork in the camp. Some, including oft-reproduced shots from an exhibit staged at the end of the war in the Granada Relocation Center, are nearly iconic. I have selected three examples that depict woodwork. The first photo shows homemade footwear: woven straw zori and wooden geta (clogs). The re-creation of

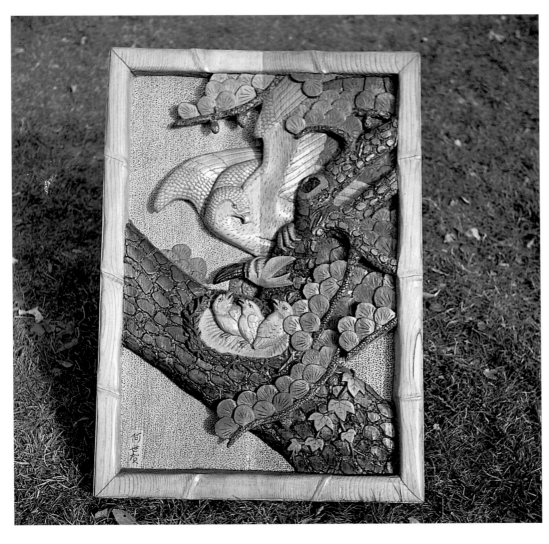

Wood carving of a mother hawk and fledglings in a pine tree nest. Photographer: Hikaru Iwasaki, October 1945.

geta in the WRA camps was ingenious and served a practical function because this traditional style of Japanese footwear could be fabricated from cheap, available materials. Moreover, the geta allowed its users to walk slightly above the muddy ground in spring and the sandy desert ground in the windy months. A second photo, showing a wood carving of a mother hawk and her chicks, demonstrates the expert wood carver's pure skill and artistry. The third photo records

Nameplates in English letters and Japanese characters carved from wood, probably for a camp barrack's "apartment" number. Photographer: Hikaru Iwasaki, October 1945.

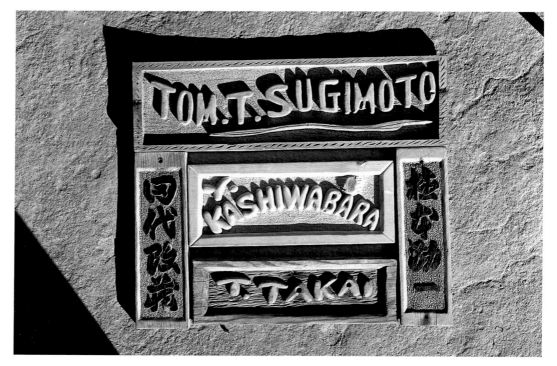

nameplates, in English and Japanese, that were probably made to put outside of a barracks' "apartment" unit. I find these significant because they have to do with assertions of family name and ethnic identity, whether in English or Japanese.

I also selected three shots showing surprising creative improvisations in the barracks, including one that actually made me laugh. There are of course plenty of WRA photos of the decorated interiors of barracks. If the viewers did not know they were looking at the interiors of family units at the Colorado River Relocation Center (Poston), they might think they were looking at the inside of a nice apartment in Des Moines, Iowa.

The first photo illustrates the theme of home and the comforts of home and shows a man clearly enjoying his homemade o-furo. The hot bath at the end of a day's work is one of the great, traditional pleasures of Japanese and prewar Japanese American culture. That this gentleman sought to re-create this pleasure in the stark, massive concrete showers of the block bathrooms makes me smile.

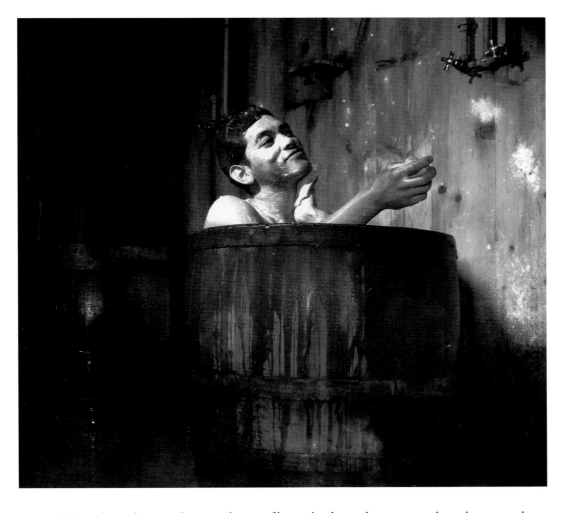

Heart Mountain resident Tag Sugiyama soaking in an improvised bathtub made from a sawed-off pickle barrel. Photographer: Hikaru Iwasaki, November 23, 1943.

National Archives photo no. 210-G-G-197

Although not by Iwasaki, two photos of barracks themselves suggest that a home can be made anywhere and that people, no matter their circumstances, have a desire to transform ugly or undesirable surroundings into something of their own, even if those surroundings have been forced on them. To see the walled veranda, complete with full-paned, high glass windows added by an enterprising carpenter to the front of his family unit in a Tule Lake barrack, is surprising. To see the full portico added to the end of another barrack at Tule, in an effort to make it more homey, is at once curious, amazing, and (to me, anyway) humorous.

Examples of the creative ways in which Japanese Americans modified the exteriors of their WRA barracks to make them more homelike. Photographers: John D. Cook (left, top); Francis L. Stewart (left, bottom; facing page). The Francis L. Stewart photos were taken on November 3, 1942.

National Archives photo no. 210-G-G-60

National Archives photo no. 210-G-I-462

National Archives photo no. 210-G-A-459

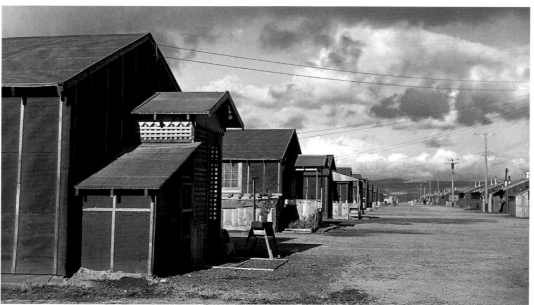

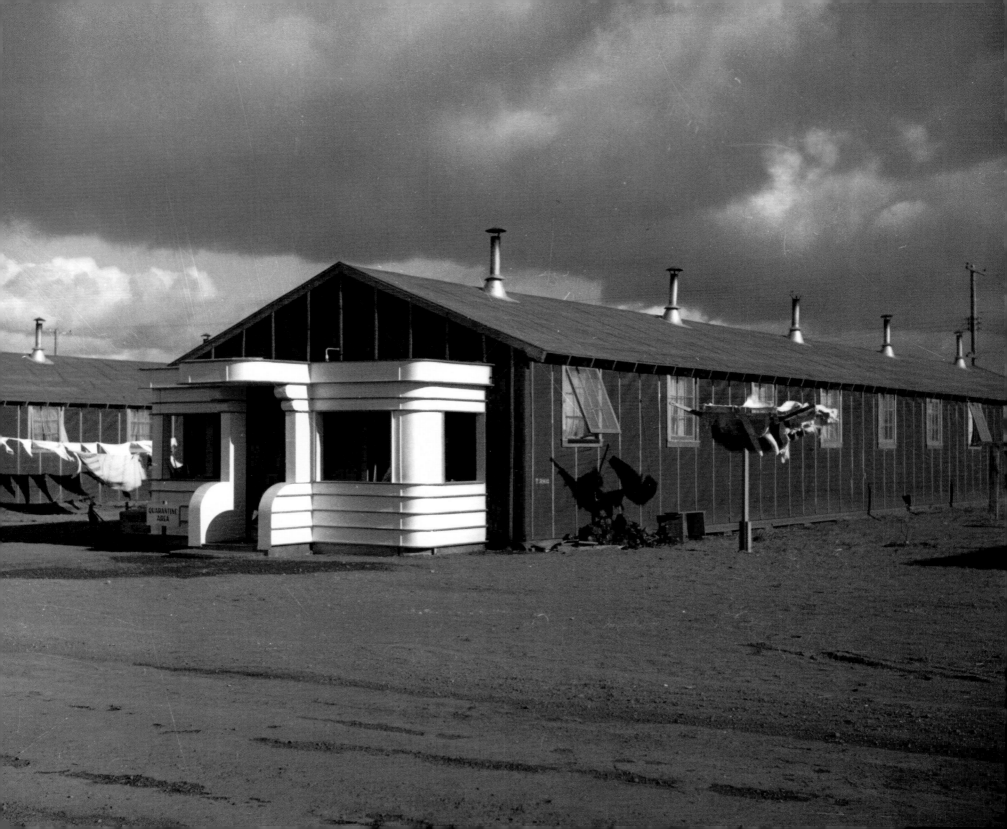

USO representative K. Okura presents Gold Stars to mothers in the Amache WRA camp whose sons were killed in action. Photographer: Hikaru Iwasaki, April 21, 1945.

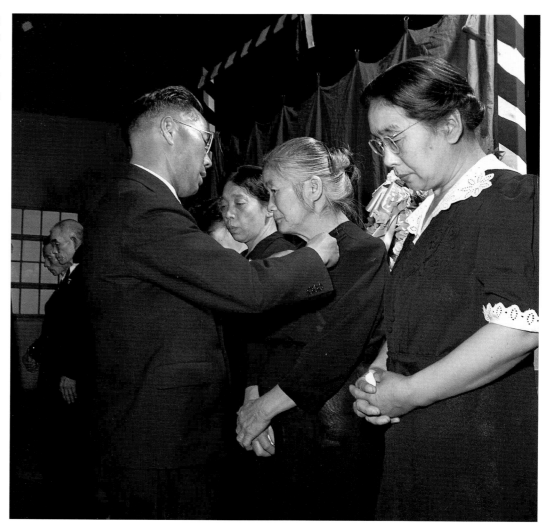

Other of Iwasaki's images of camp life remind us of life's passages. His published photographs of Issei mothers in Granada receiving Gold Stars to commemorate the loss of a son are iconic. Less well-known but equally moving is his photo of the child by his relative's grave at the Rohwer Center, Arkansas, which reminds us that not everyone left camp.

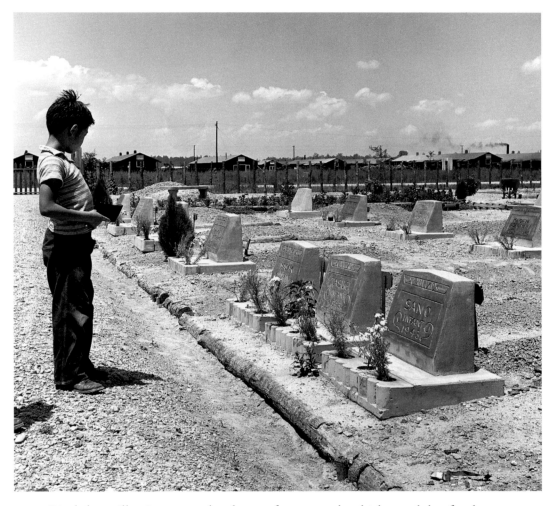

A boy views the grave of one of his relatives buried in the WRA camp cemetery at Rowher, Arkansas. Photographer: Hikaru Iwasaki, June 16, 1944.

National Archives photo no. 210-G-I-238

Lively but still poignant are the photos of camp youth, which reveal that for the young, life did go on. A young girl on a swing and jitterbuggers at a high school dance at Heart Mountain, Wyoming, are alive and in motion.

This youthful energy also shines from photographs of youth dances at the Denver Y, where Nisei youth gathered and sought each other's company as they made the transition back into society. And yet the Japanese American resettlers faced very real challenges and setbacks, some of which WRAPS photos allow us to reconstruct.

Life did go on, especially for the young. With Heart Mountain, as well as the camp barracks, in the background, a little girl enjoys a swing. Photographer: Hikaru Iwasaki, November 24, 1943.

National Archives photo no. 210-G-G-225

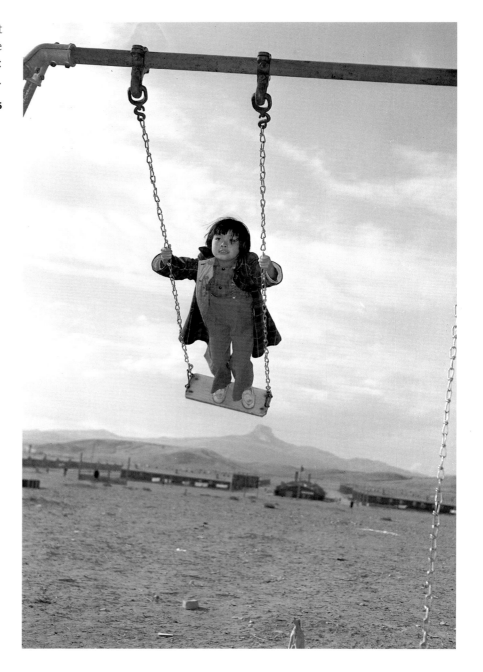

REFLECTIONS

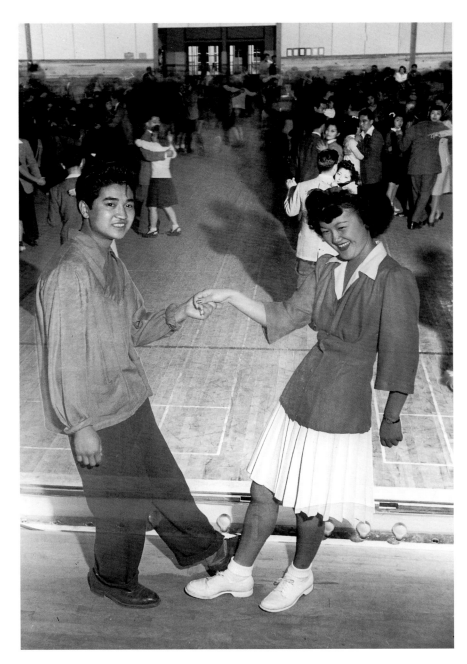

Laverne Kurahara and Tubbie Kunimatsu dance the jitterbug at a school dance held in the Heart Mountain high school gymnasium. Photographer: Hikaru Iwasaki, November 24, 1943.

National Archives photo no. 210-G-I-202

Mitzi Fujino (right) dances with Shig Sakamoto at an annual semi-formal dance at the YWCA Auditorium in Denver, Colorado. Photographer: Hikaru Iwasaki, June 14, 1945.

National Archives photo no. 210-G-I-931

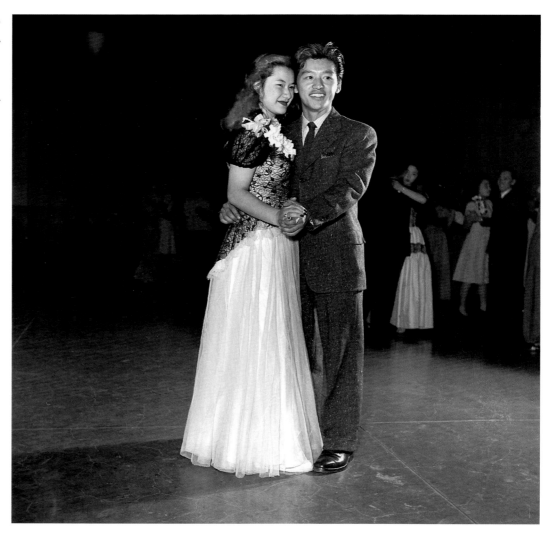

REAPPROPRIATION TWO: RESETTLEMENT CHALLENGES

I believe that WRA resettlement photographs can be deployed in order to criticize elisions in the historical record as well as to generate new oppositional accounts. Let me begin with

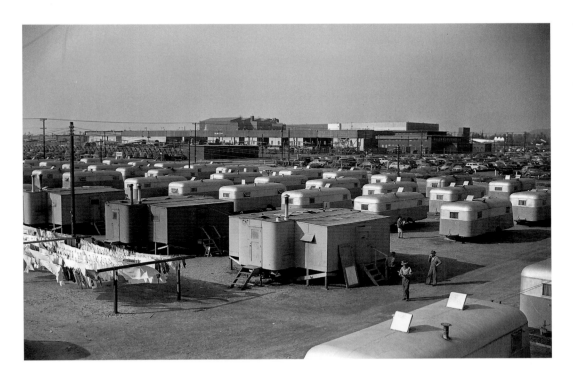

an example that revolves around the pressing problem of housing for the Japanese American resettlers.

Although the WRA admitted that obtaining housing could sometimes be a difficult task for resettlers, it claimed that it was doing what it could at various destination points.[2] These ameliorative efforts included finding temporary government shelter, seeking the cooperation and aid of churches and civic organizations for personal and group housing, and placing Japanese Americans in work situations in which room and board were included.

There are a copious number of Phase Two photographs that illustrate the above, all taken with the intent of showing a speedy and satisfactory process of adjustment. A critical review, or "re-viewing," of pictures related to housing, however, clearly demonstrates other processes at work. One is that Japanese Americans were often subject to substandard housing conditions. Although this fact has not been widely reported in the available literature, I have talked to a number of Nisei who recount that their early days after release were marred by poverty-stricken and therefore personally depressing living quarters.[3]

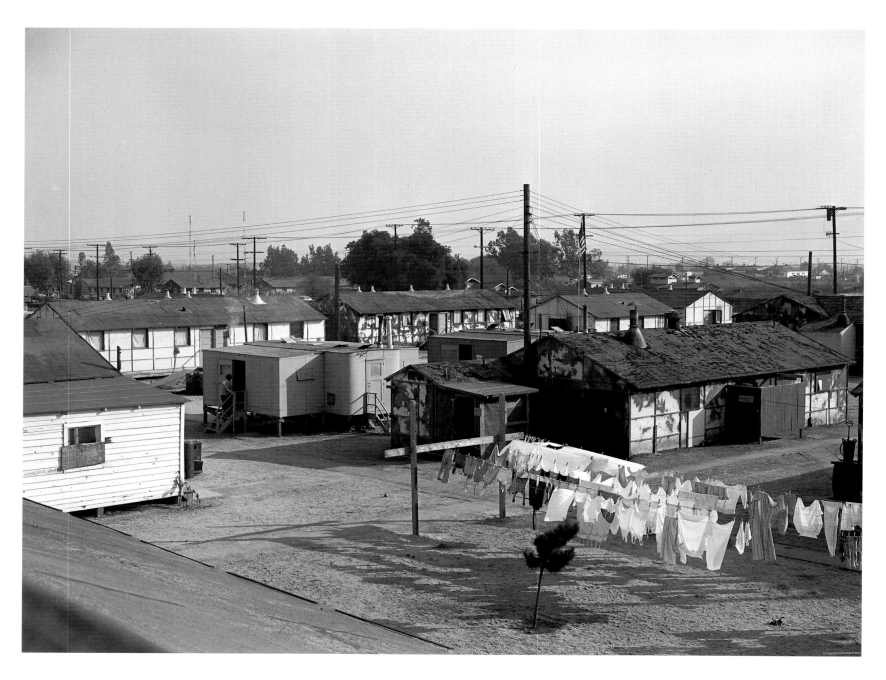

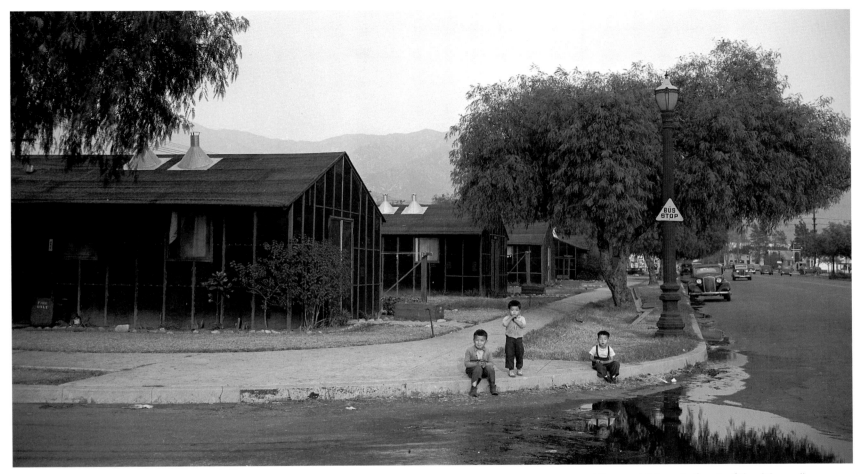

Three children in front of the Magnolia Housing Project in Burbank, California.
Photographer: Tom Parker, November 1945.

National Archives photo no. 210-G-K-493

I subsequently examined all WRA resettlement photos that were online as of 2006. I discovered that there were sets of shots documenting the poor quality of housing for Japanese American resettlers. WRAPS took series of photos in rural Colorado as well as in various farming areas of the country that illustrated squalid quarters hardly different from those found in the camps. Similar sequences were taken of the spartan settlements where resettlers lived in Burbank (northwest of Los Angeles), Hunters Point (out on the bay's edge of San Francisco), and Camp Funston, a military installation near San Francisco's Pacific coast beach.[4]

The barracks and cook shack of the Big Spruce Logging Company, Glenwood Springs, Colorado, which in August 1945 employed some two dozen Japanese Americans from five WRA camps. Photographer: O. Leon Anderson, August 1945.

National Archives photo no. 210-G-G-955

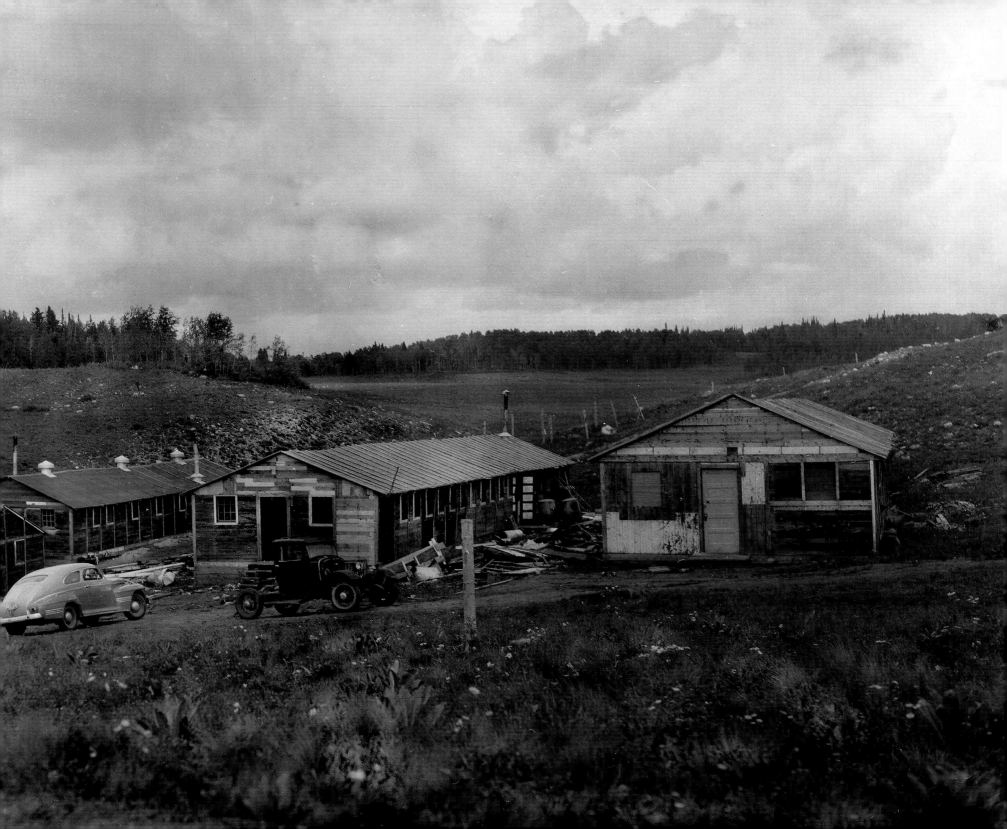

Temporary housing units at Hunters Point, San Francisco, about thirty minutes by bus to the center of the city. Photographer: Tom Parker, November 1945.

National Archives photo no. 210-G-K-456

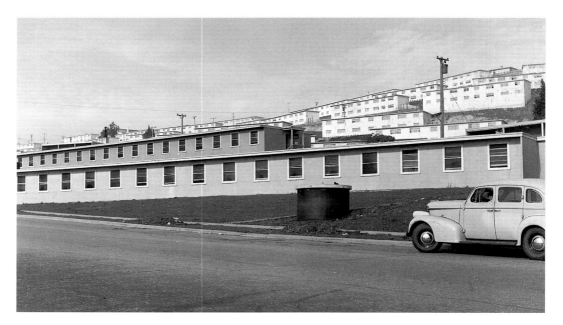

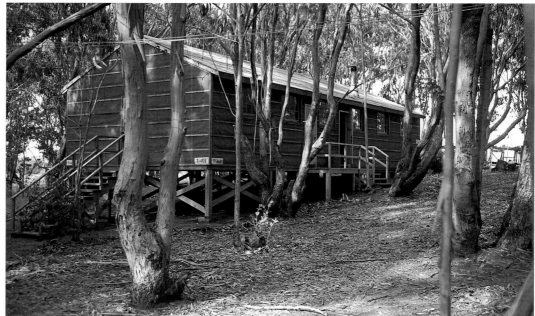

A typical family unit in the temporary housing project at Camp Funston, near Ocean Park in San Francisco, California. Photographer: Tom Parker, November 1945.

National Archives photo no. 210-G-K-453

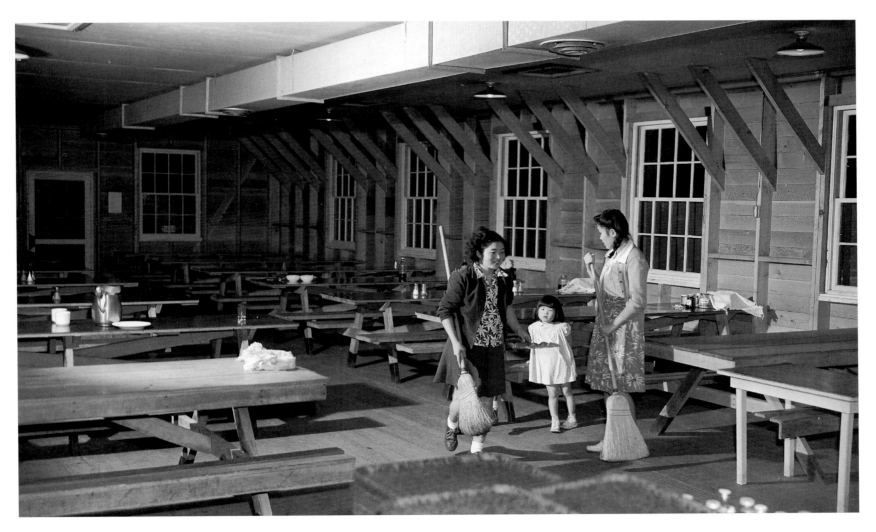

The official records hold a range of WRAPS resettlement photos that reveal the tremendous cooperative ethic that enabled Japanese American resettlers to make the most out of the available housing. In many cases, resettlers who may or may not have been related worked together to share, rent, and even build their own housing. The photos of the Nagai and Miyake families (p. 145) and the shot of Jimmy Nakatsu (p. 149) exemplify the counterinstitutional evidence that I am talking about.

The mess hall/dining room of the temporary housing project at Camp Funston, San Francisco, California. Photographer: Tom Parker, November 1945.

National Archives photo no. 210-G-K-452

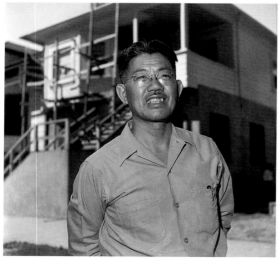

Buddhist Temple Hostel, Fresno, California (top); Peter Osuga in front of Hostel No. 1, Sacramento, California (bottom). Photographer: Hikaru Iwasaki.

National Archives photo no. 210-G-I-966

National Archives photo no. 210-G-K-210

This cooperative behavior seen in the WRAPS photos was at odds with the WRA-promoted ideal of dispersing the Japanese Americans to achieve resettlement goals. Sticking by their families and compatriots gave the resettlers a better chance of obtaining adequate housing during times of serious limitations, especially in major urban areas.[5]

Finding adequate housing was not the only difficulty faced by resettlers. Phase Two photos also reveal that the WRA's claims of fairness in employment opportunities were not always accurate, despite the fact that the resettlement pictures were taken in part to reassure Japanese Americans that opportunities were available on the outside if they made a sincere effort to join with and contribute to the larger society.

For example, the images and text from Iwasaki's photo essay focusing on the Oki family in the Heart Mountain camp (a selection of which are reproduced here; see p. 5) purport to illustrate how a "typical" Japanese American family in a WRA camp initiated the resettlement process. The shots show, in documentary fashion, the different steps as the family applies for, is cleared, prepares for release, and then boards the bus for freedom.

A critical rereading, however, clearly shows that the entire sequence actually documents the damage to Mr. Oki's promising career trajectory (see p. 5). Here is a college-educated professional who was on the cusp of building a very bright career, but he had to abandon it all when he was subjected to forced confinement in a harsh setting. True, he and his family were released in the end, but resettlement brought "freedom" in the form of displacement and downward occupational mobility. As Oki is shown in a factory in Cleveland, Ohio, spraying coating on plastics, the official WRA caption endeavors to suggest that there just might be a bright future for him if he hangs in there a little longer.

Another excellent example of counterinstitutional reading could be carried out on Iwasaki's photograph of Mr. Harvey Suzuki. This graduate of University of California at Berkeley in agricultural economics is photographed feeding chickens in Delaware (see p. 69).

It is important to remember that if only the most successful examples were depicted in the WRAPS photos, the average resettler's experience must have been even more difficult. With this in mind, a reexamination of the corpus reveals that resettlement often entailed an initial period of downward occupational mobility. Such experiences may even be subjected to analysis based on specific occupational sectors. The point is that all—Issei, Nisei, Kibei, and Sansei—with significant educational, managerial, and investment capital probably lost out during the war in terms of what they stood to gain if they had not been subject to removal.[6] A serious and

systematic study might well be able to use the WRAPS photos to further document the initial downward mobility of Japanese Americans in the months and quite possibly years after being released from the WRA camps.[7]

REAPPROPRIATION THREE: RECAPTIONING WRAPS PHOTOS

In a post-Redress context, individuals have begun to claim photos of themselves and family members and recaption them, implicitly or explicitly. Some appropriations along these lines involve tragedies; some, affirmations.[8] But in reclaiming these images and rewriting the captions, I sense the emergence of a post-Redress sensibility.[9] Japanese Americans should not forget the past, but perhaps now they can lay claim to the past in new and creative ways that are ultimately healing.[10]

As part of my preparation for writing this book, over the course of about a week I worked through all of the 1,300-plus of Iwasaki's photographs that were then on the JARDA and NARA Web sites. In the process, I flashed by a photograph that I did not print out at the time but I could not forget long after I had turned off the computer. The photograph was of five old Issei men. The caption identified these Issei individually by name as well as by their profession before the war. At the time this photo was taken they were residents in a home for senior citizens at San Francisco's Laguna Honda Hospital. One man, Mr. Takachika Fujii, was on crutches, and Mr. Kiyokichi Yamagishi was in a wheelchair. All of the men looked frail and worn as they posed with a Euro-American nurse outside of the hospital.

The reason I could not shake this image was in part that it was one of the few photos I saw online that acknowledged that there were Issei who were infirm after the war. In fact, there were thousands of first-generation men and women who, for whatever reasons, were simply not able to recover their lives or reclaim their homes after the end of the war. Although this was not an image that the WRA would have prioritized for circulation during the 1940s, there it was in the NARA collection, waiting for someone to see it and reread it in terms of its subtle but crushing implications. This photo was especially poignant to me because this particular image of old and infirm Issei resettlers resonates with my earliest memories as a child.

Before the war was over, my father's family (including my grandfather, grandmother, father, and the two youngest children in the Hirabayashi family—my aunt Esther and my uncle Richard) had resettled in Spokane, Washington. As the war ended and all but the Tule Lake camp were shut down, the WRA faced the problem of finding housing for the older, sometimes

Laguna Honda Home, San Francisco, California. From left to right are Mr. Yujiro Hoshino, Topaz; Mr. Yataro Takashima, Heart Mountain; Mr. Kiyokichi Yamagishi, Topaz; Mr. Takachika Fujii, Topaz; and Mr. Yasuhiro Inouye, Topaz. These gentlemen resided in San Francisco prior to evacuation. Mr. Fujii was a photographer, Mr. Hoshino was a house cook, Mr. Takashima was in the life insurance business, and Mr. Inouye was doing domestic work.—Photographer: Iwasaki, Hikaru—San Francisco, California. 7/24/45

National Archives photo no. 210-G-K-214

ORIGINAL WRAPS CAPTION, 1945

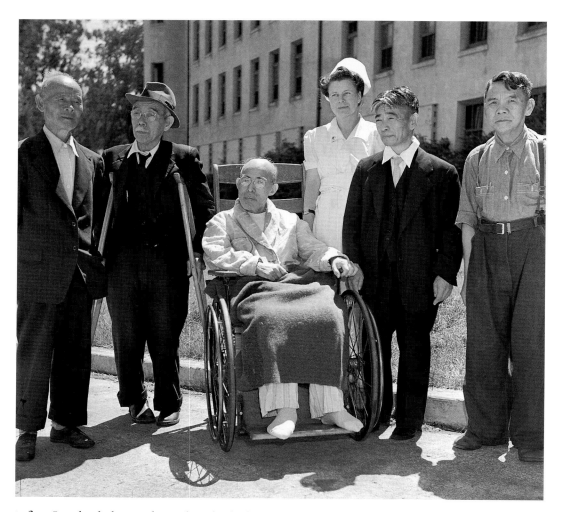

infirm Issei bachelors and couples who had no relatives to take them in or help care for them. Because of my uncle Gordon's ties to the Quakers, after the war ended the American Friends Service Committee offered to help my grandfather set up a special nursing home to take in elderly Japanese American resettlers. There my grandfather could house and care for the Issei bachelors and other senior citizens unable to go out into society, work, and otherwise start over.

My grandfather agreed to this proposal. Since running the facility was a large responsibility and there was only enough money to hire essential staff, the whole family pitched in to make

the enterprise viable. Thus, my earliest memories are of living with my mom, my grandparents, and extended family members in the Hirabayashi Nursing Home while my father was in Boston, working on his Ph.D. at Harvard University.

As I remember it, the facility was a family-style place where the Issei were made to feel at home. They could eat the foods they liked, cooked the way they liked, and spend their twilight years with compatriots who enjoyed similar pastimes, such as chatting, playing cards, and watching television as well as the occasional Japanese-language movies that were screened in the dining area. As the youngest child living in the rambling facility, I remember the old men (and a couple of ladies) around me, some of them chasing me away when I got too rambunctious, others spoiling me with attention as well as with candies.

After we moved away to Boston, and then eventually to San Francisco, I thought of the Hirabayashi Nursing Home in these terms. But later, as I started reading about Japanese American history as a college student, it gradually dawned on me that many of the seniors I had grown up around were in the nursing home because they were infirm, needed care, or otherwise had no particular place to go after the end of the war.

The plight of these Issei—single, elderly, infirm, poor—is something that I have not found discussed in any detail in the official WRA, or even in the scholarly, literature. I know of no particular record of the circumstances and stories of the Japanese American seniors like the ones living in the Hirabayashi Nursing Home in Seattle. So Iwasaki's single photo of the old and infirm Issei men in front of the Laguna Honda Hospital has to represent the thousands of Issei whose lives were ruined by federal policies and who did not have the energy or the resources to recover after they were released from camp. They cannot speak for themselves, so it remains for me, through one of the thousands of WRAPS photos, to convey their tribulations. Thus, in the memory of such Issei, I have reproduced this photo one more time, but this time with my narrative as I want their untold stories to be considered by future generations.

This, then, is what might be characterized as a post-Redress politics of interpretation.[11] In this process, the past and the present merge through artifacts like Carl Iwasaki's photographs more than sixty years after his WRAPS shots were taken.[12] Originally, this photograph had nothing to do with me. Yet when I gazed on that image of the elderly Issei men, personal/collective histories refracted, splintered, and were transformed as I recaptioned the photograph to intersect with my own biography and life's meanings. In that appropriation, I came to know the Japanese American experience, and myself, more deeply than I had known either before.

After I first saw this photo, I could not erase the image from my mind. My earliest memories are of elderly Issei who lived in the Hirabayashi Nursing Home after the end of the war. When I lived with them, I was not old enough to understand what brought us together. Now, twenty years after the Civil Liberties Act of 1988, I ask, Who will remember the thousands of Issei who could not recover after their release? Who can articulate their insecurity, losses, their pain when found "guilty by reason of race"? This picture compels me to raise these questions, even as it compels me to locate my childhood in the context of Japanese American resettlement.

LANE R. HIRABAYASHI, 2009

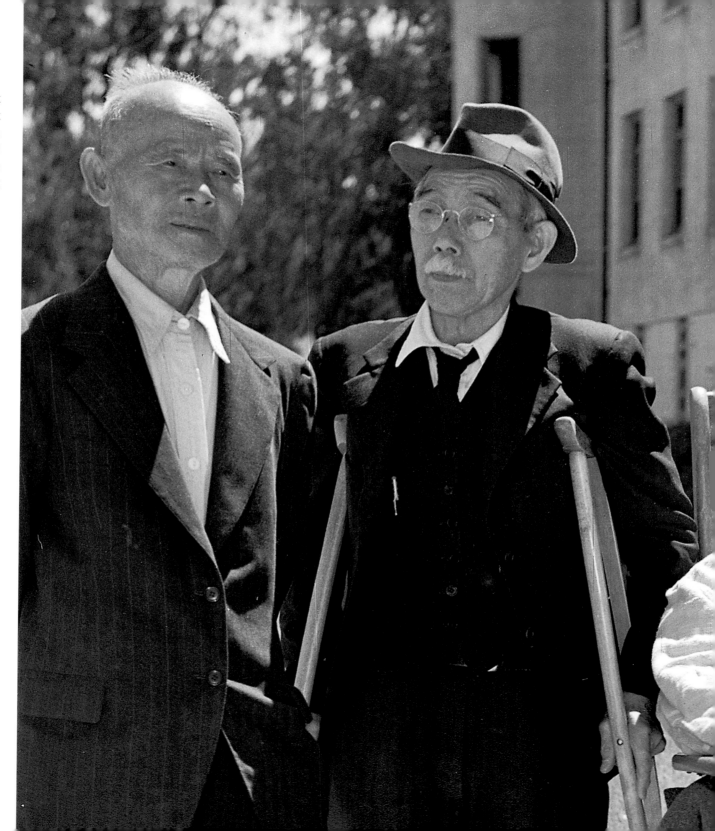

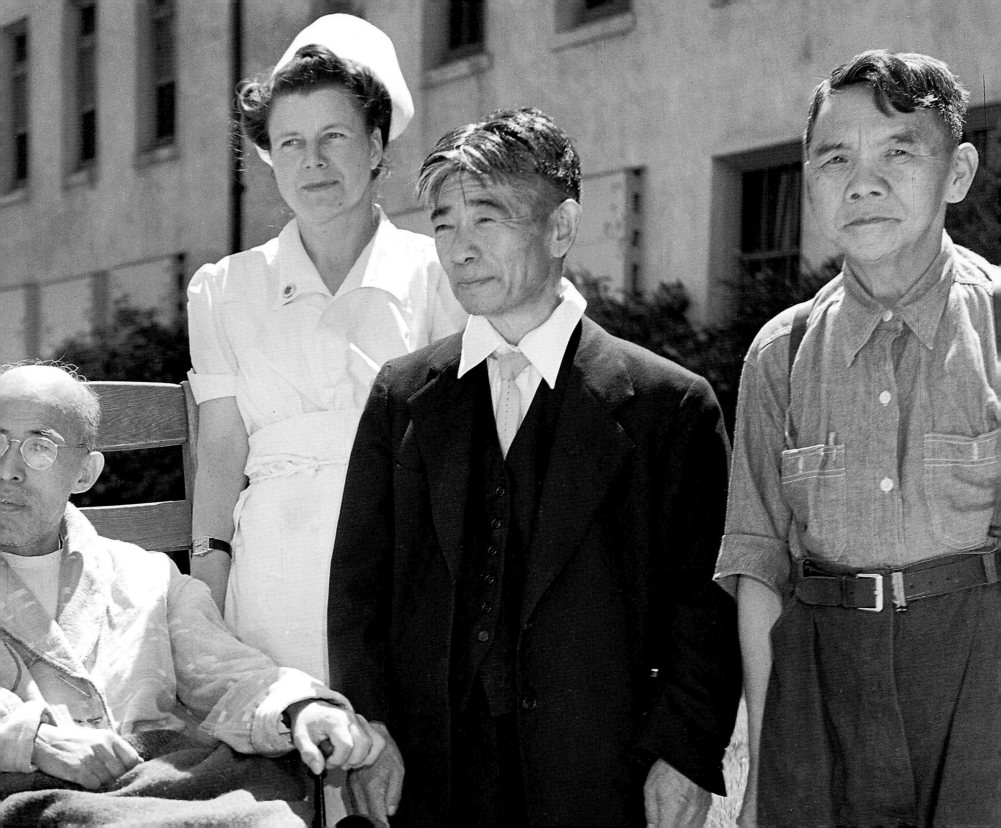

CONCLUSION

By highlighting the politics of the institutional photography in this book, I have argued that the use-value of the WRA photographs has been inherently shaped by the political projects of the WRA. I also believe that the use of these same photographs has been shaped by specific historical moments that reflect the needs of the Japanese American community at large.

In this sense, it is possible to identify a politics of Redress/Reparations that in the 1970s and 1980s shaped perception and selection of images. The Conrats' remarkable book *Executive Order 9066* exemplifies this orientation. Exercising a perspective very much within the larger interests of the community, the Conrats determined that only a few select WRA photographs really captured the travails of Japanese Americans who suffered mass removal and incarceration. Although this perspective had a significant function in a pre-Redress context, it now seems too limited. Not everyone received reparations, and so the crusade for justice still continues for some—most notably the Japanese Latin Americans. However, the Japanese American community in the United States can afford to start thinking about official documents, including the WRA photographs, in terms of a "post-Redress" field of interpretation.

My hope is that the information presented in this book about the WRA photographs— including the history, analysis, and examples of reappropriation—is a step toward this end. If nothing else, I am gratified if this book inspires many inside the community to re-view the WRA's photos and join me in an effort to reclaim them. If we can do this, future generations may view and appreciate the images, but do so with a different set of narratives. These new image-textual packages could be put on the record and written by those who experienced the 1940s, or by those, like myself, who have spent a great deal of time trying to understand an era when our families and communities were shaken to their very core.

Notes

PREFACE

1. The first publication making extensive use of WRA photographs, selected to illustrate the racism that mass removal and incarceration entailed, was Maisie and Richard Conrat's *Executive Order 9066: The Internment of 110,000 Japanese Americans* (Los Angeles: The California Historical Society, 1972). Other pre-Redress books that used photographs to illustrate the period are Ansel Adams's *Born Free and Equal* (New York: U.S. Camera, 1944) and Allen W. Eaton's *Beauty behind Barbed Wire: The Arts of the Japanese in Our War Relocation Camps* (New York: Harper, 1952). The story of how over 110,000 persons of Japanese ancestry were removed from their homes and communities and incarcerated by their own government during World War II is fairly well-known. An authoritative overview is available from the U.S. Commission on Wartime Relocation and Internment of Civilians, *Personal Justice Denied* (Washington,

DC: Government Printing Office, 1982). For details about many aspects of mass incarceration, a useful and readable resource, replete with bibliographic citations, is Brian Niiya, ed., *Encyclopedia of Japanese American History*, rev. ed. (New York: Facts on File, 1992).

2. The California Digital Library (CDS) features its WRA photos in the Japanese American Relocation Digital Library (JARDA). The URL for the overall site is http://www.calisphere.universityofcalifornia. edu/jarda. The bulk of the JARDA collection is properly seen as a subset of the official WRA photos that are held in the National Archives. Moreover, the 7,000-plus WRA photos that JARDA has put online are images derived from prints. Specifically, the Bancroft Library at the University of California at Berkeley holds only fifty-seven negatives. The bulk of the holdings are black-and-white 5" × 7" prints that

are stored in eighty-eight volumes. According to a principal curator, all of the 5" × 7" WRA prints held by the Bancroft Library have been digitized (Mr. Jack von Euw, Bancroft Library, personal communication, January 29, 2007). A finder's guide for the National Archives and Records Administration (NARA) holdings of War Relocation Authority photographs is available at the ARC Gallery: Japanese American Internment Web site, http://www.archives.gov/ research/arc/topics/japanese-americans/search-hints.html. A NARA curator explained to me that the National Archives holds the original WRA negatives, along with a complete set of small (e.g., 4" × 6" or smaller) first-generation prints attached to 5" × 8" mount cards (Nicholas Natanson, NARA, Branch II, Still Pictures Unit, personal communication, November 13, 2007). Similarly, there is a series of related Wartime Civil Control Administration

(WCCA) photographs that were taken under the auspices of the Office of War Information. See the summaries put online by the Library of Congress, pertaining to both black-and-white and color photos, available at http://memory.loc.gov/ammem/collections/anseladams/aamrel.html. Many of these photos were taken in 1942 as Japanese Americans packed up, were transported, and were incarcerated in points of assembly by the WCCA. These early photos are what we call "Phase One" of what became the WRA's photo operation. Readers should note that none of the online collections represent the entire set of official WRA photographs held in the National Archives and Records Administration, Still Pictures Section, Branch II. One might ask, how many official government photos are we talking about in total? Without citing a source, the Conrats, in *Executive Order 9066*, claim that, counting the images made during that period, there are some 25,000 photographs dealing with the evacuation. The National Archives records, however, indicate that it holds almost 17,000 images classified as WRA 210.3.4 "Records of relocation centers" (see http://www.archives.gov/research/guide-fed-records/groups/210.html). Despite the discrepancy in numbers, no matter how you count them, there are a lot.

3. Materials in the public domain can be used by anyone without obtaining permission, unlike copyrighted material, which usually requires a signed permission agreement from the copyright holder.

4. See the entry "Resettlement" in *Encyclopedia of Japanese American History* for a discussion of the phenomenon and a list of published books and articles that have focused on this topic; Brian Niiya, ed., *Encyclopedia of Japanese American History*, rev. ed. (New York: Facts on File, 1992), 347–348. Niiya refers to those who fled the West Coast before the execution of Executive Order 9066 as "voluntary resettlers." This book does not include such persons.

CHAPTER 1

1. For a firsthand account of this policy by the then-head of the WRA bureaucracy, see Dillon S. Myer's *Uprooted Americans: The Japanese Americans and the War Relocation Authority during World War II* (Tucson: University of Arizona Press, 1971). The archival record provides indispensable insights into how the WRA bureaucrats rationalized their mission. An excellent example appears in Solicitor's Memo #11, 1942 ("Constitutional Principles Involved in the Relocation Program," Japanese Evacuation and Resettlement Study, Reel 23, Frame 577 [originally JERS file E 2.23]), in which the WRA's solicitor, Philip Glick, claims that the WRA leave regulations were essential to the legal foundation of the Authority because "[t]hese leave regulations establish a procedure under which the loyal citizens and law-abiding aliens may leave a relocation center to become reestablished in normal life." The rules and regulations governing leaves were established as of at least September 1942; see Dillon Myer's "Circular Letter, No. 71," to all project directors, subject "Application for Leave," Japanese Evacuation and Resettlement Study, Reel 20, Frame 435 (JERS file D 4.00).

2. For a theorized perspective on the power of a photograph, see John Tagg, *The Burden of Representation* (Minneapolis: University of Minnesota Press, 1993). For related perspectives, see James C. Faris, "A Political Primer on Anthropology/Photography," in *Anthropology and Photography 1860–1920*, ed. Elizabeth Edwards (New Haven, CT: Yale University Press, 1992); Allan Sekula, *Photography against the Grain: Essays and Photo Works, 1973–1983* (Halifax, Nova Scotia: Press of the Nova Scotia College of Art and Design, 1984); Sekula, *Dismal Science: Photo Words, 1972–1996* (Normal: University Galleries, Illinois State University, 1999), 155; and Boris Kossoy, "Reflections on the History of Photography," in *Photography: Crisis of History*, ed. Joan Fontcuberta (Barcelona: ACTAR, 2002).

3. There is no definitive study of the Wartime Civil Control Administration. Many basic records of the WCCA, however, are available in the Japanese Evacuation and Resettlement Study Records, BANC MSS 67/14 c, "The Wartime Civil Control Administration," Reels 12–14, Bancroft Library, University of California, Berkeley.

4. See Roger Daniels, *Concentration Camps, North America* (Malibar, FL: Krieger Publishing, 1983), for a thoughtful and balanced overview of mass incarceration.

5. The most comprehensive treatment available on how the WRA, the Armed Forces, and government bureaucrats handled the question of loyalty is Eric Muller's *American Inquisition: The Hunt for Japanese American Disloyalty in World War II* (Chapel Hill: University of North Carolina Press, 2007).

6. "Work of the War Relocation Authority: An Anniversary Statement by Dillon S. Myer, March, 1943," 2, passim, Papers of Dillon S. Myer, Harry S. Truman Museum and Library. All of the documents by Myer cited as being held by the Harry S. Truman Museum and Library can be found at http://www.

trumanlibrary.org/whistlestop/study_collections/ japanese_internment/docs.php.

7. "Press Conference of Dillon S. Myer," Washington, D.C., May 14, 1943, 25. Dillon S. Myer, Harry S. Truman Museum and Library. Perhaps the most detailed analysis of the evolution of the WRA's rhetoric in regard to Japanese American resettlement is presented in an unpublished dissertation by Michael John Wallinger, "Dispersal of the Japanese Americans: Rhetorical Strategies of the War Relocation Authority, 1942–1945" (Ph.D. dissertation, Department of Speech, University of Oregon, 1975).

8. See the fascinating study by the historian Richard Drinnon, *Keeper of Concentration Camps: Dillon S. Myer and American Racism* (Berkeley: University of California Press, 1987), in which Drinnon draws from declassified FBI documents to show that the Bureau was involved in surveillance of relocated Japanese Americans in key destination points, such as Chicago, Illinois. Drinnon was one of the first scholars to correctly indicate that the seemingly benign assimilationist policies that Myer promoted—first as director of the WRA and then as the director of the Bureau of Indian Affairs—damaged the "subjects" who suffered their consequences.

9. Muller, *American Inquisition*, chapters 6–9.

10. See Myer's comments in the following statement: "Speech transcript, 'The Relocation Program' (Myer's address to a meeting of the State Commanders and State Adjutants of the American Legion in Indianapolis, Indiana), November 16, 1943," 6–7, passim, Papers of Dillon S. Myer, Harry S. Truman Museum and Library.

11. Drinnon, *Keeper of Concentration Camps*, 52–54.

12. See my review of Drinnon's *Keeper of Concentration Camps, San Francisco Chronicle*, "Book Review," January 18, 1987, 1.

CHAPTER 2

1. The first published account of the WRA's photographic mission and activities that I have located is Sylvia E. Danovitch's "The Past Recaptured? The Photographic Record of the Internment of Japanese-Americans," *Prologue: The Journal of the National Archives* 12:2 (Summer 1980):91–103. Similarly, Danovitch is the first author I know of who pointed out the importance of WRA Administrative Instruction No. 74, titled "Photographic Documentation of the WRA Program." The first paragraph of this document states: "It is the intention of the War Relocation Authority to document its program as fully as possible. . . . Photographs will be used not only for documentary purposes, but also for information to be made available to the public and to the evacuees" (WRA, January 8, 1943, 1, WRA Control Files, National Archives and Records Administration, 23.1). Danovitch's account, however, does not address the full range of key issues, such as censorship, the staging of WRA photo shoots, or the production, selection, and handling of the official WRA photographs.

2. Little is known about Clem Albers beyond the fact that he worked for the *San Francisco Chronicle* both before and after the war. One of the few published accounts is a brief biography available in Gerald H. Robinson's *Elusive Truth: Four Photographers of Manzanar* (Nevada City, CA: Mautz, 2002). Some of Albers's photographs of Manzanar are available online at http://www.nps.gov/manz/photosmultimedia/ clem-albers-gallery.htm. I briefly discuss the three other key Phase One photographers herein.

3. Clem Albers, Dorothea Lange, Russell Lee, and Francis L. Stewart were among the first official photographers assigned by government agencies to photograph mass incarceration. In 1943, as the WRA's Photographic Section was solidified, they all moved on to other projects. Ansel Adams also took photographs of the Japanese Americans, but as an independent photographer because he never was employed by the WRA. Adams had been invited to take his famous photographs in the WRA's Manzanar camp by its director, Ralph Merritt. Adams's story is well documented. An interesting and accessible Web site featuring biographical details as well as Adams's photos is http://memory.loc.gov/ammem/collections/anseladams/aamabout.html. Other Manzanar photographs were taken by Issei photographer Toyo Miyatake, who smuggled lenses into the camp, built a wooden camera, and shot surreptitiously for a period. Eventually, when his activities became known, Miyatake was hired by Manzanar's administration to document camp life, but his activities were carefully monitored. A wonderful documentary about Miyatake, including his stint as a clandestine and then official photographer of Manzanar, is available in the video *Toyo Miyatake: Infinite Shades of Gray* (directed by Robert A. Nakamura; Los Angeles: UCLA, Visual Communications, Inc., 2002). This program is currently available for purchase and is marketed by the Japanese American National Museum, Los Angeles, California.

4. F. Jack Hurley, *Portrait of a Decade: Roy Stryker and the Development of Documentary Photography in*

the *Thirties* (Baton Rouge: Louisiana State University Press, 1972), 164. Also see F. Jack Hurley, *Russell Lee: Photographer* (Dobbs Ferry: Morgan and Morgan, 1978), 21.

5. A solid history of the Office of War Information is available online in the 1946 United States Government Manual, "Emergency War Agencies: Office for Emergency Management," http://ibiblio.org/hyperwar/ATO/USGM/EEWA. html. This official document spells out the relationship between the OWI and agencies like the WRA. Also see Allan M. Winkler, *The Politics of Propaganda: The Office of War Information, 1942–1945* (New Haven, CT: Yale University Press, 1978). For a useful historical context surrounding the question of censorship, see Michael S. Sweeney, *Secret of Victory: The Office of Censorship and the American Press and Radio* (Chapel Hill: University of North Carolina Press, 2001). For a discussion of how censorship affected news in the WRA camps, see Takeya Mizuno's "The Creation of the 'Free' Press in Japanese-American Camps: The War Relocation Authority's Planning and Making of Camp Newspapers," *Journalism and Mass Communication Quarterly* 70:3 (2001):503–518.

6. Although vague on the details, Judith Davidov implies that Dorothea Lange worked first for the U.S. Army and then for the WRA; see Judith Freyer Davidov, "The Color of My Skin, the Shape of My Eyes: Photographs of the Japanese-American Internment by Dorothea Lange, Ansel Adams, and Toyo Miyatake," *The Yale Journal of Criticism* 9:2 (1966):223–227. F. Jack Hurley is equally vague about the terms of Russell Lee's employment, saying only that "[Roy] Stryker cleared the necessary permissions through Washington" before Lee went to work. See Hurley, *Russell Lee*, 21. The implication is that Lee worked for the OWI rather than for the WRA. Partial

confirmation of this fact is that Lee's photographs of Japanese Americans are available online as part of the OWI/WCCA photo collection. Interested readers can peruse a series of WCCA photographs taken by Russell Lee under the auspices of the Office of War Information. These are online at http://memory.loc. gov/ammem/collections/anseladams/aamrel.html. Many of these photos were taken in 1942 and are good examples of Phase One of the WRA's photo operations.

7. Linda Gordon, "Dorothea Lange Photographs the Japanese American Internment," in *Impounded: Dorothea Lange and the Censored Images of Japanese American Internment*, ed. Linda Gordon and Gary Y. Okihiro (New York: W. W. Norton, 2006), 5–45.

8. Kenichiro Shimada found a letter from John C. Baker, chief of the WRA's Office of Reports, to Dorothea Lange, dated July 1, 1943, in which Baker wrote that he was "glad to lend you the negative A-76, which you took for us last year" (National Archives and Records Administration, WRA File, 22.610). Given the pace at which she was working, it seems unlikely that Lange developed and printed much output herself. Thanks to Professor Malcolm Collier for this insight (personal communication, May 2008).

9. We are grateful to our colleague Professor Takeya Mizuno for sharing an internal memo written by WCCA public relations officer Major Norman Beasley to a WRA bureaucrat in the Authority's San Francisco regional office. Beasley essentially informed the WRA that the Western Defense Command had the right to review and censor any photographs that were taken "of the evacuation process" or "within the Centers themselves" (Beasley to Edwin Bates, June 9, 1942, National Archives and Records Administration, RG 210, Entry 38, Box 2, File 005.1). See Linda Gordon's biography of Lange, in Linda Gordon and

Gary Y. Okihiro, *Impounded: Dorothea Lange and the Censored Images of Japanese American Internment* (New York: W. W. Norton, 2006), for specific details about Major Beasley's harassment of Lange.

10. Judith Keller, *In Focus: Dorothea Lange: Photographs from the J. Paul Getty Museum* (Los Angeles: J. Paul Getty Museum, 2002), 142. Roger Daniels offers useful insights into the continuity between New Deal and WRA programs' use of photography in his chapter "Dorothea Lange and the War Relocation Authority: Photographing Japanese Americans," in *Dorothea Lange: A Visual Life*, ed. Elizabeth Partridge (Washington, DC: Smithsonian Institution Press, 1994), 46–55.

11. The bureaucratic evolution of the WRA is detailed in the official WRA publication *Administrative Highlights of the WRA Program* (Washington, DC: U.S. Government Printing Office, 1946).

12. A short biography of Joe McClelland is available online at http://www.aceweb.org/leadersh/mcclelland.html. Many of McClelland's WRA photographs are related to his work as RO at Camp Amache (also known as Granada), a WRA camp near Lamar, Colorado. Another WRA camp RO who took and submitted photos that became part of the WRA's official record is Pauline Bates Brown. Although it is not known if she had a background in photography before the war, Brown took a number of pictures at the Colorado River Relocation Center (also known as Poston) for the WRA that eventually became part of the Authority's official collection. Some of her photographs in the National Archives record an arson incident in the Euro-American housing quarters inside the Poston camp. This arson was alleged to have been carried out by disgruntled Japanese Americans against the camp's APs. In addition to the photographers named here, a number of unidentified photographers

are represented in the WRA's official photographic record. At least some of these individuals were local WRA camp ROs.

13. A selection of McClelland's photographs, most of the WRA camp popularly known as Amache, can be found online on the Japanese American Relocation Digital Archive (JARDA). McClelland continued his career in journalism after the war and eventually served as the president of the Association of Communication Excellence from 1957 to 1958.

14. Opinion No. 24, from the Solicitor's Office to the Director (of the WRA), Subject: Censorship of Photographs Taken by the War Relocation Authority at Relocation Centers, October 10, 1942, National Archives and Records Administration, WRA File number 32.110. See also a declassified FBI document that confirms this information. The document in question is an official memorandum from D. M. Ladd, assistant director of the FBI, to John Edgar Hoover, director, dated December 15, 1942. Ladd forwarded to his boss information that included a section concerning the WRA's stance vis-à-vis the censorship of photographs as of the end of 1942. The information presented is fully consistent with the opinion presented in Opinion No. 24. The URL for this memo is http://home.comcast.net/~eo9066/1942/42-12/IA092.html. What is interesting about both documents is that they suggest that newspaper photographers may have had more leeway to shoot what they pleased than did Phase One or even Phase Two WRA photo staff.

15. Data and quotes are from Parker's Federal Employment Application Forms (dated June 4, 1948, and October 17, 1949), which were released to me by the National Personnel Records Center.

16. Administrative Instruction No. 74, titled "Photographic Documentation of the WRA Program" (WRA, January 8, 1943), 1, WRA Control Files, National Archives and Records Administration, File 11.211.

17. Ibid., 3–4.

18. These points were taken from the WRA's postwar publication *Administrative Highlights of the WRA Program* (Washington, DC: U.S. Government Printing Office, 1946).

19. This interpretation is based on James L. McCamy's account in *Government Publicity: Its Practice in Federal Administration* (Chicago: University of Chicago Press, 1939). McCamy, who knew Roy Stryker, included a discussion of still photography in his text and featured the Farm Security Administration's contributions to federal rural relief policies in a number of illustrative passages in his book.

20. Indexicality has often been identified as the central attribute of the photograph. This characteristic has been heavily examined by theorists because of the epistemological assumptions embedded in realism. For a classic treatment, see Richard Shiff, "Phototropism (Figuring the Proper)," *Studies in the History of Art* 20 (1989):169–171. A useful introduction to the relevant literature and debate appears in James Elkins, ed., *Photography Theory* (New York: Routledge, 2007), 125–155, passim.

21. Letter, M. M. Tozzier to Tom Parker, December 3, 1943. More generally, Dillon Myer's speeches and press while he was head of the Authority until the end of World War II reflect his orientation toward release of loyal Americans. The relevant materials go back to 1943 and are included in a section on the War Relocation Authority in the Truman Library; see http://www.trumanlibrary.org/whistlestop/study_collections/japanese_internment/docs.php.

22. The official WRA publication in regard to resettlement is the U.S. Department of the Interior's publication *The Relocation Program* (Washington, DC: U.S. Government Printing Office, 1946). According to Dillon S. Myer in his book *Uprooted Americans*, *The Relocation Program* was prepared for the Authority by Rex Lee, head of the WRA's Relocation Division. Although it contains useful information, Lee's total endorsement of the WRA's resettlement policies renders his work of little value in terms of critical analysis of the Authority's mission or impact (p. 350).

23. Parker's Federal Employment Application Forms, 1948, 1949.

24. Francis L. Stewart's prewar biography and employment history are delineated in his "Request for Personnel Action," made to the Office for Emergency Management on July 17, 1942, National Personnel Records Center, St. Louis, Missouri.

25. Information about Mace's life and prewar photo work in the Rocky Mountains of Colorado is derived from *Estes Park Trail Gazette* (August 1931 and January 1973).

26. Projected WRAPS budget, n.d., but ca. late 1943. Projected budgets were part of the standard operating procedure for the WRA's different departments. The WRAPS office records and correspondence cited in this chapter were located by Kenichiro Shimada in the National Archives and Records Administration, Washington, D.C. This material was difficult to identify because the documents and correspondence are not classified in files indicative of the close operational ties between the WRA's Office of Information in Washington, D.C., and the WRA's Photographic Section. Shimada deserves full credit for locating the archival documents in R.G. 210, File 22.610, and related files. The letters, cited by date here and below, are from that file.

27. Iwasaki interview, September 20, 2006, Denver, Colorado. Among the clerical staff, Iwasaki remembered a Nisei woman (possibly with the surname Masunaga) and a couple of Euro-American women—a Miss Truesdale and a Miss Winters—all of whom helped Edna George with the secretarial work.

28. I am grateful to the Aoyama family—especially Mr. Calvin Aoyama, Bud's nephew—for their generous help in ascertaining key facts about Takashi Aoyama.

29. It is not certain if Bud was Aoyama's legal name; he is referred to as both "Bud" and "Takashi" in the WRAPS office correspondence. Perusal of Aoyama's online photographs indicates that he submitted shots of Heart Mountain, resettlers, and Japanese Americans serving in the U.S. Army.

30. The late Tom Masamori was the person who first told me about Carl Iwasaki when I was a member of the Japanese American Community Graduation Program (JACGP), Denver, Colorado, during the 1990s—an organization that we both belonged to and volunteered for. Masamori was himself an avid photographer and often took pictures at local community events, many of which were then published in vernacular newspapers.

31. This was Iwasaki's explanation for why he, Parker, and Mace did not use the Speed Graphic camera even though photos taken with it were of superior quality. For some technical details of the cameras used by WRA photographers, see Gerald H. Robinson, *Elusive Truth: Four Photographers of Manzanar* (Nevada City, CA: Mautz, 2002), 51n22, 52n36.

32. I have chosen to cite assignments during the year 1944 to exemplify how much ground Iwasaki covered to photograph resettlement in many different regions of the United States.

33. Examination of the Oswego photographs that are online indicates that Iwasaki's WRA colleague Gretchen Van Tassel was also assigned to take pictures at that facility. It was difficult to obtain information about Van Tassel, although she appears to have been trained as a professional photographer. While she worked for the WRA, Van Tassel was the main secretary in the Reports Division who handled the WRAPS photos. After the war, Van Tassel worked for the Federal Public Housing Authority.

34. Some of the press clippings that document the use of WRAPS photographs in displays at the Topaz, Gila River, Heart Mountain, and Jerome WRA camps are available in the War Relocation Authority, "WRA Information Digest," March 1945 (Los Angeles: UCLA Libraries).

35. The JARDA online collection contains many photos of Japanese American veterans recovering at army medical facilities. Along with students and men and women at work, Nisei in uniform and wounded veterans were featured subjects of WRAPS work. For good overviews of stories of service, see Masayo Duus, *Unlikely Liberators* (Honolulu: University of Hawaii Press, 1987), and Gary Y. Okihiro, *Storied Lives* (Seattle: University of Washington Press, 1999).

36. Letter, Tozzier to Parker, June 20, 1944. Documenting these events was so important that local photographers were hired occasionally to do quick assignments, when it proved difficult for WRAPS photographers to be on location or when the WRAPS staff needed additional support. The WRA bureaucrats hired, for example, a local photographer to shoot the departure of Japanese Americans from Jerome, as well as their arrival at different destination points. Also see letter, John C. Baker to Charles E. Mace, May 14, 1944.

37. I was unable to find any online examples of the photographs that Iwasaki said he took in and near Kent, Washington. This does not mean, however, that these shots were impounded; they simply may not have been put online yet. Unfortunately, none of the online photo Web sites provide information about how the images that appear were selected, how many images are not online yet, or even how many more images the sites plan to post in the future. Through personal inquiry I did learn that the Bancroft Library does not intend to digitize its negatives, which only number fifty-seven. The Bancroft has already digitized the approximately 7,000 official WRA photographic prints it presently holds in its collection (Mr. Jack von Euw, personal communication, January 29, 2007).

38. Letter, Evacuee Property Office to the WRA's Photographic Section, November 30, 1945.

39. This was one among a number of explicit letters documenting that WRAPS photographs had to be cleared by the War Department before they could be released for distribution and publication.

40. Letter, September 17, 1945. Unfortunately, specific details, such as who took the photograph in question and what was the questionable subject, are not given.

41. I asked Iwasaki about censorship on a number of occasions, and he always insisted that he had freedom to shoot whatever he wanted to and was never interfered with at work.

42. Phone conversation between Iwasaki and Lane R. Hirabayashi, February 3, 2007. The original negatives, which were held in the WRAPS office in Denver, were transferred to the National Archives after the end of the war.

43. There are a variety of WRAPS photos that show how WRAPS photos were used in the field for public relations purposes. We have reproduced only some illustrative examples herein. No one, to the best of our knowledge, has systematically evaluated the impact of the WRAPS photos inside or outside of the camps.

44. NARA II holds four films in Record Group 210.6, "Motion Pictures": *Go for Broke, The Way Ahead, A Challenge to Democracy, Valor: Jap-American* [sic] *Soldiers Win Combat Citations.*

45. John Tagg, in *Burden of Representation*, and Allan Sekula, in *Photography against the Grain: Essays and Photo Works, 1973–1983* (Halifax, Nova Scotia: Press of the Nova Scotia College of Art and Design, 1984) and *Dismal Science: Photo Words 1972–1996* (Normal: University Galleries, Illinois State University, 1999), are perhaps the most articulate theorists of this broad position. An excellent discussion of photographs used by the state for its political agendas is available in Nick Natanson's "Old Frontiers, New Frontiers: Reassessing USIA and State Department Photography of the Cold War Era," http: wwwarchives.gov/research/cold-war/conference/natanson.html (1999).

46. See McCamy, *Government Publicity*. Abigail Solomon-Godeau points out that when considering a photograph, "the resulting image is thought to have a relation to the real. . . . It is precisely this assumption that has underwritten all the juridical, evidentiary, scientific, and veristic uses of the medium"; Abigail Solomon-Godeau, "Assessments," in *Photography Theory*, ed. James Elkins (New York: Routledge, 2007), 260. It is also imperative to highlight the distinction between the style of the WRAPS photographers and the discipline of visual anthropology; see John Collier Jr., *Visual Anthropology: Photography as a Research Method* (New York: Holt, Rinehart, and Winston, 1967); John Collier Jr. and Malcolm Collier, *Visual Anthropology*, rev. and exp. ed. (Albuquerque: University of New Mexico Press, 1986). If the latter exemplifies the standard of work that allows documentary photography to serve as a serious foundation for ethnography, then WRAPS photo work is best characterized as photojournalism.

47. See Wallinger, "Dispersal of the Japanese Americans," 1975.

48. At one point in an extended face-to-face interview, I asked explicitly if the WRAPS photographers had ever discussed critical perspectives on the camps and on resettlement. Or if they had ever talked about using their photos to comment on what was going on or how they as photographers felt about it. According to Iwasaki, these topics never came up as far as he knew. I mentioned Dorothea Lange's work as an example of this critique. Iwasaki acknowledged that her work involved critique, both during the 1930s and in her work with Japanese Americans during the 1940s. He commented, "That's why she's a great photographer." It is certainly worth noting that Lange was already in her mid-forties when she photographed the mass incarceration. She was also a trained, well-established professional who had worked under Roy Stryker's direct supervision using the FSA's tradition of photographic advocacy plus art. See Elena Tajima Creef, *Imaging Japanese America: The Visual Construction of Citizenship, Nation, and the Body* (New York: New York University Press, 2004).

49. Tom Parker, Federal Employment Application Forms, 1948, 1949.

CHAPTER 3

1. Robert Hariman and John Lucaites present a masterful discussion of what constitutes an iconic photograph and how such images can capture the public imagination vis-à-vis contemporary crises. See Hariman and Lucaites, *No Caption Needed* (Chicago: University of Chicago Press, 2007). Although none of Iwasaki's photographs made Conrat and Conrat's *Executive Order 9066*—surely one measure of iconic status in terms of photos of Japanese Americans and mass incarceration—I present a number of his images that have been used to the point that they are recognizable.

2. A fascinating sample of Carl Iwasaki's postwar photographs is available online at http://www.getty_images.com and now includes some of Iwasaki's work for *Sports Illustrated*. (To access these images, select "Images" and then "Editorial" and enter "Carl Iwasaki.") These images also provide a sense of how many different kinds of famous people, from many different walks of life, Iwasaki photographed over the course of his illustrious career.

3. The biographical data were provided in a series of phone conversations, as well as an extended personal interview, with Hikaru Iwasaki. The phone conversations took place in 2006 and 2007. The personal interview took place in Denver, Colorado, on September 20, 2006. I also spent afternoons with Iwasaki in Los Angeles on January 4, 2007, and June 18, 2008. Since my approach to interviews is somewhat unorthodox (or so I have been told), it seems worthwhile to describe it in some detail. I start by clearing my work with the university's human subjects review committee. This process is sometimes time-consuming, and sometimes annoying, but I believe that subjects have rights and protections, and so I like to follow protocol. (I cleared this project through the University of California at Riverside's Human Subjects Office: Human Subjects Protocol HS-06033, titled "Images of Resettlement," 2006–2007.) When I make contact with individuals to ask for an

interview, I also explain the project and their right to informed consent. This step includes the point that at any time and for any reason my respondents are free to terminate our conversations. They also have the right to ask me not to use the interview(s) or the data for research purposes. I tend not to tape record or videotape my interviews because I like the casual and free-flowing interaction I get when I can interact with and respond freely to whomever I am talking to. Furthermore, I personally am not able to concentrate and think about a conversation if I am worried about machinery. Instead, I tend to write notes soon after the conversation or interview is over, and then I type up detailed notes while the interaction is still fresh in my memory. I was taught to do field interviews for sociocultural anthropology using this system in the mid-1970s. Over the years, I have begun sharing my rough interview notes with the respondent. I initially gave drafts of my notes to Iwasaki to review, partly to make sure I got his story right and partly because I hoped that he would want to amplify certain subjects that we had covered. Subsequently, I sent him an entire rough draft of this book in manuscript form to make sure that he understood the project and agreed with my representations and analysis.

4. I offer some information about Santa Anita and its camouflage net production in my *Inside an American Concentration Camp* (Tucson: University of Arizona Press, 1995), 24–32.

5. His close ties to his high school classmates indicate that Carl was not cut off or alienated from the Euro-American mainstream.

6. Early on, however, some youth were actually arrested for sledding outside of the formal boundaries of Heart Mountain. See Mike Mackey, *Heart Mountain* (Powell, WY: Western History Publications, 2000), 71. Strict regulations along these lines were relaxed as the war, and especially threats to internal security, gradually wound down.

7. The WRAPS resettlement shots have the same photographic themes established by those taken by the Farm Security Administration; that is, these pictures were designed to inscribe subjects as normal Americans—human beings—who were doing the best they could despite challenging circumstances, imbuing the photographs with something of a heroic sense.

See F. Jack Hurley, *Portrait of a Decade: Roy Stryker and the Development of Documentary Photography in the Thirties* (Baton Rouge: Louisiana State University Press, 1972).

8. The Conrats were probably the first published authors to note this aspect of the WRA photographic corpus; Conrat and Conrat, *Executive Order 9066*, "Foreword," n.p. The Conrats posited that the smiling responses of Japanese Americans were caused by the fundamental awkwardness of the WRA photographers. Wendy Kozol has published a number of pieces commenting on the smiles of the Japanese Americans, as well as the posed nature of WRA photographs. See, for example, her review, "Marginalized Bodies and the Politics of Visibility," in *American Quarterly* 57 (2005):237–247. She, however, does not mention the Conrats' original speculation. Also see Wendy Kozol, "Relocating Citizenship in Photographs of Japanese Americans during World War II," in *Haunting Violations: Feminist Criticism and the Crisis of the "Real,"* ed. Wendy Hesford and Wendy Kozol (Urbana: University of Illinois Press, 2001).

CHAPTER 4

1. It seems strange that the WRA invested so much time, effort, and money in public relations, including the whole WRAPS endeavor, but did not put aside funds to measure its impact. Perhaps this apparent oversight was understandable given that in early 1944 Myer publically announced that he intended to shut down the WRA by the end of the war.

2. National Opinion Research Center, *Attitudes toward "the Japanese in Our Midst"* (Denver, NORC, Report No. 33, 1946).

3. Ibid., 12–17; see also 4–11.

4. Ibid., 27.

5. Ibid., 18–25.

6. Dorothy Swaine Thomas, *The Salvage* (Berkeley: University of California Press, 1952).

7. Ibid., 105–106.

8. For details on the All Center Conference, in which Issei and Nisei pressed these and other demands, see Lane Ryo Hirabayashi, *Inside an American Concentration Camp: Japanese American Resistance at Poston, Arizona* (Tucson: University of Arizona Press, 1995), 163–233.

9. This is a point of confusion on the part of many Japanese Americans who condemn WRAPS resettlement photo work as hopelessly biased. Many who argue this position do not take into account that the temporal frame of WRAPS meant that the vast majority of their photographs were taken of what might be thought of as "the salvage," albeit the cream of the "salvage" crop, to be sure. Although this does

not place WRAPS work above criticism, it is not appropriate to condemn WRAPS photographers for not documenting the most difficult cases of resettlement, many of which took place at the end of the war when WRAPS and the WRA were being shut down.

10. Geoffrey Batchen, *Burning with Desire: The Conception of Photography* (Cambridge, MA: MIT Press, 1999), 202.

11. As cited by Sabine T. Kriebel, "Theories of Photography: A Short History," in *Photography Theory*, ed. James Elkins (New York: Routledge, 2007), 30–31. Also see John Tagg, *Burden of Representation*.

12. For a concise overview of some of the analytic tools that art historians and critics have derived from semiotics, see Martin Lefebvre, "The Art of Pointing: On Peirce, Indexicality, and Photographic Images," in *Photography Theory*, ed. James Elkins (New York: Routledge, 2007), 220–244.

13. Along with John Tagg, Allan Sekula, in particular, has issued a devastating analysis of photographic portraiture as both honorific and repressive. Upon reflection, the true counterpart of the honorific WRAPS portraits of the resettlers is Charles Mace's

"portable folding device of fixed focus, comprising indirect lighting, an inexpensive camera and a roll paper name panel all in one unit."

14. In this sense, I am not a realist—at least not in terms of the emphasis that I place herein on the role of power in the creation of resettlement images.

15. I derive the notion of the photograph, and its capacity to perform, from Margaret Iverson, "Following Pieces: On Performative Photography," in *Photography Theory*, James Elkins (New York: Routledge, 2007), 91–108.

16. My historical methodology, in terms of how I have approached and interrogated WRAPS, draws heavily from Michel Frizot. His analytic framework in regard to defining photography and defining the study of photography is concise and incisive; Michel Frizot, "Who's Afraid of Photons," in *Photography Theory*, ed. James Elkins (New York: Routledge, 2007), 275, 282–283, passim.

17. Ibid., 282–283.

18. Photographic portraits have a large, and fascinating, history of their own; see John Tagg, *Burden of Representation*. For an excellent discussion of the tension between power and aesthetics

in the analysis of photographs and how they work, see Abigail Solomon-Godeau, "Ontology, Essences, and Photography's Aesthetics: Wringing the Goose's Neck One More Time," in *Photography Theory*, ed. James Elkins (New York: Routledge, 2007), 256–269.

19. Pierre Bourdieu cautions that the purposes of photography vary by class background, as do readings of photographs and art; see Pierre Bourdieu and Jean-Claude Passeron, *Reproduction in Education, Society and Culture* (Beverly Hills, CA: Sage, 1977); and Pierre Bourdieu, *Photography: A Middle Brow Art* (Stanford, CA: Stanford University Press, 1990). We acknowledge this is an important point, although we are not able to engage it here, preferring to focus on power as a more pertinent variable under these circumstances. Readers interested in investigating how power influences composition might compare any of the official WRA portraits of domestic life with the vernacular images of Japanese American family life presented in a book like Richard Chaflen's *Turning Leaves: The Photographic Collections of Two Japanese American Families* (Albuquerque: University of New Mexico Press, 1991).

CHAPTER 5

1. As previously mentioned, the Conrats' photo book, *Executive Order 9066*, exemplifies such appropriation.

2. The Department of the Interior's study *People in Motion*, which was based on regional case studies carried out in cities across the country (including Seattle, Denver, Los Angeles, Chicago, and New York), concluded that access to adequate housing was one of the key challenges that Japanese American resettlers faced when leaving camp.

3. Interestingly enough, the WRAPS corpus includes a fair number of photos of what most viewers would classify as substandard housing. Perhaps these shots were taken for documentation purposes, since they all show government housing projects of one kind or another.

4. It is interesting how many of the physical landscapes of mass incarceration have been erased over the years. It is to the credit of community organizations, dedicated to history and preservation, that at

least some of the WRA campsites will be conserved for future generations.

5. These sentiments of mutual aid and cooperation for the sake of the group as a whole were positive Japanese core values from which first- and second-generation Japanese Americans had drawn to survive prejudice and institutional discrimination even before the war. Unfortunately, in promoting assimilatory Americanization, the WRA bureaucrats tended to overlook the fact that ethnicity and community had

clear benefits for Japanese Americans, at both personal and collective levels.

6. See Leonard Broom and Ruth Riemer, *Removal and Return: The Socio-Economic Effects of the War on Japanese Americans* (Berkeley: University of California Press, 1949), for a detailed study documenting specific economic losses in the greater Los Angeles area. In this important scholarly contribution to the literature, Broom and Riemer discuss the differential impact across different sectors of the regional economy that Japanese Americans worked in.

7. Some have argued that despite facing downward mobility for two decades after the end of the war, by the 1970s, second-generation Japanese Americans were doing quite well in their educational and financial achievements. My response to this argument has always been, But at what price?

8. See the wonderful account written by Phil Tajitsu Nash, "Washington Journal: Finding Family on the Web," *Asian Week*, February 13, 2004 (online in the archives of *Asian Week*, http://news.asianweek.com). Nash writes a regular column for this vernacular newspaper, often commenting on political happenings in Washington, D.C. In this instance, however, Nash wrote about finding a series of online WRA photos of his grandparents as resettlers in New York while searching for an old *Asian Week* column about his grandfather Masao Tajitsu. In a remarkable commentary, Nash describes how he used a magnifying glass to read the titles of the books on the shelf in his grandparents' New York apartment. Thus, despite the rather artificial and posed domesticity of the shots—which were taken, incidentally, by Hikaru Iwasaki—Nash was able to gain insight into his grandparents' lives by generating his own "reading" of these Phase Two photos. He looked up the book titles, in a sense perusing their library some sixty years after the fact. Nash found that one particular book at the end of the shelf was actually a popular self-help, motivational tome of the day. From this information, Nash determined that despite all of the family's losses and travails, his grandfather Masao was doing everything in his power to keep moving forward for the sake of his family. By the end of his essay, Nash has created new meaning from these old photos, despite the limitations of the original mission that generated their production. Reflecting on images taken more than half a century before, Nash affirms the "heroic" interpretation that Iwasaki produced of his grandparents, even as he reaffirms their willingness to face the challenges of making new lives for themselves in New York after the war. For another affirmative example, see "Ligaya Wada of San Diego Writes," http:www.owensvalleyhistory.com/manzanar2/page12b.html (accessed August 2007).

9. By "post-Redress sensibility," I mean only to say that Japanese Americans have the option of seeking other kinds of meanings as opposed to just evidence of oppression and resistance.

10. My point of reference here is Karen Ishizuka's remarkable book, *Lost and Found: Reclaiming the Japanese American Incarceration* (Urbana: University of Illinois Press, 2006).

11. What I mean here is the quest by those of Japanese ancestry—including those who were born after the war and also whose families did not go through camps—to develop their own special relationships to the mass incarceration experience.

12. Such is the remarkable potential of the still photograph when it is a portrait of the deceased; see Geoffrey Batchen's moving treatise in this regard, *Forget Me Not: Photography and Remembrance* (New York: Princeton Architectural Press, 2004).

Glossary

AP	Appointed personnel
ARC	Archival Research Catalog
FSA	Farm Security Administration
FWA	Federal Works Agency
LOC	Library of Congress
OEM	Office of Emergency Management
OWI	Office of War Information
NORC	National Opinion Research Center
RD	Reports Division, War Relocation Authority
RO	Reports Officer (local; at a specific WRA camp)
WCCA	Wartime Civil Control Administration
WDC	Western Defense Command
WPA	Works Progress Administration
WRA	War Relocation Authority
WRAPS	War Relocation Authority's Photographic Section

References Cited

Adams, Ansel Easton
1944 *Born Free and Equal: Photographs of Loyal Japanese Americans of Manzanar Relocation Center, Inyo County, California*. New York: U.S. Camera.

Batchen, Geoffrey
1999 *Burning with Desire: The Conception of Photography*. Cambridge, MA: MIT Press.
2004 *Forget Me Not: Photography and Remembrance*. New York: Princeton Architectural Press.

Bourdieu, Pierre
1990 *Photography: A Middle Brow Art*. Stanford, CA: Stanford University Press.

Bourdieu, Pierre, and Jean-Claude Passeron
1977 *Reproduction in Education, Society and Culture*. Beverly Hills, CA: Sage.

Broom, Leonard, and Ruth Riemer
1949 *Removal and Return: The Socio-Economic Effects of the War on Japanese Americans*. Berkeley: University of California Press.

Chaflen, Richard
1991 *Turning Leaves: The Photographic Collections of Two Japanese American Families*. Albuquerque: University of New Mexico Press.

Collier, John, Jr.

1967 *Visual Anthropology: Photography as a Research Method.* New York: Holt, Rinehart, and Winston.

Collier, John, Jr., and Malcolm Collier

1986 *Visual Anthropology,* revised, expanded ed. Albuquerque: University of New Mexico Press.

Conrat, Maisie, and Richard Conrat

1972 *Executive Order 9066: The Internment of 110,000 Japanese Americans.* Los Angeles: California Historical Society.

Creef, Elena Tajima

2004 *Imaging Japanese America: The Visual Construction of Citizenship, Nation, and the Body.* New York: New York University Press.

Daniels, Roger

1983 *Concentration Camps, North America.* Malibar, FL: Krieger Publishing.

1994 "Dorothea Lange and the War Relocation Authority: Photographing Japanese Americans." In *Dorothea Lange: A Visual Life,* ed. Elizabeth Partridge, 46–55. Washington, DC: Smithsonian Institution Press.

Danovitch, Sylvia E.

1980 "The Past Recaptured? The Photographic Record of the Internment of Japanese-Americans." *Prologue: The Journal of the National Archives* 12(2):91–103.

Davidov, Judith Freyer

1966 "The Color of My Skin, the Shape of My Eyes: Photographs of the Japanese-American Internment by Dorothea Lange, Ansel Adams, and Toyo Miyatake." *The Yale Journal of Criticism* 9(2):223–244.

Drinnon, Richard

1987 *Keeper of Concentration Camps: Dillon S. Myer and American Racism.* Berkeley: University of California Press.

Duus, Masayo Umezawa

1987 *Unlikely Liberators: The Men of the 100th and 442nd.* Honolulu: University of Hawaii Press.

Eaton, Allan W.

1952 *Beauty behind Barbed Wire: The Arts of the Japanese in Our War Relocation Camps.* New York: Harper.

Elkins, James, ed.

2007 *Photography Theory.* New York: Routledge.

Faris, James C.

1992 "A Political Primer on Anthropology/Photography." In *Anthropology and Photography 1860–1920,* ed. Elizabeth Edwards. New Haven, CT: Yale University Press.

Frizot, Michel

2007 "Who's Afraid of Photons." In *Photography Theory,* ed. James Elkins, 269–283. New York: Routledge, 2007.

Gordon, Linda, and Gary Y. Okihiro, eds.

2006 *Impounded: Dorothea Lange and the Censored Images of Japanese American Internment.* New York: W. W. Norton.

Hariman, Robert, and John Louis Lucaites

2007 *No Caption Needed: Iconic Photographs, Public Culture, and Liberal Democracy.* Chicago: University of Chicago Press.

Hirabayashi, Lane Ryo

1987 "Book Review." Review of *Keeper of Concentration Camps,* by Richard Drinnon. *San Francisco Chronicle,* January 18, p. 1.

1995 *Inside an American Concentration Camp: Japanese American Resistance at Poston, Arizona.* Tucson: University of Arizona Press.

1999 *The Politics of Fieldwork: Research in an American Concentration Camp.* Tucson: University of Arizona Press.

Hurley, F. Jack

1972 *Portrait of a Decade: Roy Stryker and the Development of Documentary Photography in the Thirties.* Baton Rouge: Louisiana State University Press.

1978 *Russell Lee: Photographer.* Dobbs Ferry: Morgan and Morgan.

Ishizuka, Karen L.

2006 *Lost and Found: Reclaiming the Japanese American Incarceration.* Urbana: University of Illinois Press.

Keller, Judith

2002 *In Focus: Dorothea Lange, Photographs from the J. Paul Getty Museum*. Los Angeles: J. Paul Getty Museum.

Kossoy, Boris

2002 "Reflections on the History of Photography." In *Photography: Crisis of History*, ed. Joan Fontcuberta. Barcelona: ACTAR.

Kozol, Wendy

2001 "Relocating Citizenship in Photographs of Japanese Americans during World War II." In *Haunting Violations: Feminist Criticism and the Crisis of the "Real,"* ed. Wendy Hesford and Wendy Kozol. Urbana: University of Illinois Press.

2005 "Marginalized Bodies and the Politics of Visibility." *American Quarterly* 57(1):237–247.

Mackey, Mike

2000 *Heart Mountain: Life in Wyoming's Concentration Camp*. Powell, WY: Western History Publications.

McCamy, James L.

1939 *Government Publicity: Its Practice in Federal Administration*. Chicago: University of Chicago Press.

Mizuno, Takeya

2001 "The Creation of the 'Free' Press in Japanese-American Camps: The War Relocation Authority's Planning and Making of Camp Newspapers." *Journalism and Mass Communication Quarterly* 70(3):503–518.

Muller, Eric J.

2007 *American Inquisition: The Hunt for Japanese American Disloyalty in World War II*. Chapel Hill: University of North Carolina Press.

Myer, Dillon S.

1971 *Uprooted Americans: The Japanese Americans and the War Relocation Authority during World War II*. Tucson: University of Arizona Press.

Nakamura, Robert

2002 *Toyo Miyatake: Infinite Shades of Gray*. Los Angeles: UCLA, Visual Communications, Inc.

Nash, Phil Tajitsu

2004 "Washington Journal: Finding Family on the Web." *Asian Week*, February 13. http://news.asianweek.com/news/view_article.html. Accessed October 15, 2006.

Natanson, Nick

1999 "Old Frontiers, New Frontiers: Reassessing USIA and State Department Photography of the Cold War Era." http://www.archives.gov/research/cold-war/conference/natanson.html. Accessed November 14, 2007.

National Opinion Research Center

1946 *Attitudes toward "the Japanese in Our Midst."* Report No. 33, December. Denver: National Opinion Research Center, University of Denver, Colorado.

Niiya, Brian, ed.

1992 *Encyclopedia of Japanese American History*, rev. ed. New York: Facts on File.

Okihiro, Gary Y.

1999 *Storied Lives: Japanese American Students and World War II*. Seattle: University of Washington Press.

Robinson, Gerald H.

2002 *Elusive Truth: Four Photographers of Manzanar*. Nevada City, CA: Mautz.

Sekula, Allan

1984 *Photography against the Grain: Essays and Photoworks, 1973–1983*. Halifax, Nova Scotia: Press of the Nova Scotia College of Art and Design.

1999 *Dismal Science: Photoworks, 1972–1996*. Normal: University Galleries, Illinois State University.

Shiff, Richard

1989 "Phototropism (Figuring the Proper)." *Studies in the History of Art* 20:169–171.

Solomon-Godeau, Abigail

2007 "Assessments." In *Photography Theory*, ed. James Elkins, 260. New York: Routledge.

2007 "Ontology, Essences, and Photography's Aesthetics: Wringing the Goose's Neck One More Time." In *Photography Theory*, ed. James Elkins, 256–269. New York: Routledge.

Sweeney, Michael S.

2001 *Secret of Victory: The Office of Censorship and the American Press and Radio*. Chapel Hill: University of North Carolina Press.

Tagg. John

1993 *The Burden of Representation: Essays on Photographies and Histories*. Minneapolis: University of Minnesota Press.

Thomas, Dorothy Swaine

1952 *The Salvage*. Berkeley: University of California Press.

U.S. Commission on Wartime Relocation and Internment of Civilians

1982 *Personal Justice Denied*. Washington, DC: Government Printing Office.

U.S. Department of the Interior

1946 *The Relocation Program*. Washington, DC: U.S. Government Printing Office.

1947 *People in Motion: The Postwar Adjustment of the Evacuated Japanese Americans*. Washington, DC: U.S. Government Printing Office.

Wallinger, Michael

1975 "Dispersal of the Japanese Americans: Rhetorical Strategies of the War Relocation Authority, 1942–1945." Ph.D. dissertation, Department of Speech, University of Oregon.

War Relocation Authority

1946 *Administrative Highlights of the WRA Program*. Washington, DC: U.S. Government Printing Office.

Winkler, Allan M.

1978 *The Politics of Propaganda: The Office of War Information, 1942–1945*. New Haven, CT: Yale University Press.

About the Authors

LANE RYO HIRABAYASHI

is a faculty member in the Asian American Studies Department, UCLA, where he is also currently the George and Sakaye Aratani Professor of the Japanese American Internment, Redress, and Community.

KENICHIRO SHIMADA

was born and raised in a town in the northern part of Kyoto Prefecture, Japan. He completed a master's degree in the Department of Religious Studies at the University of Colorado at Boulder in 2003. Subsequently, he completed a master's degree in library science with an archives concentration. He currently works in the Gordon W. Prange Collection, made up of Japanese-language materials gathered during the occupation, held at the University of Maryland Libraries.

HIKARU CARL IWASAKI

is currently retired and living in Denver. After working as the only full-time photographer of Japanese ancestry in the War Relocation Authority's Photographic Section, 1943–1946, Mr. Iwasaki entered the field of photojournalism. His photographs have been widely published, and he has served as staff and assignment photographer for many national magazines, including *Life*, *Time*, *Sports Illustrated*, and *People*.

served as the fifty-ninth mayor of San Jose, California, from 1971 to 1975, and was a member of the U.S. House of Representatives for California's Thirteenth and Fifteenth Districts between 1975 and 1995. From 2000 to 2001, Mr. Mineta served as the thirty-third U.S. Secretary of Congress. From 2001 to 2006 Mr. Mineta was the fourteenth U.S. Secretary of Transportation and the first Asian American to serve as a presidential cabinet member. Presently, Mr. Mineta is vice chairman at Hill & Knowlton Inc. in Washington D.C.

Index